The Goetheanum Cupola Motifs of Rudolf Steiner

Rudolf Steiner (1861–1925)

THE GOETHEANUM
CUPOLA MOTIFS
OF RUDOLF STEINER

———

PAINTINGS BY GERARD WAGNER

Translated and edited by

PETER STEBBING

STEINERBOOKS
2011

Published to commemorate the 150ᵗʰ year of Rudolf Steiner's birth in 1861.
This edition has been made possible with the support of the Gerard and Elisabeth Wagner Association.

Library of Congress Cataloging-in-Publication Data
The Goetheanum cupola motifs of Rudolf Steiner : paintings by Gerard Wagner / translated and edited by Peter Stebbing. – 1st ed.
 p.cm.
A collection of various lectures and essays in German.
"Published to commemorate the 150th year of Rudolf Steiner's birth in 1861."
Includes bibliographical references.
ISBN 978-0-88010-737-2
1. Wagner, Gerard–Themes, motives. 2. Steiner, Rudolf, 1861-1925–Aesthetics. 3. Wagner, Gerard–Criticism and interpretation. 4. Mural painting and decoration, Swiss–Switzerland–Dornach. 5. Goetheanum. 6. Ceilings–Decoration–Switzerland–Dornach. 7. Art and anthroposophy–Switzerland–Dornach. I. Stebbing, Peter.
 ND853.W24G64 2011
 759.9494–dc22
 2011006864

Quotations from written works and lectures of Rudolf Steiner are printed by permission of the Rudolf Steiner Nachlassverwaltung, CH-4143 Dornach.

Black-and-white photographs and color reproductions, courtesy of the Goetheanum Archive (Dornach), the Rudolf Steiner Archive (Dornach), the Gerard and Elisabeth Wagner Association, CH-4144 Arlesheim, and the Staatsarchiv Basel.

Paintings by Gerard Wagner © Gerard and Elisabeth Wagner Association, CH-4144 Arlesheim.

Cover illustration:
Painting by Gerard Wagner: *Faust* motif (Plant colors).

Typeset in Palatino by Urs Rüd, Basel.
Layout: Peter Stebbing and Urs Rüd.
Printed in China.

CONTENTS

Foreword

Along with the architectural and sculptural forms of the double-domed first Goetheanum, the cupola paintings further epitomized the artistic conception of this unique building. The painting motifs extending over the surface of the two cupolas encompassed the evolution of the world as a whole, from its creation by the biblical Elohim to the great epochs of Lemuria and Atlantis which followed. Traversing the post-Atlantean cultural epochs, the beholder was gradually led to the building's central motif: to the Mystery of Golgotha as the mid-point of world-evolution, with its implications for the future development of the earth and humanity.

This mighty panorama presented itself in the large and small cupolas in two distinct motif sequences. Plant colors produced especially for the purpose, and applied for the first time on such large surfaces, were to impart a luminous quality to the painting, in subdued light. The motifs themselves were to be fetched directly out of the living, flooding background colors, in accordance with a new way of painting inaugurated by Rudolf Steiner. Therein lay at the same time, however, the main problem in carrying out his intention. On account of their specialized training and background in a prevailing contemporary style (art nouveau, Expressionism, etc.), most of the painters around Rudolf Steiner were at first unable to enter sufficiently into this pioneering new conception of art. Only quite slowly did this come about, in the actual process of working. Thus Rudolf Steiner again and again offered advice and suggestions – eventually even repainting the motifs in the small cupola himself.

This had become especially crucial in the case of the central motif of the *Representative of Humanity* between Lucifer and Ahriman in the eastern part of the small cupola. Following the less-than-successful attempts of his co-workers, Rudolf Steiner took brush in hand himself, and painted this figure, toward which all the painting motifs were aligned. Only thus could the work succeed as a whole.

For the artists working with Rudolf Steiner, the difficulty in comprehending his artistic intention lay in the completely new, unknown territory in painting entered into here. Hence, at the time, and still more so after the burning of the first Goetheanum and the consequent loss of the works of art it contained, many things remained an open question. A number of problems relating to this new art were left unsolved.

Since then, several generations of anthroposophical artists have attempted in various ways to arrive at answers to these questions in actual practice and to solve remaining riddles.

The endeavor has been to do justice as far as possible to the painting impulse of Rudolf Steiner and even to develop it further.

Among the works of these many painters, the corresponding portion of Gerard Wagner's extensive artistic estate occupies a special, if not unique position. For, as hardly any other painter, he succeeded in entering with his artistic intuition into what was Rudolf Steiner's chief concern, carrying it further. This was bound up in the first place with a renewal out of the spirit in every field of artistic activity. Both for the painter and for the observer, the path becomes an inner path of schooling on which soul-spiritual as much as artistic capacities are developed and nurtured. Gerard Wagner, more than anyone else, took up this unique starting point of Rudolf Steiner's art impulse and made it his life's task.

Given the magic conveyance of his brush, the various painting motifs of both cupolas became stages on just such a purely artistic training path. The spiritual forces secreted into these motifs by Rudolf Steiner emerged – in their further development and metamorphosis – as though with renewed power.

In this way, the special segment of Gerard Wagner's comprehensive oeuvre in which he concerned himself with the painting motifs of the first Goetheanum becomes a real journey of discovery, taking the observer to the spiritual sources of the anthroposophical art impulse. There the cosmic forces are originally anchored and themselves become creative, that had found their manifestation and their speech organ in the first Goetheanum as a comprehensive work of art.

Therein lies the abiding, singular value and artistic magic of the works of the master reproduced in this book. They can become an indispensable, future-oriented source of inspiration in the life of everyone interested in the anthroposophical art impulse.

– Sergei O. Prokofieff
The Goetheanum, Dornach
Advent, 2010

Preface

It is hoped that this publication will make Gerard Wagner's approach to the Goetheanum cupola sketches of Rudolf Steiner more widely known. Wagner recreated these archetypal motifs in ever new ways, over a period of decades. They constitute an artistic high point of his work as a whole. However, they cannot be separated from the Goetheanum itself and the art impulse for which it stands. They can be fully understood only in the context of anthroposophical spiritual science, of which the Goetheanum is, in Rudolf Steiner's words, a 'true emblem.'

A further purpose of this book is therefore to draw attention to the historic importance of the first Goetheanum building. (Of equal significance, the second Goetheanum exceeds for the most part the scope of this presentation.) Both the lecture of Rudolf Steiner of October 25, 1914, and the one on the paintings of the small cupola given January 25, 1920, appear here for the first time in an English translation, together with the extant color photos from 1922. Also included are the little known colored etchings of the Goetheanum window motifs carried out by Assya Turgenieff in collaboration with Rudolf Steiner – along with other centrally important contributions to an understanding of this new direction in art.

Though the main emphasis is on visual examples, the intention has been to achieve something more than a catalog of the works of art in question with accompanying data. The principal aim has been to convey, as far as possible, a sense of the artistic process itself. Thus the observations of Gerard Wagner in this regard have an altogether special relevance. Further practical indications on painting out of the color will be found in the book *The Individuality of Colour*.

– Peter Stebbing
Arlesheim, September 2010

*Not that I do something, but that the suggestions
I make are developed further, that is my actual aim.*

–Rudolf Steiner
(November 10, 1918 in Dornach)

*It belongs to the character of the spiritual forces
now making a breakthrough, that they appear
unspectacular. The new shows itself in subtle ways
and always stands in danger of being overlooked or
denied.*

–Albert Schmelzer
Die Menschheitskrise der Gegenwart

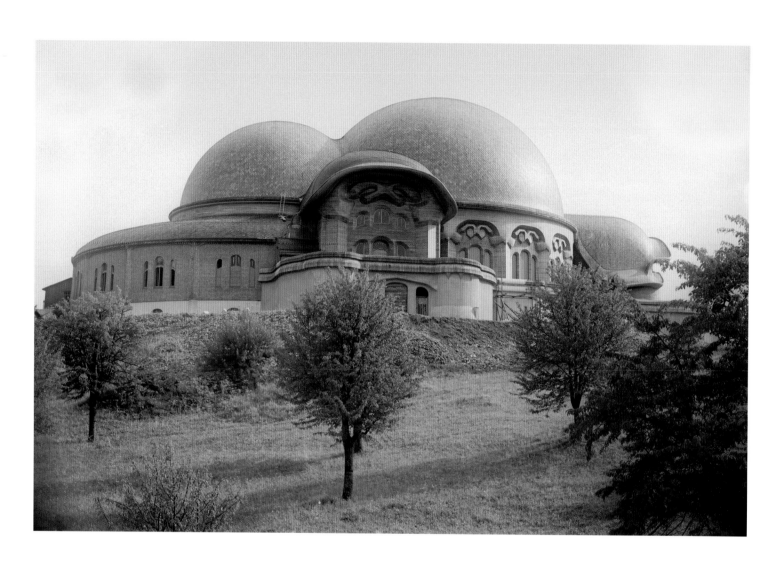

The first Goetheanum from the north. 1922.

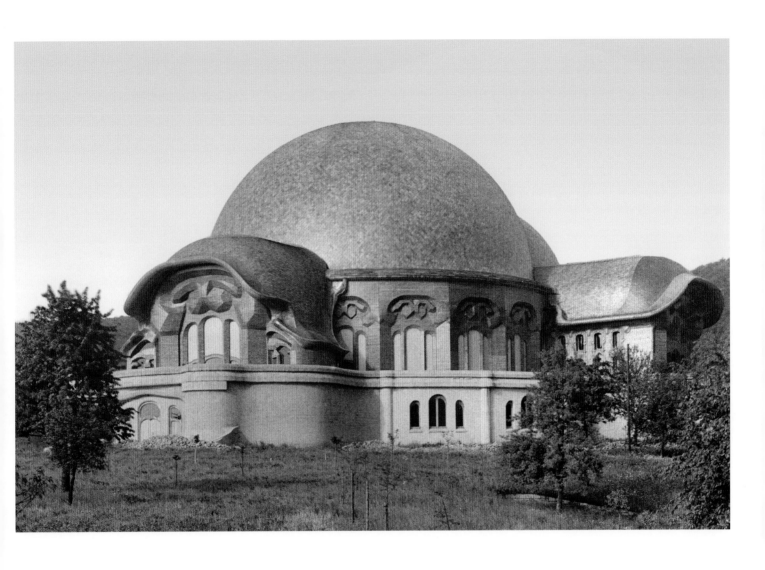

The first Goetheanum from the southwest. 1922.
(An early tinted black-and-white photo, restored for this edition 2010)

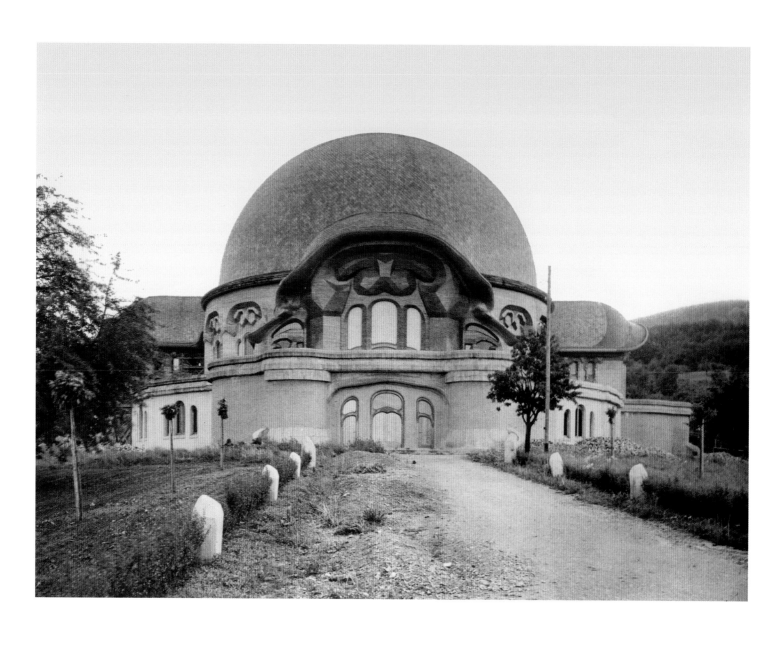

The first Goetheanum from the west. 1922.
(An early tinted black-and-white photo, restored for this edition 2010)

The Renewal of the Artistic Principle

(A lecture held in Dornach, October 25, 1914)

Rudolf Steiner

We spoke yesterday of impulses of will, of feeling and of thinking that live in the human being, and that are to find expression in our building.

It will follow from what has been said here over the last few days, that the artistic element in our building is to feature something new, that it is to embody something not extant till now in the artistic evolution of humanity, yet essential nonetheless for humanity's further development. Hence, this has to be incorporated from now on in human evolution.

It will be difficult, however, to enter into what is actually intended with our building if one merely seeks to do so externally. In adopting an external point of view, one will likely stand in front of this building and say, 'Well, I can't really make anything of all this – it doesn't mean anything to me.' And, as a matter of course, one will engage in a critique of the building from the standpoint of what one has been accustomed to regard as artistic until then. In every age of humanity's development, whatever enters human evolution as a new impulse has been judged from the vantage point of the past.

It will help us to understand what chiefly matters if we look for a 'formula' to express in a few words the essential requirement for a renewal of the artistic principle out of a true anthroposophical conception. Surveying the art of the past, we can direct our gaze to what humanity has brought forth in the way of original architectural forms in Egyptian, Greek and in Gothic architecture. Or, we may direct our gaze to what presents a renewal of earlier forms in a later age, as in the Renaissance. We can contemplate sculpture, painting and so on in the same way.

Comparing the effect on us of this art of the past with what is intended in our building, it can be said: it is as though something at rest were called to life. The previous artistic development of humanity may be contemplated as the image of a human being who stands before us at rest, having assumed a particular gesture. And now someone comes and says something to this human being, who then begins to walk, to move. That is how we may regard the

artistic development up to our time. In observing it as something that stands there at rest, we should like to call out the magic word by which it is brought into motion, brought to life inwardly. Indeed, this is altogether something we would bring about by means of our entire spiritual scientific movement, demanded as it is by the transition impulses that live in our time, and that summon us to seek something new for the future evolution of humanity.

If we contemplate, let us say, a beautiful Greek architectural work of art, we shall see that the main consideration is that relationships of symmetry are there that mutually carry and support each other in a state of rest. In somewhat the same way, the single members of the human being carry and support each other in standing before us at rest.

And now let us compare this with what we hope to achieve with our building. Self-evidently, this will eventually develop beyond the primitive beginnings and the limited forces with which we now have to work.

We have in the building a progressive movement from west to east. We have motifs that evolve from the simplest forms, to be seen in the west in the capitals and architraves, becoming more complicated and taking an 'inward' turn, and in this 'inwardizing,' becoming simpler toward the small cupola space. What had previously been subject only to an inorganic principle of symmetry is brought into movement. What had supported and carried itself in a state of rest now becomes mobile. This principle will especially have to come to expression, in so far as we are already able to achieve it in our time, in what is to be striven for in painting.

In a sense, painting has two poles. The one pole is that of drawing, the other pole being that of color. Basically, everything in painting is made up of these two poles. It can happen that someone is a significant draftsman, which involves the capacity to reproduce in lines what is predisposed toward form. But we have to be clear about the fact that anyone entering in this way into the drawing pole of painting has necessarily to be very one-sided in regard to external reality, or as is frequently said, in regard to nature. For nature works not only with lines the painter can hold fast, but possesses far more significant means for expressing the qualities of things. For that reason, the painter or draftsman has to express more by means of lines than nature is capable of expressing in lines, in being inwardly moved by a particular subject, for instance.

Even so, in regard to drawing one will always have the feeling that in relation to nature, drawing is ultimately no more than a surrogate. Whatever we achieve through drawing, whatever we manage to express by means of it, we are never able to render anything that transcends nature – we are not even able to reach her. What we strive for with respect to nature has to remain mere bungling after all, since with her far richer means, nature can bring to expression the essential inner qualities of her creations.

For that reason, drawing can never be anything more than an expedient. And I believe anyone who is really competent in drawing will feel it to be no more than a framework, a scaffold, subsequently to be dismantled – that is all the better, the less it can be seen later.

Whoever has artistic feeling will experience a painting in which drawing is particularly

prominent or conspicuous, as being rather like a building where the scaffolding has not been taken away but has remained standing. This can reach a point where drawing is felt to be something that 'leans,' as I should like to put it, rather awkwardly on the artistic as such.

It is different with the other pole of painting, with color. There it has to be taken into consideration that the art of color records what is basically not there at all in nature, or can at best be held fast only for a moment. Properly speaking, one cannot count local color as belonging to the art of color. For, it goes without saying that painters who put the main emphasis on imitating the colors of the clothing, for instance, of the people they are painting, are bad painters.

But fundamentally, someone would still not be a good painter who especially wanted to bring to expression, in coloring the face, the vital condition of the human organism. Whoever paints a pale face – to cite an extreme case – so as to indicate with this pale face that the person being painted is perhaps unwell, would in actual fact not give evidence of anything truly artistic. And it hardly needs to be said that wanting to paint a wine drinker with a red nose would have little to do with what is artistic.

In wishing to record in terms of color what is static and on the surface of things, one does not in fact work out of actual artistic impulses. However, if one paints, let us say a cloud, and brings to expression the whole magic of nature – for instance the morning sun and the effect of the morning light on the color nuances of the clouds – one then holds fast what passes, and does not proceed from the single entity, the single cloud. What is held fast is thus something transitory, yet accounted for by the entire surrounding conditions, indeed by the cosmos, in so far as it comes into consideration. If we paint an illumined cloud at a particular time of day, we are basically painting the whole world as well, present at that time of day. If we paint a human being with the intention of representing the person's inner constitution, then we are not within the bounds of what is actually artistic. However, if we succeed in bringing to expression what this person has experienced, being able, for example, to depict what causes a person to have a certain redness of the face, then we do stand more within what is artistic. We do so still more as soon as it can be seen from the picture itself what experience the person must have undergone that determines the red of the cheek. Thus, once again we have something not inherent in the individual being or entity, but in the entire surroundings, in the whole cosmos.

What I am saying here is connected in a sense with what I spoke about in the lectures on 'Occult Reading and Occult Hearing.' There I said that the soul is actually always outside the body, also in waking life, and the body is only a mirror by means of which the human being becomes conscious of what lives outside in the cosmos. Only they are true artists who live to an extent together with things out there in the cosmos and for whom artistic activity is but the occasion for reproducing their life within the cosmos.

If we paint a cloud as described in the example just given, we are actually outside the cloud with everything we feel and imagine, and the cloud is only what provides the reason to project onto a single entity what lives in the entire cosmos. But in seeking to live in this

way in the cosmos, wherever color comes into consideration we are called upon to awaken the color to life. Colors approach us as attributes of things in external nature. We recognize colors on the objects of nature, in observing them on the physical plane. To see colors, we need everywhere a bearer, a basis, with the exception of the atmospheric phenomenon of the rainbow. Thus the appearance of the rainbow has rightly been seen as something that unites the heavens, the spiritual, with the earth, since with the rainbow we do not see the sky colored, but in fact color as such.

I have pointed out in lectures previously that there is the possibility of immersing oneself in the surging color world, of living with colors. If one releases color from objects and lives with color, then it begins to reveal profound secrets, and the entire world becomes a flooding, surging sea of color.

The need then arises, however, to release the world of color from the conditions imposed on it on the physical plane. The need arises to seek the actual creative element in color.

If the painting in our building is to fit in organically with the whole, then it must arise out of this impulse. The attempt will have to be made to realize by means of color what does not live as color on the physical plane, where all color – with the exception of the rainbow and similar phenomena – is only fixed to objects. It must then be possible, for example, to live with one's whole soul in blue, as though the rest of the world were not there, as though only blue existed and the soul felt itself flowing out into the blue filling the entire world.

But what then emerges, if one truly lives in the flooding, surging color world, will not be only a mere laying-on of color tones. Immersing oneself in the creative element of color, one will find that color differentiates itself inwardly. In living in blue and gradually entering into it, it will be found that blue has something that attracts the soul, in which the soul would like as though to lose itself, yearning after it, and wanting to do so continuously. It will be found that out of this, figures arise, figures that bring to expression secrets of the cosmos – that bring to expression the soul of the universe. From the creative element in color a world will arise of itself, a world that configures itself, that inwardly differentiates itself – that is of the nature of being. The form will be born out of the color. It will be felt that one not only lives in color, but that color gives birth to form out of itself, that in this way the form is the work of color.

Indirectly, by means of color, one will thus enter into the creative element in the world. Only in this way can it happen that painting not only covers the surface, but directs us out into the entire cosmos, uniting us with the life of the whole cosmos. Thus, what was set forth yesterday as the necessary content of our cupola painting will have to be inwardly grasped – the impulses of the Lemurian, the Atlantean and our post-Atlantean life, in the ancient Indian, ancient Persian, Egypto-Chaldean and Greco-Latin cultures. Out of such inner identification with color that captures form, it will be possible to come to what lives in the evolution of humanity.

Whoever looks at how painting has been practiced till now, will see that painting has essentially tended to occupy itself with color as something attached to objects on the physical

plane. If what should arise with our cupola painting is actually to come about, there will have to be a freeing, an emancipation of color from objects. It will thus be a matter of a fundamental spiritualizing and 'setting in motion' of painting as an art.

It will be difficult to make what is intended here comprehensible to our contemporaries. Indeed, it will be necessary for us to do without such comprehension. As long as the judgment remains possible, whereby someone finds a work of art 'right' or 'good,' or what have you, provided it is reminiscent of something 'real,' our painting will not be understood. As long as anyone is capable of saying a tree is well painted if it is as naturalistic as possible, and one believes oneself standing in front of something like a real tree – as long as this is the yardstick for judging painting and everything artistic, nothing of our painting will be understood. What is painted in our sense will necessarily be considered foolishness. One will find nothing in it.

For what purpose were works of art always there? To be looked at! Who would ever have thought that works of art are there for anything else than to be looked at? What is to be created in our building, however, will not be there in order to be looked at; not in the least! We can actually be glad if those who believe, based on their prerequisites and previous studies, that works of art are there in order to be looked at, find our works of art as bad as possible. For one thing is certain, namely, that what these people do not want, is just what we do want!

One sometimes experiences quite characteristic things on occasion. One of our friends met me once on the way from the Glass House studio to our house and related how he had spoken with an old gentleman who said, 'If the person who proposed the idea of these two cupolas had ever seen St Peter's Basilica in Rome, he would have made these cupolas differently.' Well, the person who had the idea for these two cupolas *has* seen St Peter's Basilica, not only once but several times, and took pleasure in it, sensing the whole magnitude of the building. Even so, he made the cupolas as they now are.

It is quite natural that such judgments arise, for St Peter's Basilica is also there to be looked at. But what is done here is not only there to be looked at, but to be properly *experienced*. And what would the answer have been for that old gentleman? The right response would have been to ask him, 'Do you know the fairy tale of the king's son... [gap in the transcript], who had only seen the things that could be seen from his window? And do you know what happened one day when he had 'eaten of the snake'?[1] He then began to understand what the sparrows on the roof, what the chickens in the courtyard discussed among themselves. The old gentleman had evidently not 'eaten of the snake'. What does it mean to 'eat of the snake'? – It means not only to have peeked into spiritual science theoretically, but to be taken hold of by it with every fiber of one's being, in one's very heart, so that one senses a reflection of this spiritual science within one. If one is able to feel that with one's whole being, then one has 'eaten of the snake,' and then one *experiences* what is intended with our building and does not merely look at it. One experiences what is actually intended with it. At the same time, one has a sense of how, dull and unconscious in their will-life, human beings

go from incarnation to incarnation, in being incorporated now in this, now in another folk.

Just as one can experience the will impulses of the human being in our building in the progression from west to east, in the sequence of columns, of capital and architrave motifs, so the feeling element can be experienced in what develops from below upwards. But one must experience it. And the thinking element is there, thinking that is not mere abstract, cold, functional thinking, but is enlivened by the heart of the cosmos itself: that is to be experienced in the conclusion represented by the cupolas. It ought to be experienced yet again in the details of the individual cupola motifs. If for example, a color is next to another color that never occurs next to it in nature, if a being appears, bearing features similar to those of the human being, in colors it could never have in nature – it will then be necessary to *experience* how, in what comes to expression there, an inner, ensouled, living and mobile element is brought to expression.

If this succeeds in coming about to some extent, then something will be attained for the first time – even if only in its first beginnings – whereby nothing in painting is as it is in nature. All the more, however, will everything be as it is in the spirit.

And two things, my dear friends, will have to be attained, two things that as yet only very few people profess to at present. It truly does not serve the well-being of humanity that so many people still do not want to know anything at all of the great perspectives in human evolution. You see, if one were to concentrate in a single perception, what it is that our building is to be a symbol or emblem of, then it would involve making oneself inwardly alive – enlivening the soul in all sorts of ways. What underlies our intention cannot be expressed in an easily surveyable form. It would be a matter of attempting to summarize, to gather together what would actually have to be felt in terms of the most varied perceptions and feelings.

Let us remind ourselves how it was in ages other than our own. Think of the horizons the Greeks had, to go no further back. Let us consider everything not as yet there for the Greeks, but there for people today. What did not yet exist for the Greeks? Well, America and Australia were unknown to the Greeks. They knew nothing of the western regions of the earth. They knew nothing either of all that is now known of Europe, Asia, and Africa. Their horizon was geographically limited. Try to survey for a moment the map as it was known to the Greeks. Then direct your attention to the rich world in which the Greeks lived, to all that was creative in the Greeks. Try comparing the map of the heavens the Greeks still knew how to draw, with todays map of the heavens. The map of the earth's physical formation was quite small; the map of the heavens on the other hand was truly large. What existed in Greece was essentially still a spiritual experience of the physical plane: geographically – narrowly bounded. Spiritually, however, they looked out into heavenly distances.

With the Greeks it was no longer as, for example, in the Egypto-Babylonian-Chaldean age, where one looked out into the cosmos and still experienced in astrological conceptions something of the real spiritual beings of which the heavenly bodies are the physical expression. However, a reflection of all this was still there in ancient Greek culture. Reading in

Homer's *Iliad* how Achilles is informed by Thetis that Zeus would now be unable to do anything, because he is in Ethiopia and will only return to his house in twelve days, this still has a connection to astrology. However, it is presented in such a way that the reader does not notice that this description is based on a transit of the zodiac. When the Greeks said, 'Zeus is with the Ethiopians,' they meant that he is in a certain sign of the zodiac. The number twelve also indicates this. All this is already tinged by what came later, yet it remains, on the other hand, saturated still with what human beings originally possessed in terms of the breadth of their spiritual horizon.

Let us now turn from Greece and cast a glance at more recent times. Geographically, the world becomes increasingly rounder, and today only a few regions exist that are, as it were, vacant spots on the globe. We see modern times approaching. America is incorporated by oriental peoples into their geographical maps of the earth; the America that was not there for the Greeks. Geographical horizons became ever wider, but the spiritual horizons (so to say, the map of the heavens) shrink completely. What do modern human beings know today of what populates Greek mythology? They know nothing of this anymore! Europeans have emerged from the historical development that goes back to ancient Greece. What lies further back in history than Greece, despite being researched from documents, acquires only a ghostly appearance. When modern human beings absorb the elements of Greek culture offered in schools, they absorb history. We live in the history we have come to know externally in this way. We actually drag quite a lot of history around with us.

It is not so with Asians, nor is it so today with Americans. Even if they have their history, their history still does not constitute an integral part of life. Americans live much less immersed in history than Europeans.

Few Americans will place any great importance on pursuing their genealogical tree back over a period of centuries; probably very few. But in Europe there are by no means only a few. That amounts to carting along a historical component, upon which so much depends in the whole configuration of life, social life included.

A time is thinkable, in a far future – for the occultist more than thinkable – in which everything we carry about with us since ancient Greece will cease. We need not go into where it will then be. A time is thinkable in which a cultural wave will have rolled through Asia, across to America, in which people will know as little of what we now experience of European history, as we know today of what transpired four to six thousand years ago in Europe. We can look to a time when this wave will have rolled across, and a quite different life from today's will develop; and where, so to say, everything that touches us in every fiber of our being will lie in historical-geological substrata. It will then be just as much a thing of the past as what happened on European soil three, four, or five millennia ago is for us today.

A time will come, in which Goethe, let us say, will be discovered, just as we modern human beings have discovered the ancient world in the first Egyptian hieroglyphs, becoming aware of what took place then. For there will be people who will have a need to discover Goethe in just such an external, physical manner.

Here, we are looking at great, albeit strange perspectives in human evolution. Just as the ancient Greeks knew nothing of America, so the descendents of today's Americans will know of Greek culture as of something long past, or know nothing of it in certain respects, just as I have now told you.

The process I referred to as being essentially a physical process, also takes place to some extent on a spiritual level. It takes place on a spiritual level in that, for the future, the human being will have to mature in the course of human evolution to acquire capacities for rediscovering the spiritual world. It will be a matter of becoming aware of a spiritual world that is as unknown for most people today as the America of today was unknown to the Greeks. We are at the beginning of this journey of discovery toward the spiritual America. In this connection, we also stand where people stood physically, when the first ship sailed to America from the Old World. Thus we are on a journey of discovery toward the other, spiritual half of our human existence.

With this I wanted to call forth a presentiment of the significance, the importance of what spiritual science is to become in human evolution. If we were to assume America had not been discovered, and Europeans still lived with no knowledge of America – would that be thinkable? It would not be thinkable at all, really! In the same way, a time will come in which it will be essentially unthinkable that human beings had ever been unable to arrive at discovering the spiritual world. It will be completely unthinkable.

The comparison can, however, be spun out still further. For, what has arisen as a result of the geographical horizon having been extended? Were we to look for the most ideal spiritual culture to have developed on the earth till now, we would have to seek it before the discovery of America. With the discovery of America, materialism also begins. Connected with every geographical enlargement, in a mysterious way, there is an expansion of materialism. Humanity must return to an ideal-spiritual knowledge of the world. It will reach this by means of the discovery of the spiritual America, and come to it when, in the world at large, the path is found that is already symbolized in our building.

In going from column to column, from architrave motif to architrave motif, we have pointed out the progression, the direction inherent in our building. This is a progression on the physical plane. But we have to add that there is a possibility of looking-up – that we can also follow the motifs from below upwards.

Historical development – in as much as we contemplate it externally as it comes to light on the physical plane – presents us with a progression. But a deepening of the human being will become more and more necessary, a deepening of soul that is at the same time – as with Goethe's Faust, who descends to the Mothers – a real ascent into the spiritual world. Such a deepening of the soul is self-evidently an ascent into the spiritual worlds – brought about by the good spirits.

But once human beings have raised themselves to the spiritual worlds, a kind of conclusion will come about. I say expressly, a conclusion. Let us take the word just as I said it. For, whenever development is spoken of nowadays, something comes to mind actually rather like a barrel that begins to roll, that rolls on and on. One even imagines, it never actually began to roll, but always rolled. Anyone speaking of development today almost always thinks of it in this way, as though development were always present, as though everything develops on and on, and as though things had always been like that. But that is not how it is in reality. It is only a bad habit, a kind of impertinence on the part of our thinking, to suppose, both past and future development are unlimited. The earth is in development, geographically, physically, just as every people is. But that comes to an end at some point, a conclusion. When everything has been discovered, things come to a conclusion. One cannot then say, 'Now we shall continue to equip our ships and discover more.' It does not work out like that. Evolution cannot go on to infinity. Evolution has a conclusion. And just as on the physical plane, evolution has to have a conclusion, so spiritual evolution will also have to have a conclusion. A 'cupola' will in time rise over what humanity has experienced historically. And just as it is true that no further ships can be fitted out in order to discover still more distant lands once the entire globe has been discovered, so it is equally true that what can be discovered spiritually will one day actually have been discovered. It would signify a quite erroneous conception of evolution, to tell oneself: people have already discovered so much, investigated so much, they will go on and on investigating, endlessly, and always discover new things. That would be one of the worst notions one could succumb to. In order to arrive at sound ideas, it is definitely necessary to think realistically. But very few people think realistically in our present time; they believe they think realistically, but they do not think realistically. One can, for instance, meet people today who say, 'Well, when there is nothing at all left to investigate, then the world will be quite boring, since that is after all what makes the world interesting in the first place – that one can't imagine research will come to an end.' But it will come to an end eventually, just as geographic exploration of the earth will come to an end. For those suffering qualms at the thought that human beings will one day have nothing more to investigate, asking: 'What will the human being do then?' For such individuals, it has to be said: They will do something other than investigating. And that will sort itself out.

I have now put forward a few ideas, the purpose and aim of which can be followed up. You will come to recognize the broader aim for yourselves. In a sense, we may see the whole historical life of humanity as taking place much as our building raises itself and arches

above. We experience the passage of time in going from one column to another, raising ourselves inwardly in directing our gaze to the capitals and architraves. We find a conclusion in looking up into the cupola.

A conclusion does indeed need to be there. Just as a conclusion comes about in history, so a conclusion must necessarily be there in the paintings of our cupola. These ought not merely to cover the surface, however, but should call forth the feeling that in lifting ones gaze to the heights, to what is painted on the cupola surfaces, nothing physical is to be found there. The material substance of what is painted should be forgotten. Rather should it be as though transparent. In looking out beyond what is painted on the surfaces, one then looks out into spiritual distances.

It may not be possible to accomplish this entirely with our building. But, as the principle represented by our building evolves further, it will be achieved eventually. A future humanity will directly perceive what it has received from spiritual science, recognizing it as a mighty dome, a cupola, the configuration of which points out into infinite spiritual distances.

If, my dear friends, we live at a particular place on the earth and want to travel elsewhere, and cannot do so at certain times, then we may come up against the fact that people stand in a hostile relation to one another. It may be that they quarrel or fight over earthly things. In regard to the sun and stars, however, one cannot quarrel. Even though the Chinese called their ruler the 'Son of the Sun,' or the 'Son of the Heavens' – and though they began wars for various reasons – they never began a war over ownership of the sun. It never occurred to them to want to make possession of the sun a matter of dispute with other peoples. All manner of things can be the occasion for quarreling and fighting on the earth. What draws the attention of human beings up into the spiritual worlds *cannot* in itself be a cause of quarreling and fighting. It can actually never lead to quarreling and fighting.

We must only be clear that some things will still need to happen in the course of earth evolution for humanity to see into the spiritual world by means of spiritual science. What spiritual science provides should be equivalent to what the sun and the stars are in physical life. It will above all be necessary that, by means of spiritual science, human beings begin no longer to think with the instrument of the brain alone. In certain respects, it can be said: Nothing is more alien to us than our head. – Really, nothing is more alien to us than our head! For, as far as its main structure is concerned, the head was essentially concluded at the time of the ancient Sun evolution. The rest is partly an inheritance from the Saturn evolution, developing further and acquiring important features during the Moon evolution. But what is thought with the head is basically no less alien to human beings today than knowledge of the Saturn, Sun, and Moon evolution – this being 'alien' to them still.

Many sayings in ordinary life contain profound truths. However, there is one saying that need not be believed: It is often asserted that every person has their own head. That is actually false. No one has their own head – everyone has the head of the cosmos! It would be appropriate for someone to say, they have their own heart. That would be meaningful. It is nonsensical, however, to maintain: 'I have my own head.'

Human beings will have to begin to develop thoughts that are experiences, as I described yesterday, for example, with reference to the inner experience of raising oneself into the upright position. We experience standing up actually only with the head. We experience it quite abstractly – that tremendous process taking place when we raise ourselves from the horizontal position in which we are parallel with the earth's surface, into the direction corresponding to the earth's radius. This alteration, in which we assume the direction of the vertical beam as opposed to the crossbeam of the cross, is something tremendous, if we really experience it. We then experience something cosmic: the cosmic Cross.

This is an everyday experience. But we do not think about it every day – nor that, as soon as it occurs, this cross is drawn in human life, the moment the human being gets up or lies down.

But human beings have far, far to go from this abstract standing-up and lying-down, from this perception of the cross-form, to what may be comprehended in the words: Were human beings not so constituted on the earth that they lie down and stand up again, the Mystery of Golgotha would not have been necessary in earth evolution.

If someone utters the sound 'B' or writes the letter 'B,' then that signifies the sound 'B.' Were someone to desire a specific character or sign for the earth, one that expresses the fact that the Mystery of Golgotha was necessary for earth evolution, then we have it in the sign of the cross, which incorporates the lying and standing of the human being. Since human beings lie and stand on the earth, they are so constituted that the Mystery of Golgotha had to take place.

When a beginning is made in thinking with the second brain – not with the head-brain, but with the second brain that I characterized in the lectures on 'Occult Reading and Occult Hearing,' in saying: The lobes of our brain have to be regarded as arms held firmly together, as though our arms and hands were 'grown onto' us – then you will think in such a manner that it will be impossible for there to be any doubt that this sign of the cross is the expression of the Mystery of Golgotha. Only for the head-brain is such thinking not possible today. The head-brain is also the basis of the many misunderstandings in the world. So many misunderstandings arise, for the reason that the head-brain is solely active and creative. The second brain must also become creative, to the point that something fulfills itself in the world that can be linked to our previous image. I said the Greeks did not know of the existence of America. But, referring back to other documents, we find that there were actually times during which America was known. The knowledge of America was simply lost again. In the

same way, there have been times when what spiritual science would now fetch down once again was known. We likewise know from spiritual science that much will have to be recovered that human beings possessed earlier in a dreamlike manner, out of subconscious experience. People really had something like a common language that became differentiated only later. The legend contained in the Bible of the Tower of Babel is well-founded. But as long as people think only with their heads, they will not be able to think creatively, they will not be able to be creative as in ancient times with regard to language, for example. But inherent in spiritual science is the disposition for a creative renewal of the elements of speech. And when I said in relation to the building, that there the artistic element is brought into movement, it has to be added that life itself is to be brought into movement.

A perspective comes into view, in which spiritual science will be creative. By means of what is thought and visualized in spiritual science, language will become creative. Just as it is true that spiritual science will one day be spread over the entire world, so it is true that it will bring about a common language corresponding to no existing languages. The language of the future will arise by virtue of human beings learning to live in the sounds of speech, just as they can learn to live in color.

If we learn to live in sounds, the sound gives birth to a configuration in which human beings regain the possibility of creating a language out of spiritual experience. Though we still stand at the beginning in regard to some things in spiritual science, in regard to what has just been said, we are not yet even at the beginning. But we must entertain the thought of it, in order to acquire a feeling for the far-reaching significance of spiritual science, and in order to properly sense that spiritual science bears within it a new knowledge, a new art and even a new language – a language that will not be made, but which will be born.

Just as human beings will never fight over the sun and the stars, so they will not fight over the new language alongside of which the other languages can quite well continue. These will still be there when this language has arisen.

With this, you will acknowledge, we have placed a distant ideal before our souls, a truly distant ideal. Most present-day materialistic thinkers would most definitely say of what has just been stated, 'That *really is* floating in cloud-cuckoo-land. Any fool capable of speaking of the creative element in language – and what was otherwise said in regard to spiritual science – must have lost the firm ground under their feet. '

It could easily be imagined that someone standing at the level of contemporary knowledge, having listened-in from some corner or other, on what was said, would have burst into derisive laughter at this losing-of-oneself in the clouds, this losing of all ground from under one's feet. However, we might look upon such a person with understanding, since in placing such high ideals before us today we really *have* lost the ground from under our feet. For, as long as the earth will evolve as a physical planet, this ideal will indeed not be reached. The earth will perish before this ideal is realized. But human souls will survive to live on other planetary embodiments, and will experience the realization of this ideal, provided they become conscious of it precisely in our time.

Ahriman could stand there as an arbitrator between us and the one who listens from the corner and laughs, thinking we have lost the ground from under our feet. Ahriman might then rub his hands together and say, 'They call it, having future ideals. They have lost the ground from under their feet; the man over there says it. He mocks himself, and doesn't know it. He speaks the truth and doesn't know it.'

We know, however, even if we do not stand on the firm ground of the earth, we stand nonetheless within reality with what we make the most living content of our soul. Why? Because we confess to the Mystery of Golgotha in earnestness and not with that thoughtlessness so current today. We know that Christ lives and that we can know what is right, if we let Him be the greatest Teacher and Guide with regard to our spiritual wisdom.

He has, however, spoken words that imply: You would be able to confess to me in your innermost being only if you not only confess in the external sense to those words and to those ideals that perish with the earth, but if you hear my words. The whole external configuration of the earth will perish; it will no longer be as it now is. He Himself said, '*Heaven and Earth shall pass away, but my words shall not pass away.*' We can be firmly anchored in our souls, my dear friends, even if we confess to ideals regarding which our opponents say, we no longer stand on the firm ground of the earth. In confessing to the Mystery of Golgotha we confess to ideals that are more lasting than the earth and the whole realm of the heavenly bodies circling in the universe. We should listen to the revelations of the Mystery of Golgotha, which continue to exist even when the earth will no longer exist, along with the heavens that now look down on the earth.

Truly profound is the meaning of the words that proceed from the Mystery of Golgotha. Those people do not live in reality who do not want to lift their gaze from the earth up into the cupola that is to be permeable in order for us to look into the spiritual world. For, if this cupola is to be an expression of the Mystery of Golgotha in architecture, then it must itself tell us something that can remind us of the words:

Heaven and Earth shall pass away,
But my words shall not pass away.

From Rudolf Steiner: ,*Der Dornacher Bau als Wahrzeichen geschichtlichen Werdens und künstlerischer Umwandlungsimpulse.*' CW 287. Dornach, Switzerland. Rudolf Steiner Verlag 1985. Lecture V; translated by Peter Stebbing.

[1] This appears to be a reference to the Grimm fairy tale, *The White Snake*.

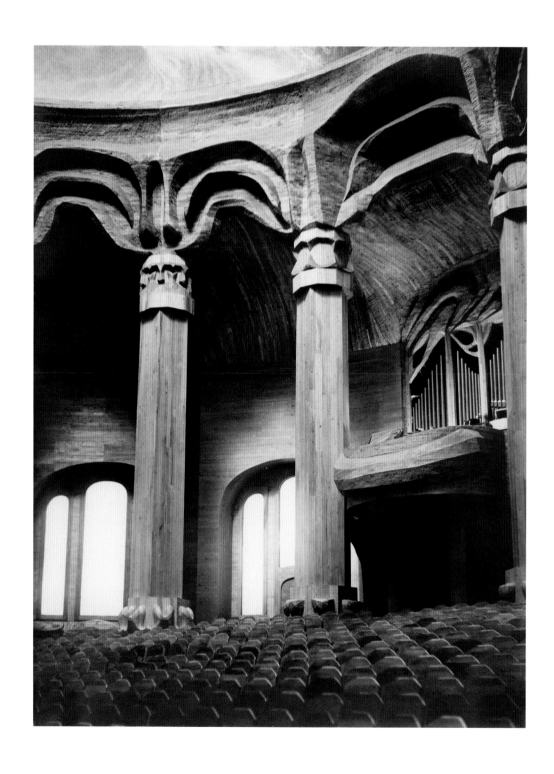

The Large Hall. View to the southwest.

Goethe and the Goetheanum

Rudolf Steiner

Anyone taking a look at the forms that joined together into a living whole in the [first] Goetheanum could see how Goethe's idea of metamorphosis had gone into the conception of the building. This idea of metamorphosis acquired meaning for Goethe in wanting to encompass the diversity of the plant world in a spiritual unity. To attain this goal he sought for the 'archetypal plant.' This was to be an ideal plant form. Any of its organs could develop in size and degree of perfection while others remained small or stunted. Thus it would become possible to dream up innumerable individual plant forms out of the ideal 'archetypal plant.' One could let one's gaze wander over the external forms of the plant world and find this or that form realized, deriving from the 'archetypal plant' as a thought-picture. The entire plant world was to be conceived, so to say, as a *single* plant, manifesting in the most diverse ways.

With this, however, Goethe assumed that in the manifoldness of the various natural forms a principle of formation was at work, replicated by the human being in the inner mobility of thought. In this, he ascribed to human knowledge something by which it is more than mere external observation of the world and world-processes – growing together with it to form a unity.

Goethe took the same position in regard to the single plant. In the leaf he saw the idea of the entire plant in its simplest form. And in the diverse forms of the plant as a whole he saw a leaf developed in complex ways – many leaf-plants, as it were, combined on the leaf principle into a unity. In the same way, the various animal forms were for him transformations of a basic organ, and the entire animal kingdom the most manifold form of an ideal 'archetypal animal.'

Goethe did not develop this thought in an all-round sense. Scrupulousness caused him – especially in regard to the animal world – to come to a stop, leaving matters unfinished. He did not permit himself to advance too far in mere thought-elaboration without having the ideas he had come to confirmed repeatedly by external facts.

One can have one of two possible attitudes to these Goethean ideas of metamorphosis. They can be viewed as an interesting idiosyncrasy of Goethe's, and left at that. Or, one can

make the attempt to align one's own ideas with Goethe's. It will then be found that secrets of nature do indeed reveal themselves, to which one finds access in no other way.

In realizing this more than forty years ago, I called Goethe the Copernicus and Kepler of the science of the organic realm (in my Introductions to Goethe's scientific writings in *Kürschners Deutscher National-Literatur*). I took the view that, for the lifeless, the deed of Copernicus consists in taking note of a factual connection independent of the human being. However, the corresponding deed in the case of the living lies in discovering the appropriate spiritual activity by means of which the organic realm can be grasped in its living mobility by the human mind.

Goethe performed this Copernicus-deed in that he introduced into knowledge the spiritual activity by which he was effective as an artist. He sought the path from artist to knower and found it. The anthropologist *Heinroth* called Goethe's thinking on that account '*gegenständlich*' ('objective' or 'concrete'). Goethe expressed himself as deeply satisfied by this designation. He adopted the word and referred to his poetry also as being 'objective.' With that he declared how closely allied artistic activity and knowledge were for him.

Entering into Goethe's spiritual worldview provided the courage needed to lead his idea of metamorphosis over into the artistic. It proved of help in coming to the building conception of the Goetheanum. In unfolding plant life, nature creates forms that grow one out of the other. In the artistic shaping power of sculptural forms, one approaches the creativity of nature, inwardly apprehending how it lives itself out in metamorphosis.

Thus a building may justifiably be called a 'Goetheanum' that has arisen in venturing (in its unifying structural design and sculptural forms) to enter into the Goethean idea of metamorphosis, bringing it to realization.

In the same way, anthroposophy itself stands as a direct continuation and further development of Goethe's views. Whoever finds access not only to thoughts concerned with the transformation of sense-perceptible forms – at which Goethe came to a standstill corresponding to his particular soul-disposition – but also to what is apprehended of soul and spirit, has arrived at anthroposophy. A quite elementary example may be pointed out, in observing the soul-activities of thinking, feeling, and willing. Regarding these three forms of the soul-life only next to each other, or in interaction with each other, one cannot penetrate more deeply into the soul's nature. However, we unite ourselves inwardly with the soul's true being in gaining clarity about *how* thinking is a metamorphosis of feeling and willing; how feeling is a metamorphosis of thinking and willing; how willing is a transformation of thinking and feeling. If Goethe, orienting himself chiefly to the sense-perceptible, found it gratifying to hear his thinking called 'objective,' a spiritual researcher finds similar satisfaction in noting that thinking becomes 'spirit-enlivened' in adopting the metamorphosis idea. Thinking becomes 'objective' in uniting itself with sense appearances, and this reverberates as inner experience. In taking up the spirit into its own stream of activity, thinking becomes 'spirit-enlivened'. Just as ideas directed to the sense-world are bearers of color or tone, so thinking becomes spirit-bearing. It undergoes a metamorphosis to become 'seeing' and has

then become free of the body. For the body can only saturate thinking with sense-perceptible content.

By means of the idea of metamorphosis we attain the capacity for comprehending the realm of the living, enlivening our thinking. From a state of having been dead, it becomes living. It becomes capable, in this way, of taking up the life of the spirit. Anyone inclined, on the basis of what is contained in Goethe's writings, to form the opinion that Goethe himself would have rejected anthroposophy, may be able to put forward external reasons for this. And it might be admitted that Goethe would have responded very guardedly in such an instance, since he would have felt uneasy about pursuing metamorphosis in regions where it lacks the checks of sense-perceptible appearances. And yet, without artifice, the Goethean worldview flows over into anthroposophy.

For that reason, what rested firmly on Goethe's worldview could properly be cultivated in a building that, in memory of Goethe, bore the name 'Goetheanum.'

From Rudolf Steiner: *Der Goetheanumgedanke inmitten der Kulturkrisis der Gegenwart.* Collected essays 1921–1925 from the weekly *Das Goetheanum.* CW 36. Verlag der Rudolf Steiner Nachlassverwaltung, Dornach, Switzerland 1961. Essay of March 25, 1923. Translated by Peter Stebbing.

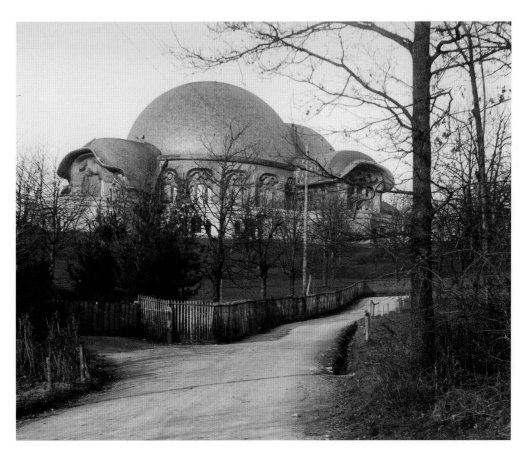

View from the southwest with approach road

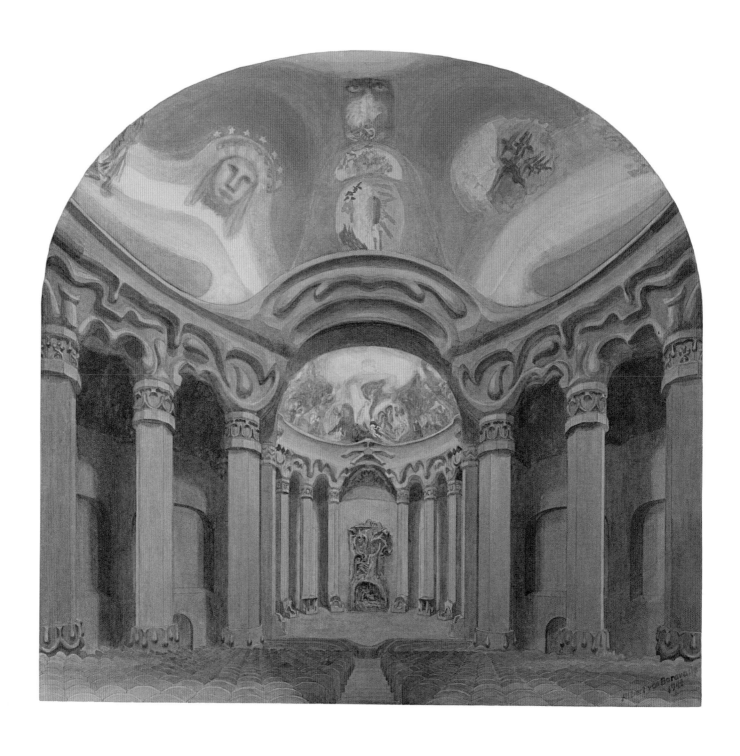

Albert von Baravalle: Large and small cupola space. 1941. Watercolor.
Copyright holder: Erika Baravalle

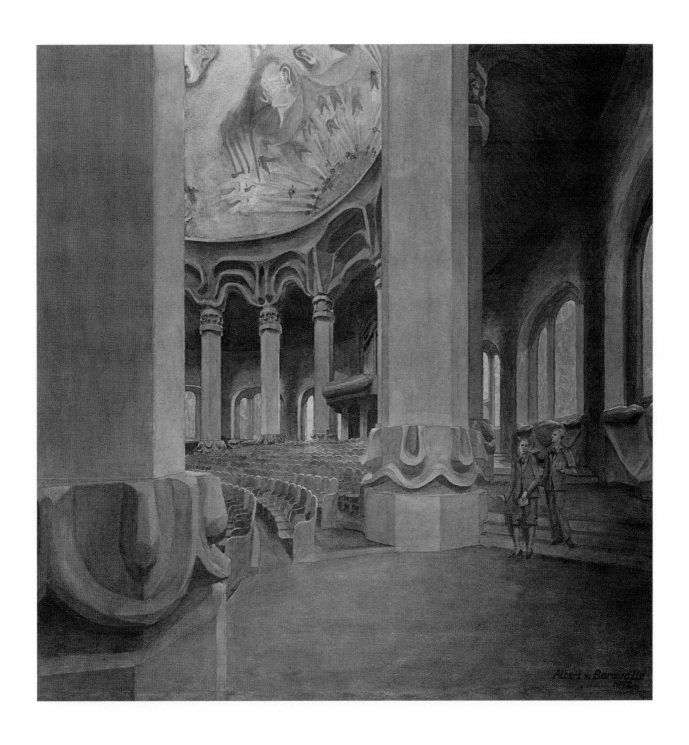

Albert von Baravalle: View from the northern Rose Window toward the West Entrance. 1942. Watercolor.
Copyright holder: Erika Baravalle

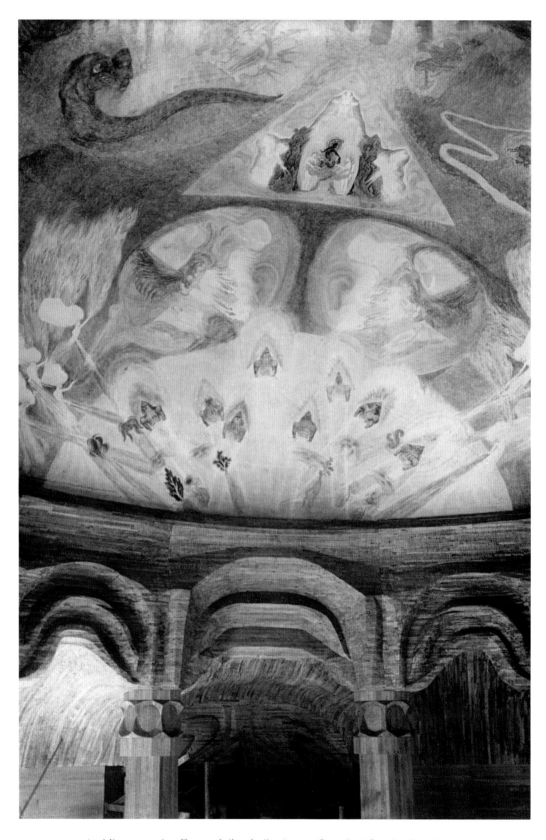

Architrave and ceiling painting in the Large Cupola. View to the West.

The Artists Who Originally Worked on Painting the Cupolas of the First Goetheanum

Hilde Boos-Hamburger (1887–1969) refers to fourteen painters in all as having worked on painting the motifs of the large and small cupolas[1]. She herself had taken on the task of applying the gesso grounding of the cupolas, as well as preparing numerous practice panels for the artists involved. In this way she had frequent contact with them over a number of years. Brief biographies of the artists listed below will be found at the end of this volume.

For each of the two cupolas Rudolf Steiner appointed an experienced painter to co-ordinate the work: in the large cupola, *Hermann Linde*, and in the small cupola, *Arild Rosenkrantz*. He assigned each of the various painters in the two 'teams' one or more motifs, to be worked out individually and executed on the basis of his motif-sketches. There were twelve motifs in the large cupola and seven in the small cupola.

Those who worked in the large cupola were:

1.	*Hermann Linde*	The 'Elohim' motif; the 'Eye and Ear' and 'Paradise' motifs in the west. The 'I,' 'A,' and 'O' motifs in the east.
2.	*Marie Linde-Hagens*	The three motifs in the west (assisting her husband).
3.	*Ottilie Schneider*	The 'Persian' and 'Egyptian' motifs.
4.	*Richard Pollack*	The 'Atlantis' and 'Greek' motifs.
5.	*Hilde Pollack-Kotanyi*	The 'Lemuria' motif.
6.	*Lotus Peralté*	The 'Indian' Motif.
7.	*Imme von Eckardtstein*	The three motifs in the east (assisting Hermann Linde).

8. *No name given*	Briefly assigned to carry out the 'Egyptian' motif, before this task was withdrawn from him by Rudolf Steiner and re-assigned to Ottilie Schneider.[2]

Those who worked in the small cupola:

1. *Arild Rosenkrantz*	The 'Middle' motif.
2. *Margarita Woloschin*	The 'Slavic Human Being' and the 'Egyptian Initiate.'
3. *Ella Dziubanjuk*	The 'Persian-Germanic Initiate.'
4. *Jeanne-Marie Bruinier*	The 'Flying Child.'
5. *Mieta Pyle-Waller*	The 'Faust' motif.
6. *Louise Clason*	The 'Athene-Apollo' motif.

Over a period of eighteen months, from April 1918 till October 1919, with longer and shorter interruptions, Rudolf Steiner repainted the central motif and the whole south side of the small cupola, as well as the orange angel on the north side. The remaining north side was then carried out as a mirror image of the south side by the four artists who had remained in Dornach following the departure of Arild Rosenkrantz and Margarita Woloschin.

– Peter Stebbing

[1] Hilde Boos-Hamburger: *Die farbige Gestaltung der Kuppeln des ersten Goetheanum.* R. G. Zbinden & Co., Basel 1961.

[2] He is reported to have crudely drawn into Rudolf Steiner's black-and-white sketch with a dark blue pencil. See Assya Turgenieff: *Erinnerungen an Rudolf Steiner und die Arbeit am ersten Goetheanum.* Stuttgart 1972. (p. 58.) As also: Rudolf Steiner: *Das Malerische Werk.* Rudolf Steiner Verlag 2007. (p. 126.)

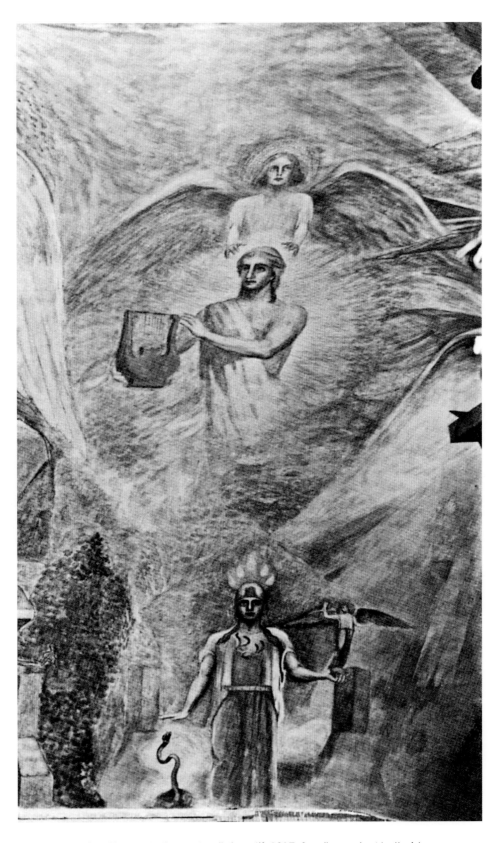

Louise Clason: 'Athene Apollo' motif. 1917. Small cupola. North side.

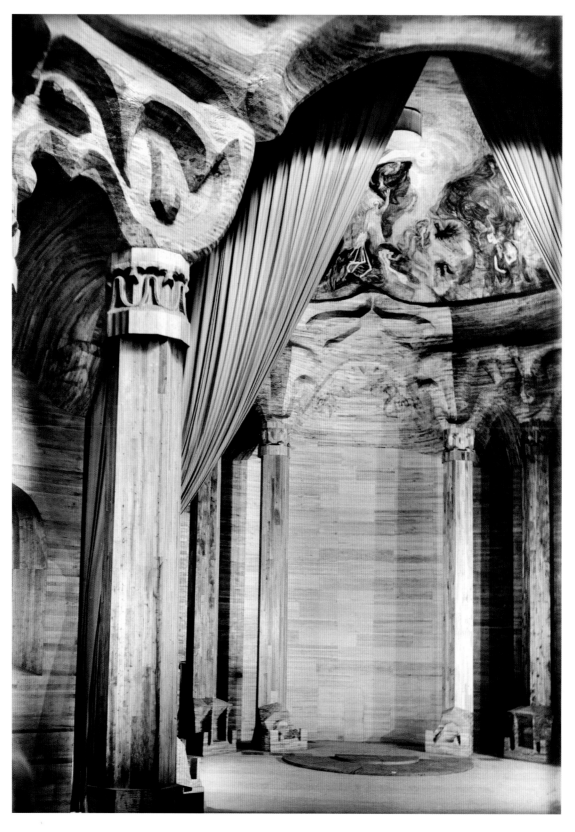

View into the Small Cupola

Recollections of the Years of Painting in the Small Cupola of the First Goetheanum

Louise Clason

When it became possible to begin the interior decoration of the first Goetheanum, Dr Steiner entrusted six painters with the motifs for the cupola above the stage (Margarita Woloschina, Louise Clason, Arild Rosenkrantz, Jeanne-Marie Bruinier, Ella Dziubanjuk, and Mieta Waller). These artists came from various countries and were of dissimilar artistic temperament. Apart from Baron Rosenkrantz, none of us had ever had experience in painting in the dimensions required of us here. A very difficult task was set us from the beginning: together, we were to create an enormous unified work, while each received a particular motif to carry out. In its entirety this had to become *one* picture. In giving Margarita Woloschina and me the first sketches in the late autumn of 1914, Dr Steiner told us, it ought to be possible to create a unified work in harmonious collaboration. He stressed this particularly, pointing out that Leonardo da Vinci and his students had successfully accomplished such a task.

Besides coming to terms with the new medium of plant colors on primed plywood boards, our main efforts in these years went into composing the motifs each had been assigned, integrating them into the space so as to mutually support and carry each other in their proportions and tonal values. Only in this way could a unified whole arise. This was no mean task, since each of us had first to master the motif entrusted us, and make it our own! This could come about only one step at a time: first on paper, on a small scale, then in the actual model, one-tenth of full-size, until we finally ventured to work on the small cupola itself. Baron Rosenkrantz was the first to complete his work – the large central part depicting the Christ figure between Lucifer and Ahriman. His artistic ability allowed him to work at a faster pace, but the pressure of time also caused him to hasten, since he had to return to England soon afterwards.

A little later, Margarita Woloschina abandoned us in going to Russia on a 'visit.' It would be years before she could return from Russia, by which time the Goetheanum had become a victim of the fire. Thus she never saw her motif of the 'Egyptian' in its final, completed form.

Whereas these two motifs in the small cupola had been concluded up to a certain point, the rest remained in flux and continual transformation until the autumn of 1917. By then a

whole had arisen out of the various motifs. Everything was in its place, and the broad contours joined together to make a more or less unified picture.

At this point, a seemingly insoluble problem became apparent. Dr Steiner had meanwhile modeled his Christ figure, to be carved in wood. This statue was to occupy the central position in the east, against the back wall of the stage area, directly below the painted representation of the Christ figure. Completed by Baron Rosenkrantz prior to his departure, this now stood in stark contrast to Rudolf Steiner's sculpted Christ figure. Rudolf Steiner himself saw it as a matter of importance that the Christ figure should have the right countenance in the painted representation as well.

Thus, after much deliberation and discussion, Rudolf Steiner finally decided to repaint the Christ figure.[1] When this was done, the necessity arose to realign the figures of Lucifer and Ahriman as well. It was then as if we experienced completely new worlds; we were filled with enthusiasm. This had as much to do with the color as with the reality of the spirit beings we had ourselves only been able to paint as though 'blind.' It was astonishing to see how Rudolf Steiner evolved and perfected his technique with each session, how he mastered the flowing color, calling forth the impression of real spirit entities.

At this point, our greatest wish was for the entire small cupola to newly re-arise in the same manner. We therefore approached Dr Steiner with the request to repaint our motifs as well. With great zeal we set about washing the color off on the large surfaces of the small cupola. However, some parts weakened as a result of our varying treatment of the surface; the top layer of the grounding came off, and we had a lot of trouble making sure the colors would adhere to these places. Our consternation can be imagined, when Rudolf Steiner one day took a toothbrush from his pocket and began working on such weakened surfaces.

Over a period of a year and a half (with longer and shorter intervals), Dr Steiner now painted – along with the central motif – the entire southern half of the small cupola, and the Russian cultural impulse adjoining the Christ composition on the north side. Here we were amazed to see the blue angel, the inspirer of the Russian cultural epoch, transformed, for pure artistic reasons into his 'counter-color,' becoming orange.

Over the course of two winters, we then painted the remaining motifs of the north side, which presented a mirror image. We had trouble keeping the enclosed cupola space above freezing, by means of three electric heaters. The heaters had to remain switched on day and night, so as to prevent the colors, both on the walls and in the paint dishes, from freezing. One morning we discovered, to our horror, the Ahriman on which Dr Steiner had painted the previous day, covered with tiny ice crystals. However, the colors were in no way damaged. While working, Dr Steiner usually stood wrapped in a fur coat on the high step-ladder – quite an uncomfortable position for the arm holding the brush, particularly as the color ran down his sleeve!

It was always a great event to watch Dr Steiner paint; it was so completely different from what one was used to with other painters. Sometimes he came up only for a quarter or for half an hour; going straight to the surface he had painted the day before. He took hold of the

brush, dipping it in the fluid color and making enormous curves of color over the entire painted surface. On following days he would return ever and again, setting yet new layers of color in curved surfaces across each other. Surface by surface, the whole sea of color was brought into movement. The picture surface receded and a three-dimensional space arose before us, filled with majestic flowing color which surged and ebbed, disappearing only to reemerge elsewhere. And within these floods of color there hovered beings never before seen with the physical eye. Their eyes looked at us, speaking of mysteries which waited to be revealed to understanding human beings…

Climbing down once again into the daylight after working on the cupola, we had to rub our eyes. Such a different world received us there. We loved the world up there and could only be removed by force when the scaffolding was to be dismantled and the boards taken from beneath our feet. A lost paradise… Dr Steiner sensed our mood; at the first meeting below he said emphatically: 'Yes, that is now over! One part of the work – indeed, a major part itself!'

Today, all that remains of this world is a memory.[2]

Translated from Louise Clason: *Einige Erinnerungen an die Jahre der Malerei in der kleinen Kuppel des ersten Goetheanum-Baues.* In *Mitteilungen der Allgemeinen Anthroposophischen Gesellschaft* (later *Blätter für Anthroposophie*). June 1950.

[1] Hilde Boos-Hamburger reports: '… the other painters decided to obtain the agreement of Rosenkrantz. It will be admitted, one very seldom finds artists who would give the same answer. It came to this: no greater good fortune could befall him than if Dr Steiner wanted to paint over his entire motif!' (From Hilde Boos-Hamburger: *Die farbige Gestaltung der Kuppeln des ersten Goetheanum.* Basel 1961.)

[2] The first Goetheanum building was destroyed by fire on the night of December 31, 1922 / January 1, 1923.

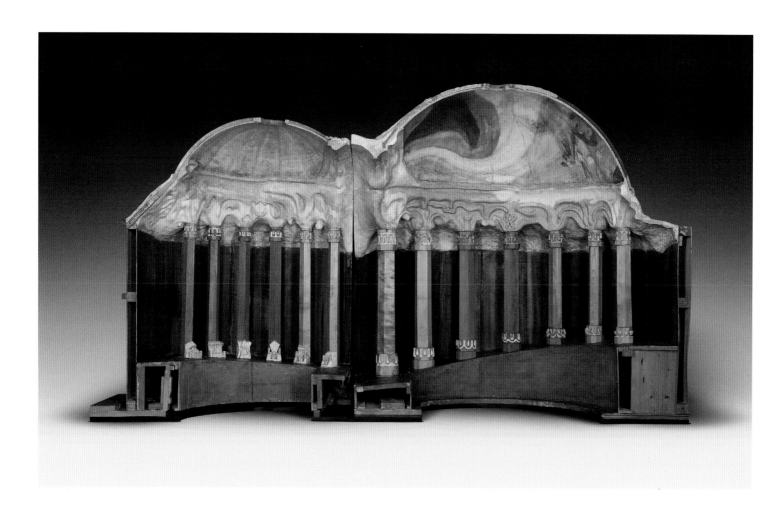

Rudolf Steiner: Interior model of the first Goetheanum. Scale 1:20.
Plaster of Paris, wax and wood. 1913. Goetheanum Art Collection.

Daniel Johann van Bemmelen (1899–1982):
The background colors of the large and small cupolas. Watercolor.

I.

THE MOTIFS OF THE LARGE CUPOLA

View looking into a scale model (1:100) of the Large Cupola. Built by Carl Liedvogel and painted by Hilde Boos-Hamburger. Exhibited as part of the Goetheanum Art Collection in Dornach, Switzerland. (The lighting fixture is indicated by a gray disc in the middle of the dome.) Copyright holder: M. Boos-Egli, Basel

1. The Elohim Work Creatively into the Earth; Light-Beings Ray In. Oil crayon and pencil.

The Large Cupola Sketch-Motifs of Rudolf Steiner

'In looking, as a human being, as though into one's own capacity for seeing, into one's own visual space, with eyes closed, one sees before one something that presents itself as the beginning of Creation. This beginning of Creation is what one comes upon here at the west end of the cupola. And it is no mere play of phantasy, that the Tree of Paradise is up there with a kind of Father God above it, and that these two eye-formations appear. All of this does indeed appear before the eye of the soul, with a deepened sense for the inner human being.'

(Rudolf Steiner: From a lecture of December 30, 1921 in Dornach.)

'In contemplating the large cupola, you will distinctly perceive, for example, that the attempt is to present (on one side, the west side) the interior of the eye, the microcosmic eye

2. The Senses Arise, Eye and Ear Come into Being. Oil crayon.

as revealed within the eye. It is not a matter of what the eye sees externally, nor the physical apparatus of the eye, but of what is inwardly experienced if one is within the eye with the observation of the soul, which one can only do, of course, having renounced utilizing the eyes as instruments for external sense perception in the usual sense – if one observes the eye inwardly, just as one otherwise looks out at one's surroundings by means of the eye.'

(Rudolf Steiner: From a lecture of December 29, 1918 in Dornach. CW 187.)

'Above the organ motif, for example, you will see something painted that a philistine person interested in the sense world will naturally regard as madness – if I now tell you the following: If you press your eyes shut, you will see something like two eyes looking at each other, in sensing, as it were, the interior of the eye. What occurs there inwardly has, in certain respects, every possibility of being developed further. In a primitive way, something then takes shape, and shines toward one out of the darkness, as two eyes. If projected outwards as

38

3. Jehova and the Luciferic Temptation – Paradise. Oil crayon.

experience, this inwardly experienced 'seeing' re-constitutes itself, so that one sees an entire 'beyond,' a whole world arising in it. Here the attempt was to create out of the color what the eye experiences in looking at itself in darkness. It is not necessary to read the secrets by means of the intellect only; one can actually behold them. They are there, all at once.'

(Rudolf Steiner: From a lecture of August 28, 1921 in Dornach. CW 289.)

'These figures you see here to the left and right, that seemingly depict mythological figures, are meant to depict the situation approximately as it was before the great Atlantean catastrophe. For spiritual experience, the materialistic theory of evolution shows itself to be altogether incorrect. If we go back in human evolution, we come first of all to the Greco-Latin period, which begins more or less in the eighth pre-Christian century. We then go back further to the Egypto-Chaldean period, which begins more or less at the turn of the fourth to the third pre-Christian millennium. We arrive at still older periods, until finally coming to a time designated in spiritual science as the time of the Atlantean catastrophe. A great shifting

4. Lemuria. Oil crayon.

of continents took place then. We look back into a time in the earth's evolution when what is now covered by the Atlantic Ocean was covered by land. This was a period of the earth's evolution in which the human being could not have existed in the form of today, with the muscles and bones of today. Taking sea creatures, jelly-fish that can hardly be distinguished from their surroundings, one has the material configuration in which the human being once existed on the earth, during that ancient Atlantean time, in which the earth was still covered everywhere by continual dense mist in which the human being lived, being then a quite different organic creature. And for clairvoyant sight – if the word is not misunderstood – there results such forms as you see here on the ceiling to the left and right.'

(Rudolf Steiner: From a lecture of December 30, 1921 in Dornach.)

'To paint the ancient Indians and their inspirers, the seven Rishis, who are inspired in turn from the stars – with heads open above – if one does that abstractly, it is actually something nonsensical: I say that quite plainly. But in entering into what was experienced in

40

5. Atlantis. Oil crayon.

the primeval Indian culture in the relationship of the pupil to the guru, the teacher, one feels this to be as though the Indian had not had a skullcap, but as though this had dissolved.'

'[It is] as though a power of soul combined out of the seven soul-rays of the holy Rishis, and [the ancient Indian] then communicated this to his world – revealed not out of himself, but out of the spirit of the holy Rishis. The more what is said here is worked out, the closer one comes to what has been painted here. Feeling has first of all to transpose itself into ancient India, into ancient Atlantis. What can be seen there is painted onto the wall here, and only afterwards can one speculate, once it is there. That is how communication stands in relation to artistic creation. And that is actually how everything in this building should arise…'

(Rudolf Steiner: From a lecture of August 28, 1921 in Dornach.)

'How Zarathustra determined the ancient Persian culture, the sunlight as it were battling with darkness, that will be seen at a second place in the cupola. How the Egypto-Chaldean

6. The Ancient Indian. Oil crayon.

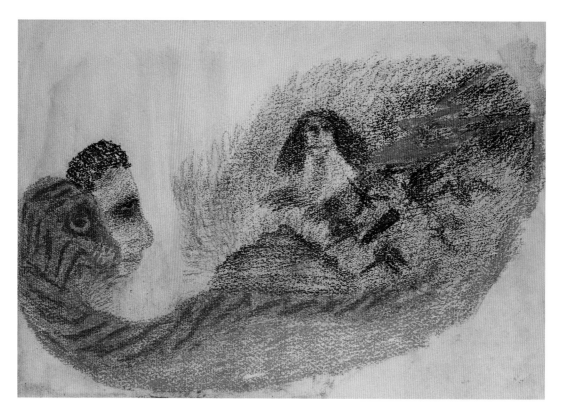

8. The Ancient Egyptian. Oil crayon.

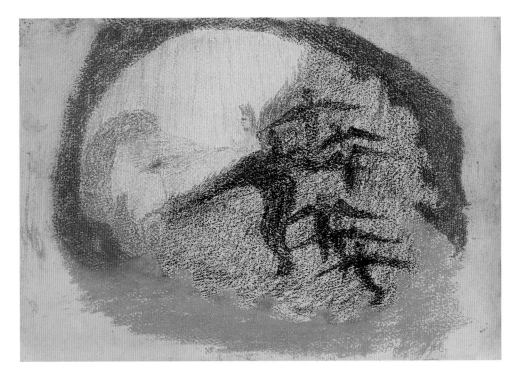

7. The Ancient Persian. Oil crayon.

9. Greece and the Oedipus Motif. Oil crayon.

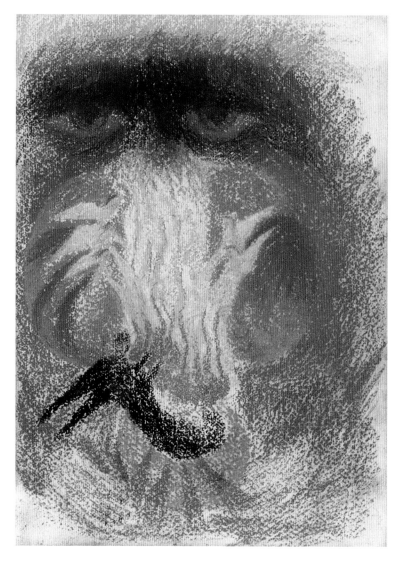

10. God's Wrath and God's Melancholy – the 'I'. Oil crayon.

culture then gradually emerges on the physical plane, how astrological, spiritual relationships still interpenetrate – that will be found in a third area of the cupola. And as though standing at a cliff-edge: the Greek human being, living in the arising rational or mind-soul culture. We see the human being confronting the necessity of solving the riddle of the sphinx, how through its solution, the sphinx falls headlong into the abyss, i.e., into the human being as such. That will be presented in a fourth area.'

'How the eternal divine powers and forces work into the evolving human being will come to expression in that, in the directions of the four points of the compass, there is to be portrayed what lies at still profounder depths than the post-Atlantean impulses in the

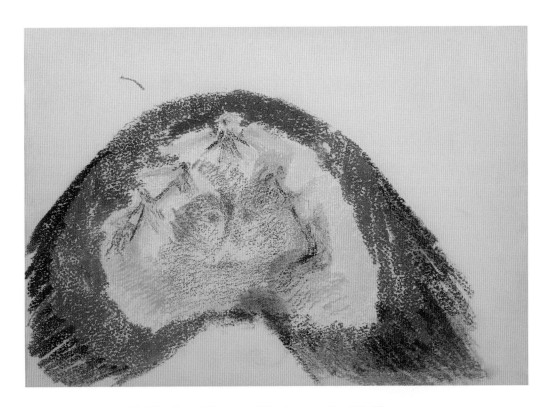

11. The Round Dance of the Seven – the 'A'. Oil crayon.

development of humanity, reaching to the Atlantean and Lemurian time: the Atlantean development in the south, the Lemurian development in the north of the cupola. And finally, the outcome of the Lemurian and Atlantean developments is to be depicted: What represents our time will come to meet one in directing one's gaze from west to east, toward the small cupola space. From the whole manner of its portrayal, the impulse inherent in cosmic evolution expresses itself in the IAO. It is not as though the IAO were presented symbolically, rather is it expressed as a motif. Correspondingly, in directing one's gaze from east to west, one has what announces itself out of cosmic reaches in the development of culture, in the same way as the IAO announces itself from within in the soul's development.'

(Rudolf Steiner: From a lecture of October 24, 1914. CW 289.)

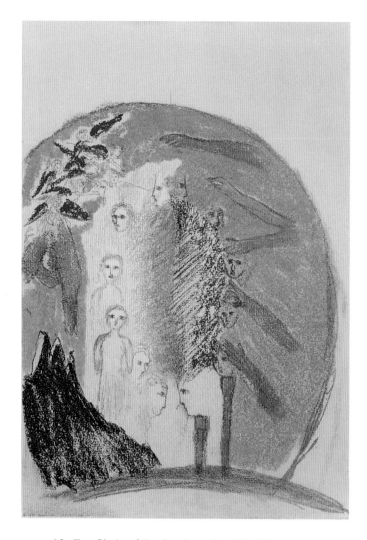

12. The Circle of the Twelve – the 'O'. Oil crayon.

'What you see here at the eastern end of the large cupola is a kind of perception of one's own 'I'. This 'I' is indeed, it may be said, a kind of trinity, and reveals itself to inner perception such that it goes in one instance to the light-imbued clarity and transparency of the thinking 'I', whereas, at the other pole, it goes over, as it were, to the side of will, to th willing 'I'; and in the middle to the feeling 'I'. That can be expressed first of all in an abstract way, just as I have now expressed it – as the thinking, the feeling, and the willing 'I'. In concrete terms, it is felt as the human being capable of observing the colors of nature with love, of looking with devotion at everything nature offers the senses.'

(Rudolf Steiner: From a lecture of December 30, 1921 in Dornach.)

Large Cupola Studies of Gerard Wagner

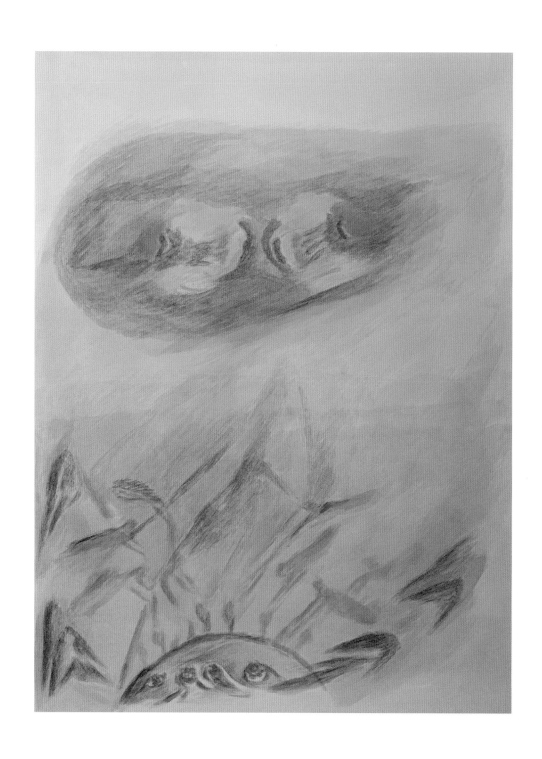

Eye and Ear / Elohim. November 28, 1991. Plant colors. 67 x 49 cm. (ca. 26 x 19 ins.)

On Painting the Motifs of the Large Cupola

Gerard Wagner

The motif-sketches for the cupola paintings of the first Goetheanum provided models for ongoing practice and study, at first primarily as regards their color moods, later on with closer attention paid to requirements of form as well as the interrelationships between them. Though the viewer's attention is drawn especially to the individual motifs as such, these are in the same sense 'the work of color' as in the other paintings and sketches of Rudolf Steiner. They can be experienced as if *one motif* were to wander through the various colors of the rainbow — extending over the large cupola space in great waves of color — undergoing in this way a transformation corresponding to the influence of the particular background color.

For a sympathetic understanding of these motifs and how they arise, it is essential to bear in mind the background colors from which they emerge. Like the 'training sketches,' the cupola motifs are imbued with an objective life and embody a principle of metamorphosis.

In the relation of one bone form to another, say in an animal skeleton, a principle of metamorphosis can be ascertained, this being common to all animals — taking on new forms with the eagle, the lion, or the cow. In the same way, one can experience a living principle at work in the cupola forms, determined in each case by the qualities of the single background colors.

As in the organic realm in general, every detail is a part of the whole and can only be as it is, and not otherwise, in accordance with the place it occupies in the total organism. This makes it possible in principle (as in paleontology) to arrive at the whole even when only a detail is given — aided by the concrete experience of metamorphosis.

So as not to fall into inartistic copying, the following procedure was adopted starting from the sketch '*Eye and Ear*': I painted a small surface of black, setting over against it a small surface of brown — in a manner comparable to the mutual relation of these two colors in the sketch — all within the mood of a blue toned page. I then asked myself: In what sequence would the further colors need to be chosen so as to lead into the formative forces giving rise to this motif? In what sense do the colors then 'crystallize' under the influence of black and brown? And I experimented with *deep blue – light blue – red – green* — until coming to a color sequence in regard to which I had the feeling, it led of inherent necessity to the given formation. — Naturally, this involved the help of the sketch, which I had constantly before me. In this way, it became possible to follow my own artistic feeling without resorting to 'copying,' yet having at the same time a continual stimulus from without that provided direction.

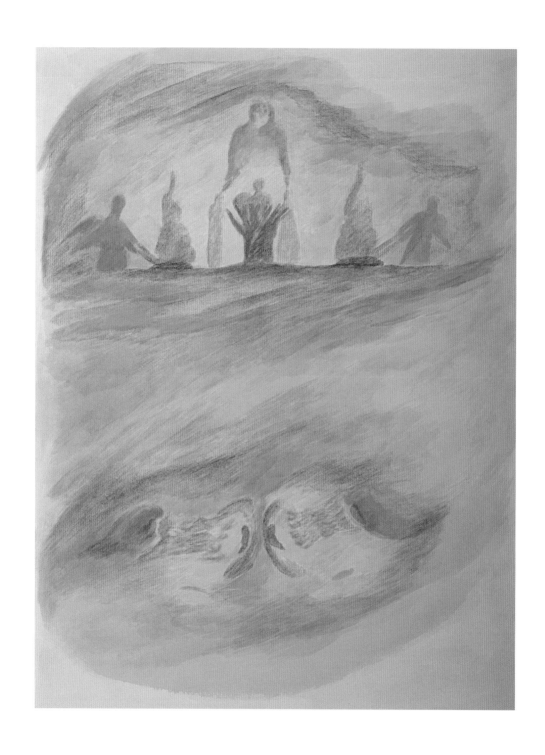

Paradise / Eye and Ear. November 29, 1991. Plant colors. 67 x 49 cm. (ca. 26 x 19 ins.)

After an initial preoccupation with the external impression, an important further step consisted in becoming aware of the living element common to all the motifs, by which they appear related to each other. It became a question of how to go about choosing the colors so they would take on the configuration of the sketch. Such investigation takes place purely on the plane of feeling. As a spiritual reality, the motif lives in a realm beyond this.

Just as we are able by means of ordinary thinking to understand the communications of spiritual facts given by the spiritual researcher, so are we able, by means of artistic investigation, to comprehend these spiritual motifs, and to come to new insights, on various levels.

Thus an approach opens up, in free artistic experience, to the archetypal sources of the motifs, out of the color. The example provided by a particular sketch indicates no more than the direction in which we are to search.

What came about in this way often bore little direct resemblance to Rudolf Steiner's original motif-sketches. Yet, it was important to me in the first place that what I painted should stand on its own and come alive artistically. How to choose the colors and experience them, so as to approach more closely the result given in Rudolf Steiner's original sketch, was a continuing question for me.

It might be assumed that one would arrive in this way merely at a state of dependency on the sketch one had recognized as a 'model.' However, just the opposite holds true. One becomes free and independent of the model precisely in placing reliance on one's own experience of what is consistent and true, even when the result apparently diverges from it. Color experience has to grow stronger than the power of mental images, replacing them altogether. We then enter that realm of mobile, living color, out of which the motifs reconstitute themselves in ever new ways.

Only occupation with the totality of the cupola motifs in practical terms can lead to the surprising recognition referred to above, presenting the painter with quite new questions. One arrives at the enigmatic *aperçu* that any *one* motif, e.g., the *Eye and Ear*, experienced as arising from the blue, were it transposed to the green of the background above it, would transform itself into the *Paradise* motif. Or, transferred to the indigo below, would convert itself into the motif of the in-streaming beings (the *Elohim* motif). Such preoccupation with the cupola motifs as a whole gives rise increasingly to the feeling that they are all in fact metamorphoses of each other. It is as though *one* motif, were to manifest itself again and again in different ways, as determined by the various background colors (as also by the shape of the cupola dome itself). These motifs come to seem like a living entity that at various times and in various places — under new conditions — 'incarnates' in different forms.

From Gerard Wagner: *Die Kunst der Farbe.* (The Art of Color.) Stuttgart, Verlag Freies Geistesleben 1980. This excerpt translated by Peter Stebbing.

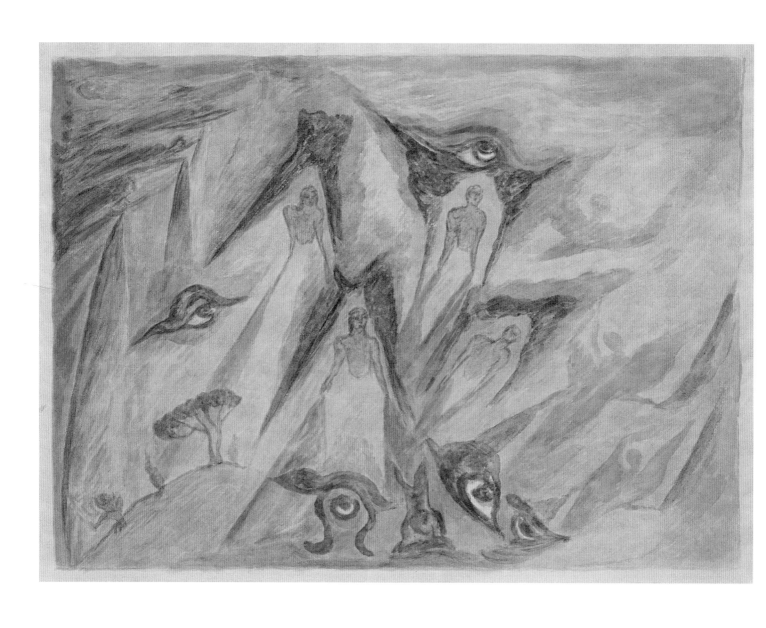

Elohim. March 1974. Plant colors. 49 x 67 cm. (ca. 19 x 26 ins.)

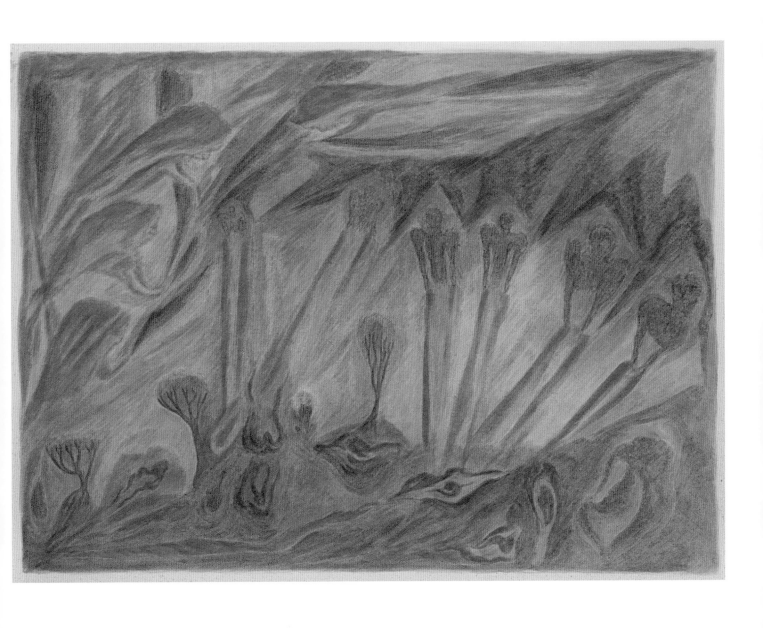

Elohim. 1975. Plant colors. 49 x 67 cm. (ca. 19 x 26 ins.)

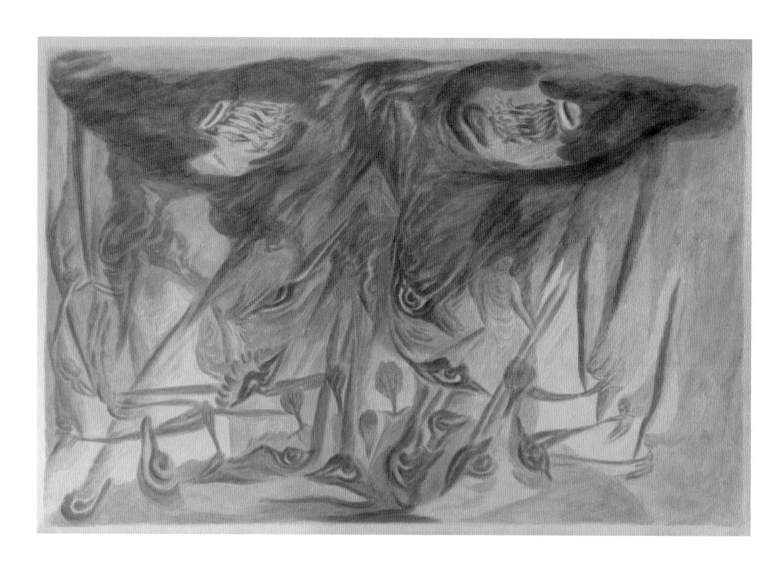

Eye and Ear / Elohim. 1976. Plant colors. 49 x 67 cm. (ca. 19 x 26 ins.)

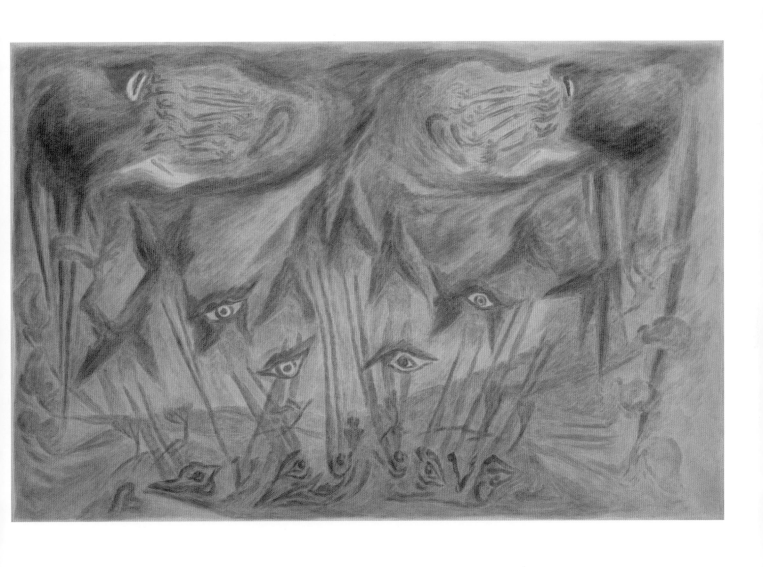

Eye and Ear / Elohim. October 1976. Plant colors. 49 x 67 cm. (ca. 19 x 26 ins.)

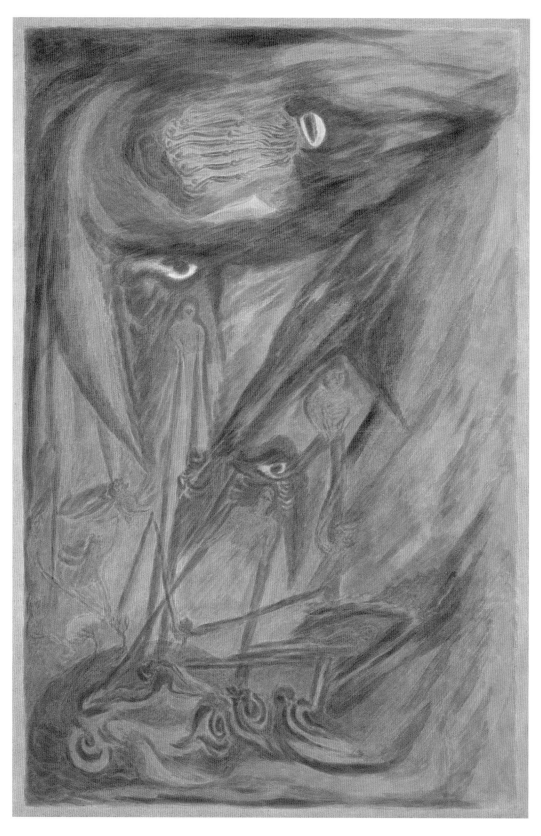

Eye and Ear / Elohim. August 1976. Plant colors. 99 x 67 cm. (ca. 39 x 26 ins.)

56

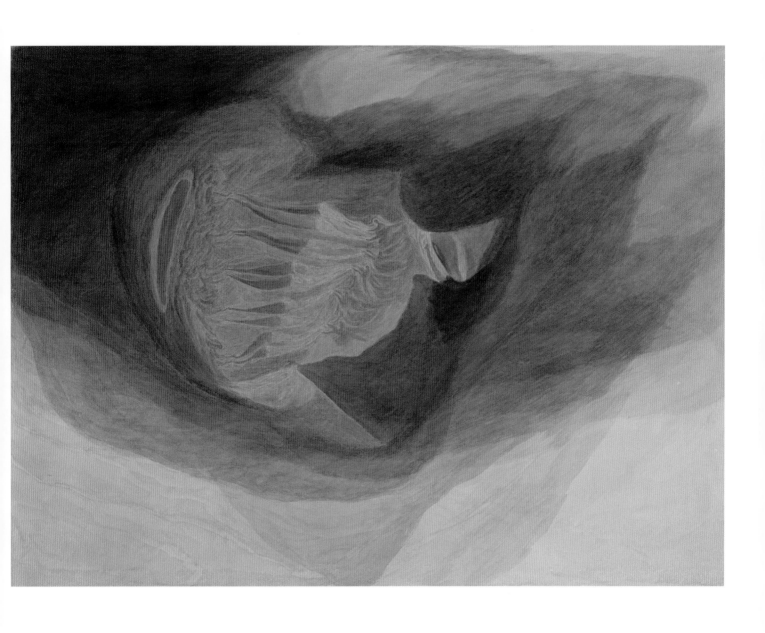

Eye and Ear. 1951. Plant colors. 49 x 67 cm. (ca. 19 x 26 ins.)

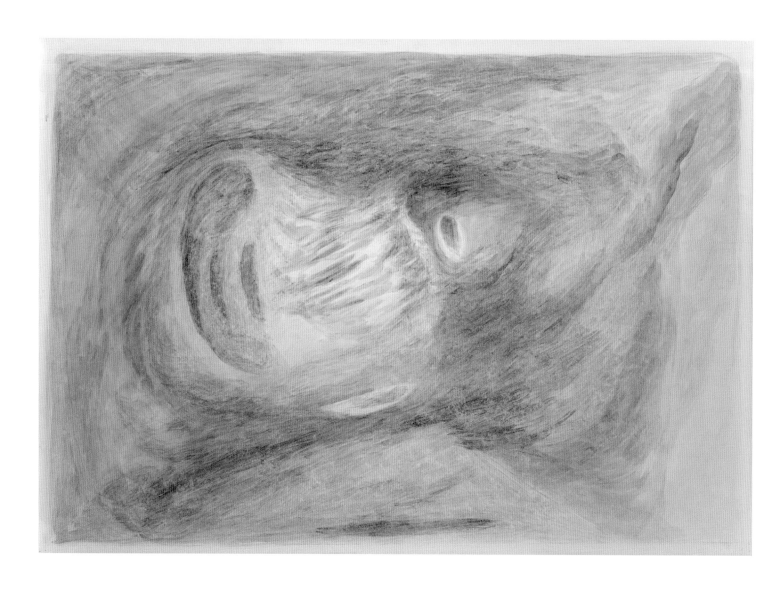

Eye and Ear. ca. 1995. Plant colors. ca. 67 x 99 cm. (ca. 26 x 39 ins.)

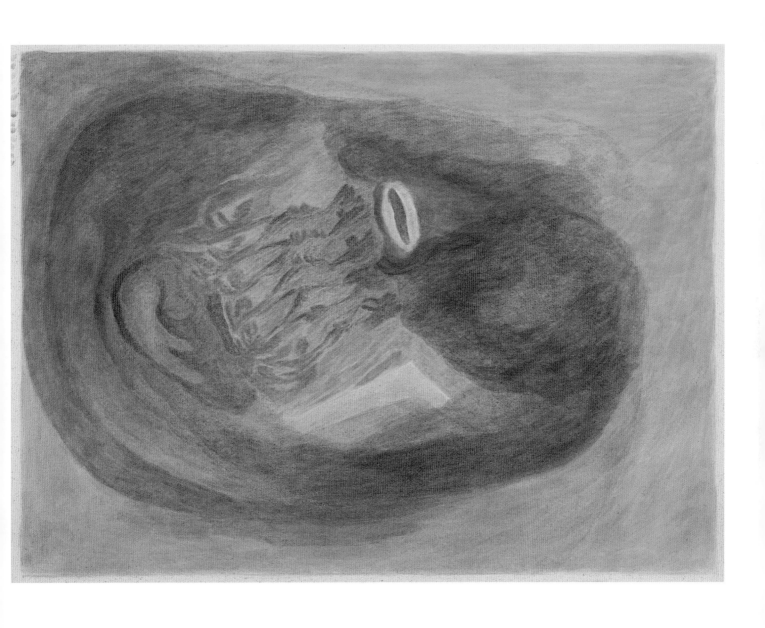

Eye and Ear. August 1975. Plant colors. 49 x 67 cm. (ca. 19 x 26 ins.)

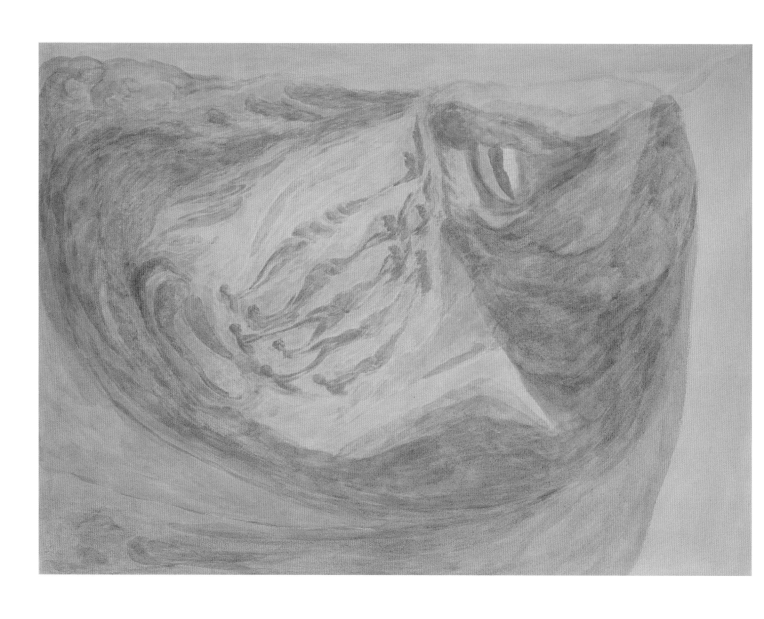

Eye and Ear. March 1974. Plant colors. 49 x 67 cm. (ca. 19 x 26 ins.)

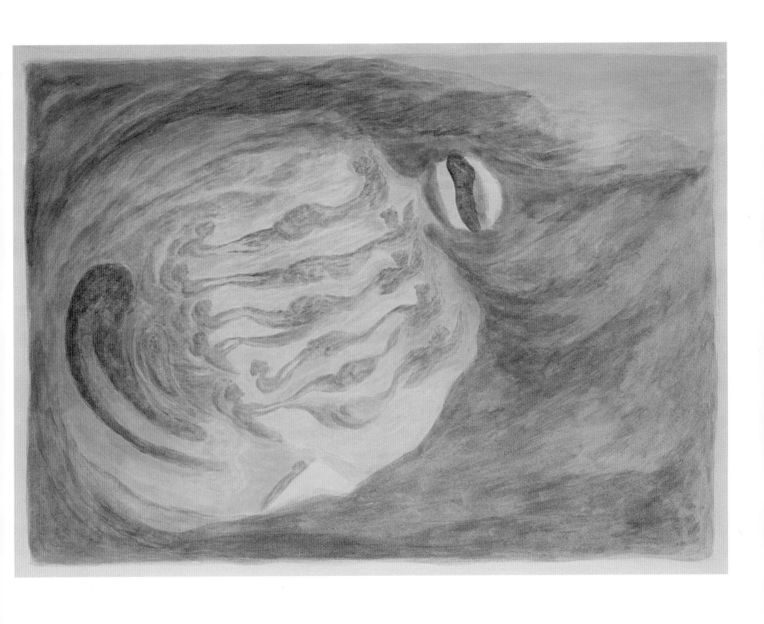

Eye and Ear. March 1974. Plant colors. 49 x 67 cm. (ca. 19 x 26 ins.)

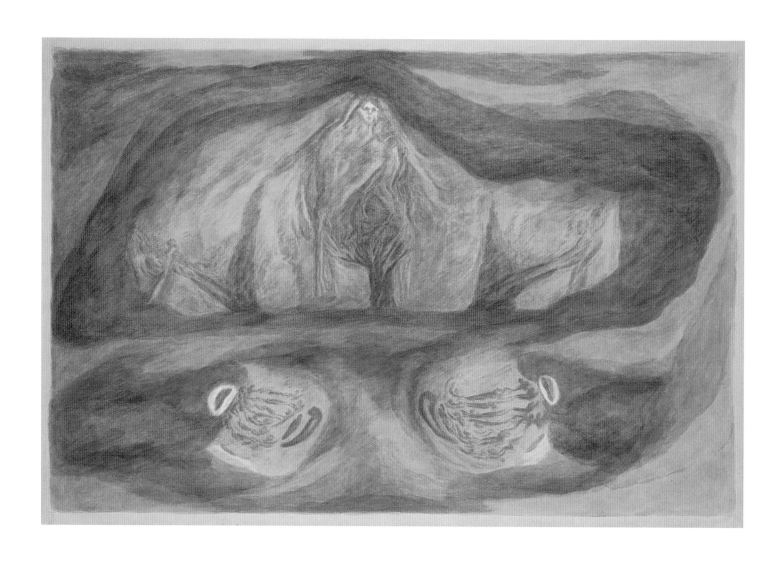

Paradise / Eye and Ear. November, 1976. Plant colors. 67 x 99 cm. (ca. 26 x 39 ins.)

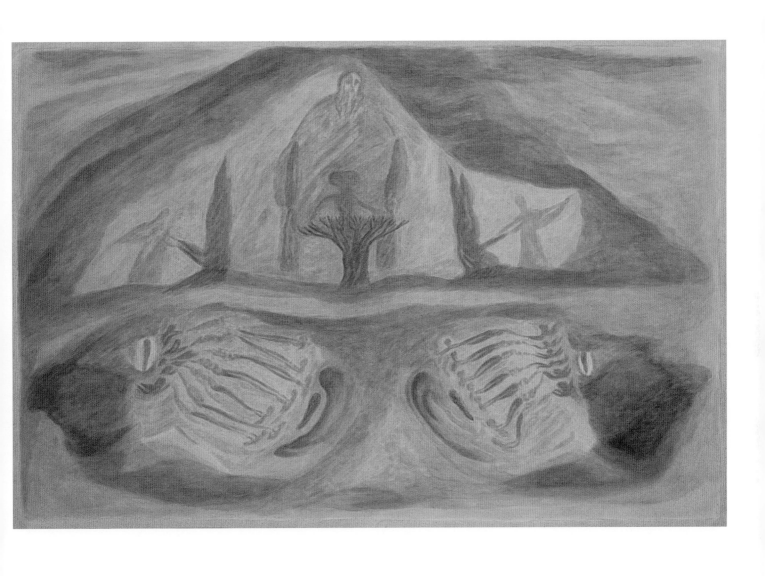

Paradise / Eye and Ear. October 1975. Plant colors. 67 x 99 cm. (ca. 26 x 39 ins.)

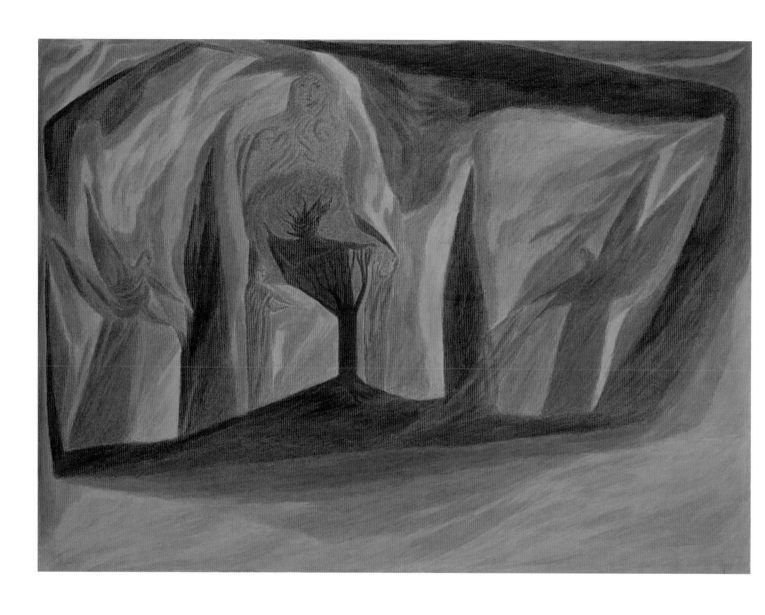

Paradise. December, 1951. Mineral colors. 53 x 74 cm. (ca. 21 x 29 ins.)

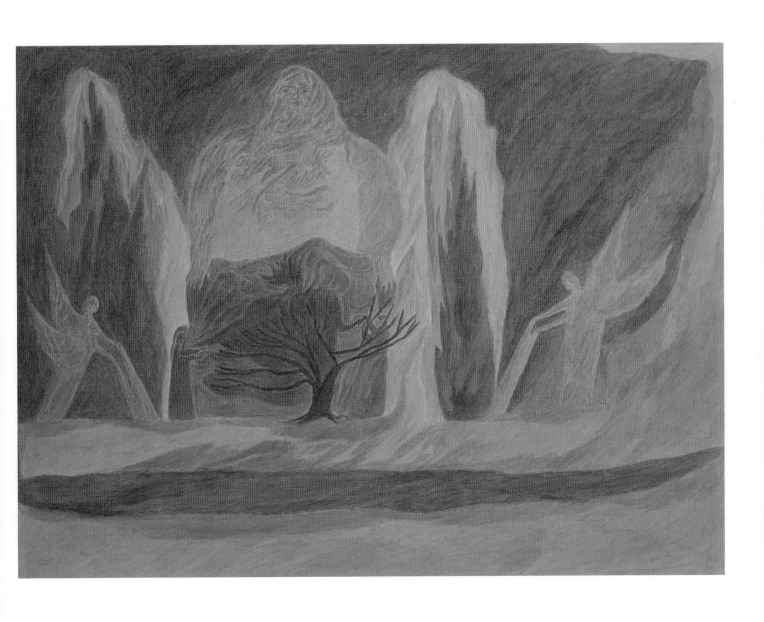

Paradise. December, 1951. Mineral colors. 49 x 67 cm. (ca. 19 x 26 ins.)

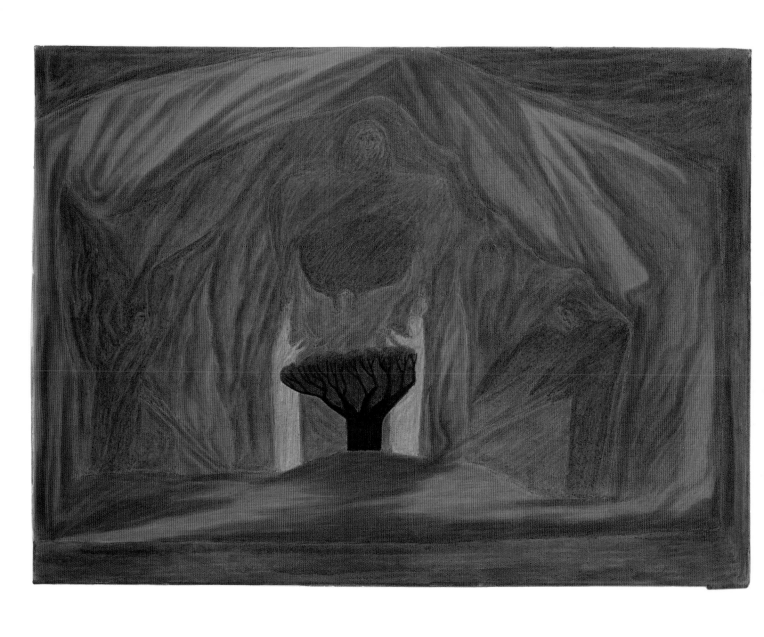

Paradise. 1951. Mineral colors. 50 x 68 cm. (ca. 20 x 27 ins.)

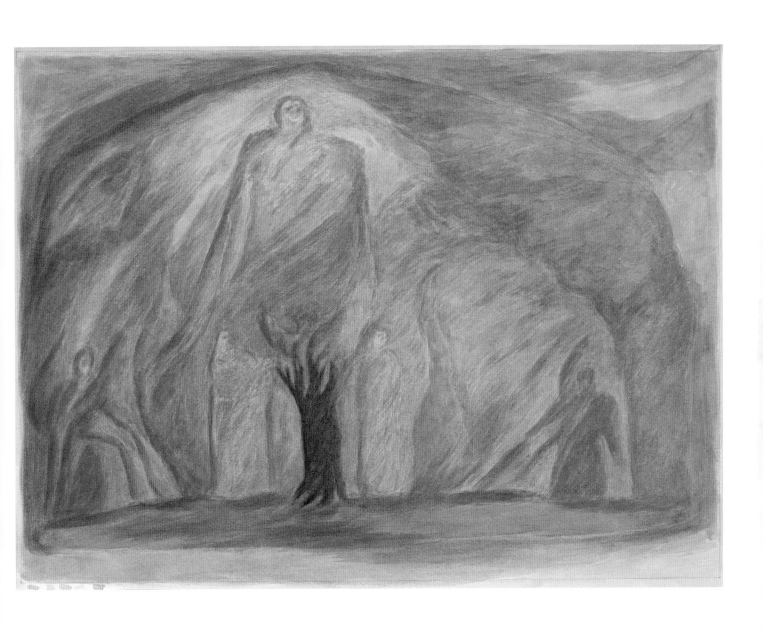

Paradise. September 1982. Plant colors. 49 x 67 cm. (ca. 19 x 26 ins.)

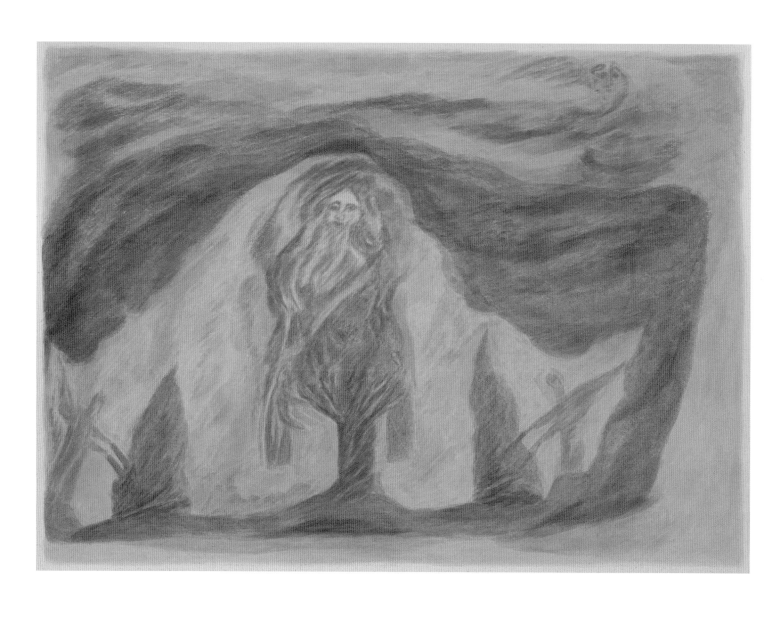

Paradise. August 1976. Plant colors. 49 x 67 cm. (ca. 19 x 26 ins.)

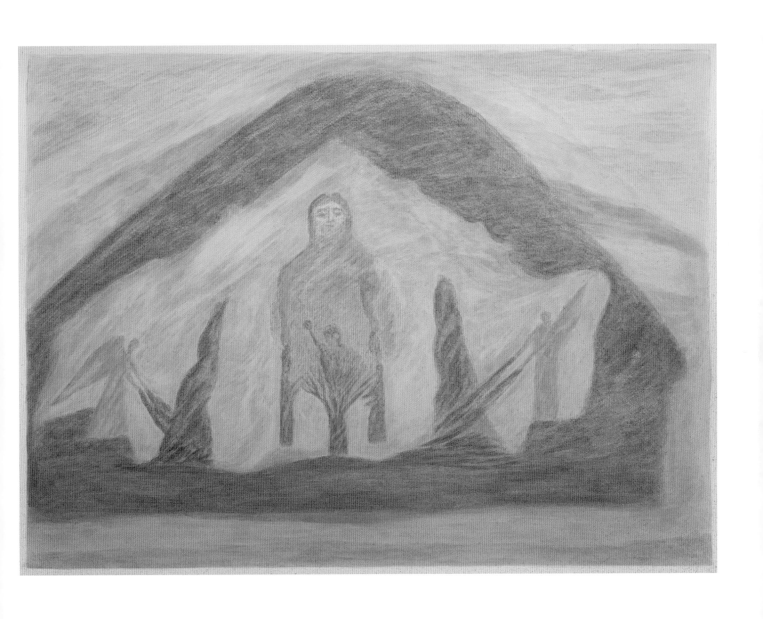

Paradise. September 1975. Plant colors. 49 x 67 cm. (ca. 19 x 26 ins.)

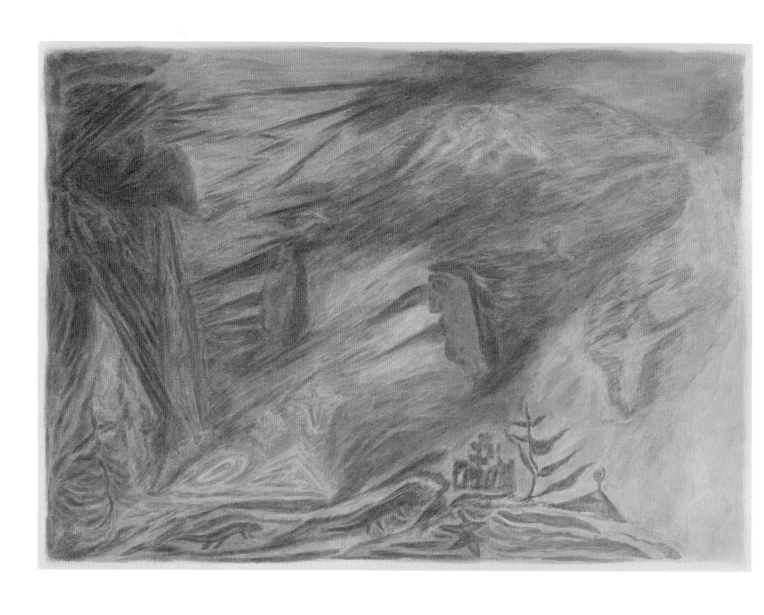

Lemuria. 1976. Plant colors. 49 x 67 cm. (ca. 19 x 26 ins.)

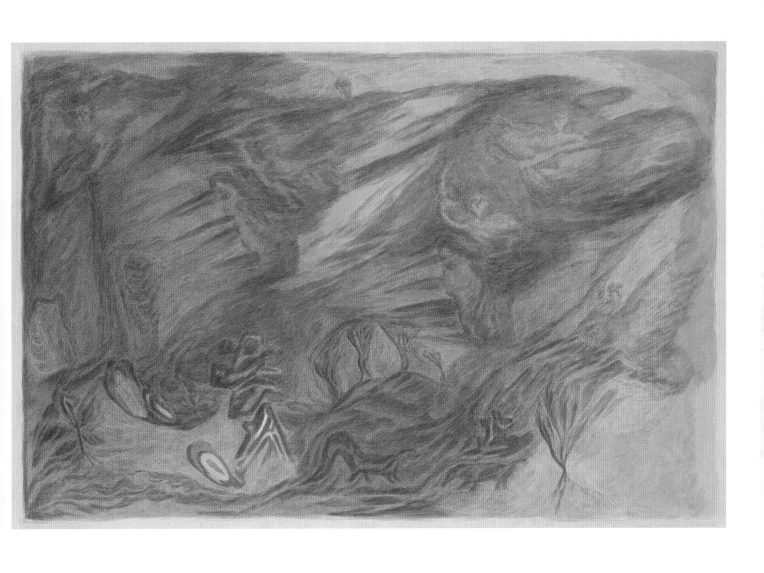

Lemuria. August 1976. Plant colors. 67 x 99 cm. (ca. 26 x 39 ins.)

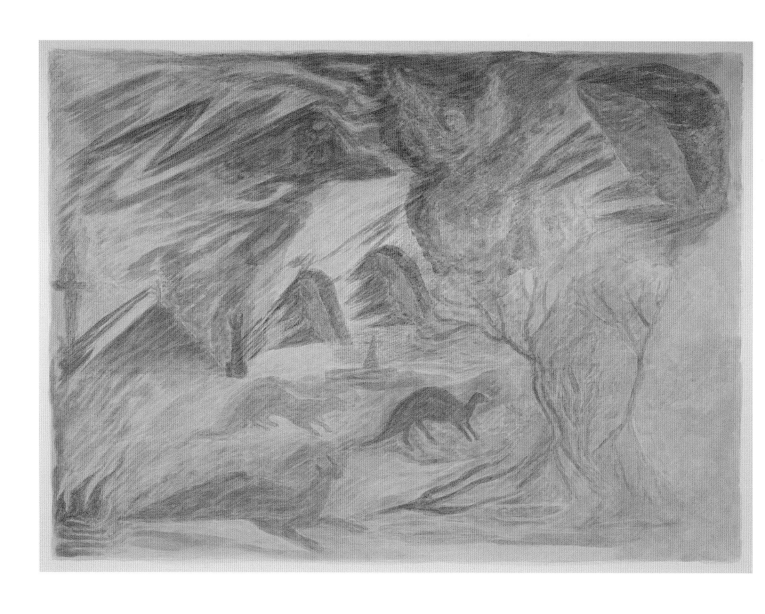

Greece / Lemuria. May 1974. Plant colors. 49 x 67 cm. (ca. 19 x 26 ins.)

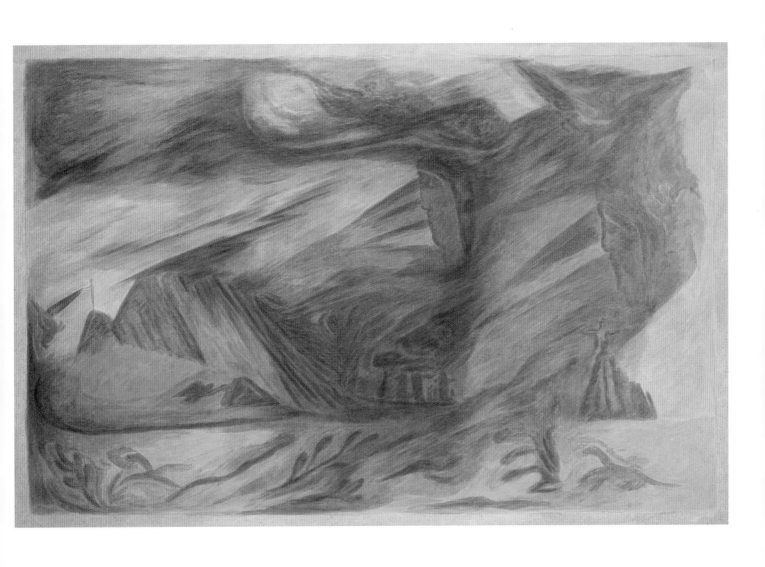

Greece / Lemuria. October 1976. Plant colors. 67 x 99 cm. (ca. 26 x 39 ins.)

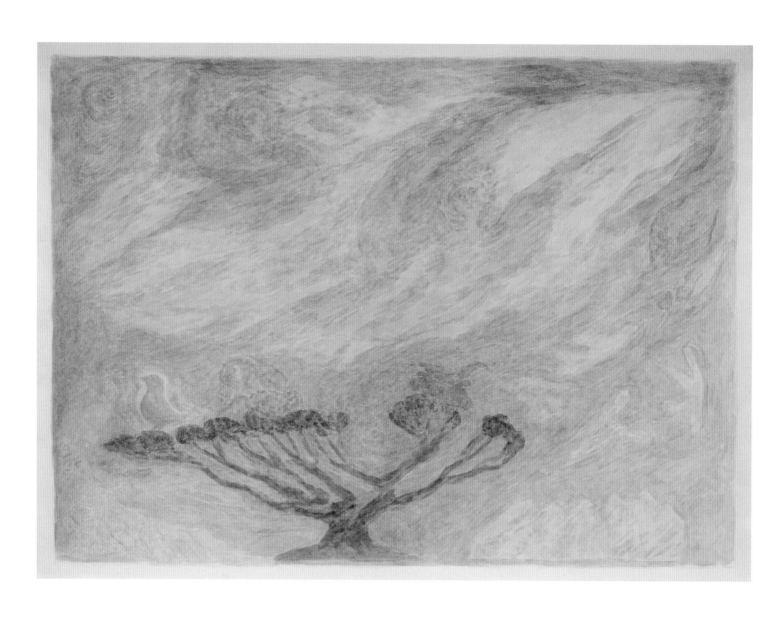

Atlantis. 1974. Plant colors. 49 x 67 cm. (ca. 19 x 26 ins.)

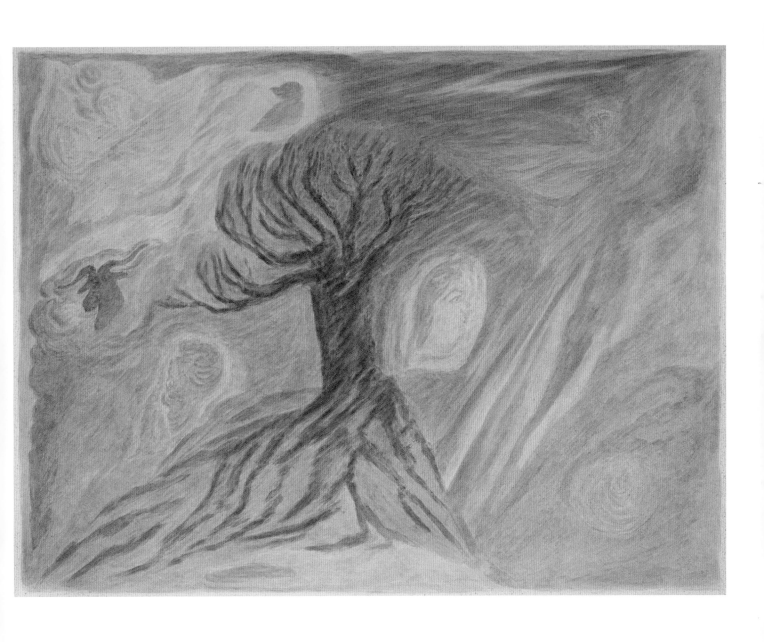

Atlantis. September 1975. Plant colors. 49 x 67 cm. (ca. 19 x 26 ins.)

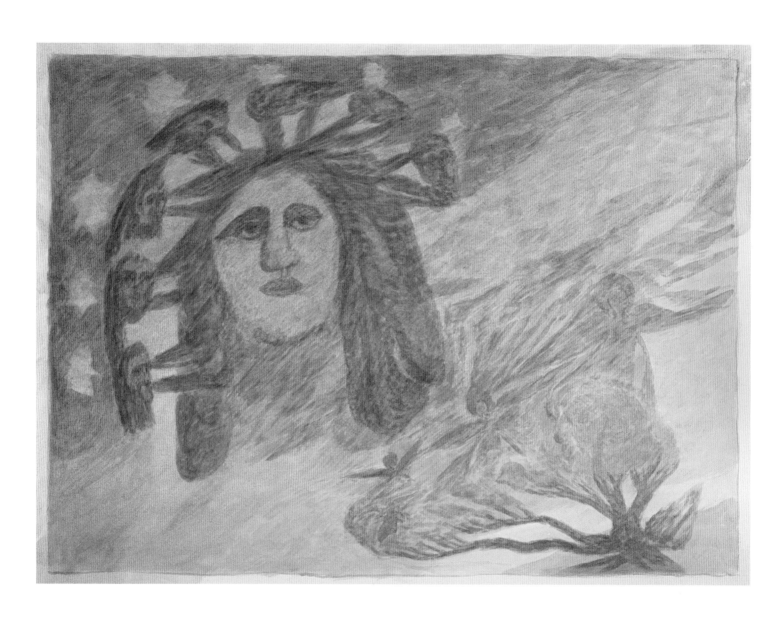

The Ancient Indian / Atlantis. 1974. Plant colors. 49 x 67 cm. (ca. 19 x 26 ins.)

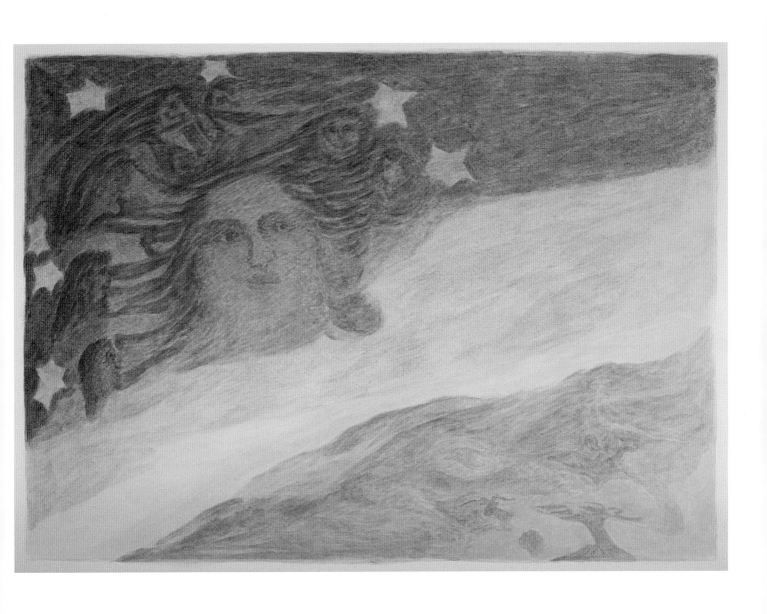

The Ancient Indian / Atlantis. 1974. Plant colors. 49 x 67 cm. (ca. 19 x 26 ins.)

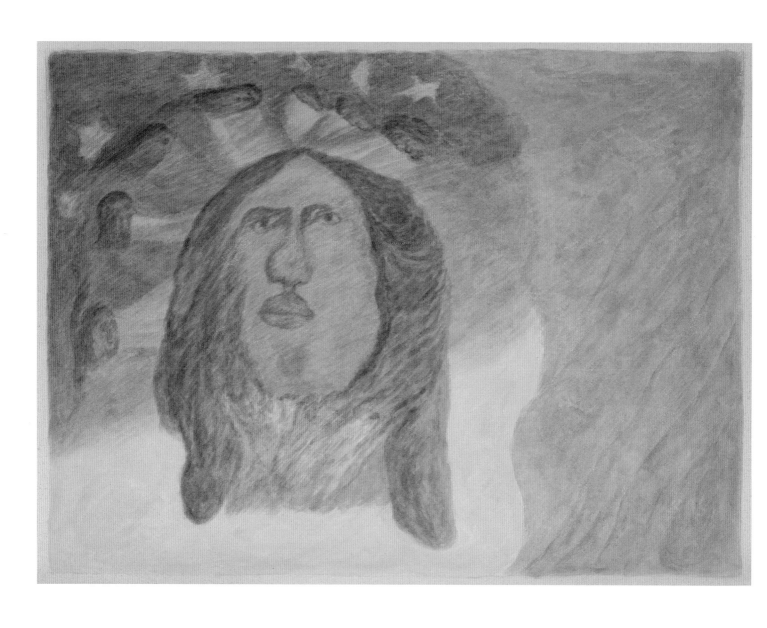

The Ancient Indian. September 1975. Plant colors. 49 x 67 cm. (ca. 19 x 26 ins.)

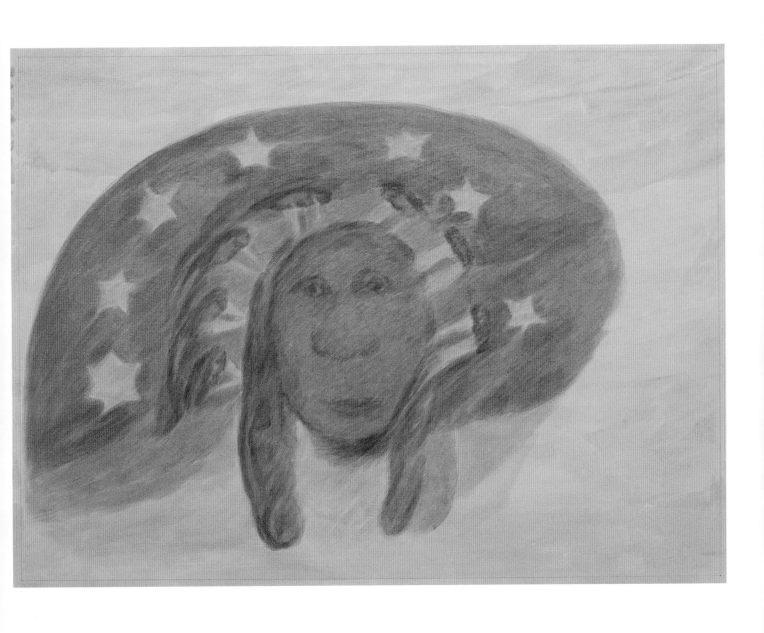

The Ancient Indian. May 1989. Plant colors. 49 x 67 cm. (ca. 19 x 26 ins.)

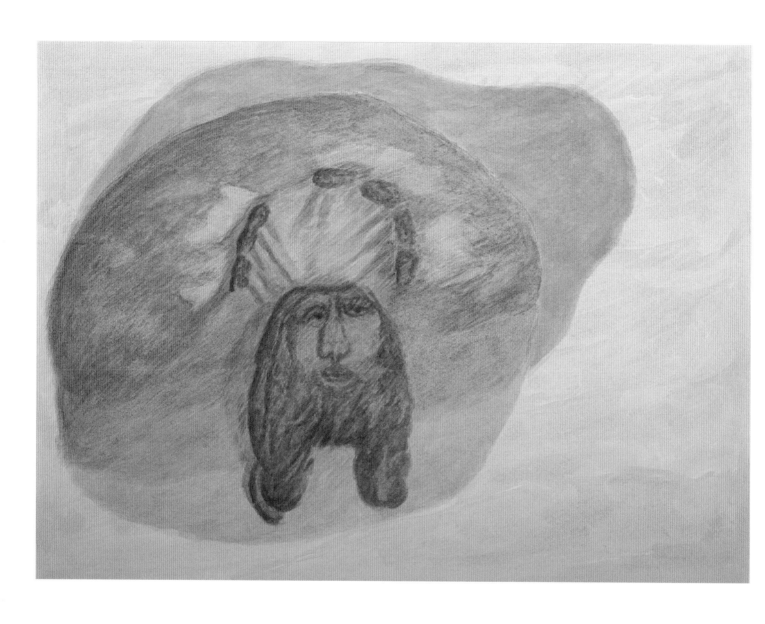

The Ancient Indian. November 25, 1991. Plant colors. 49 x 67 cm. (ca. 19 x 26 ins.)

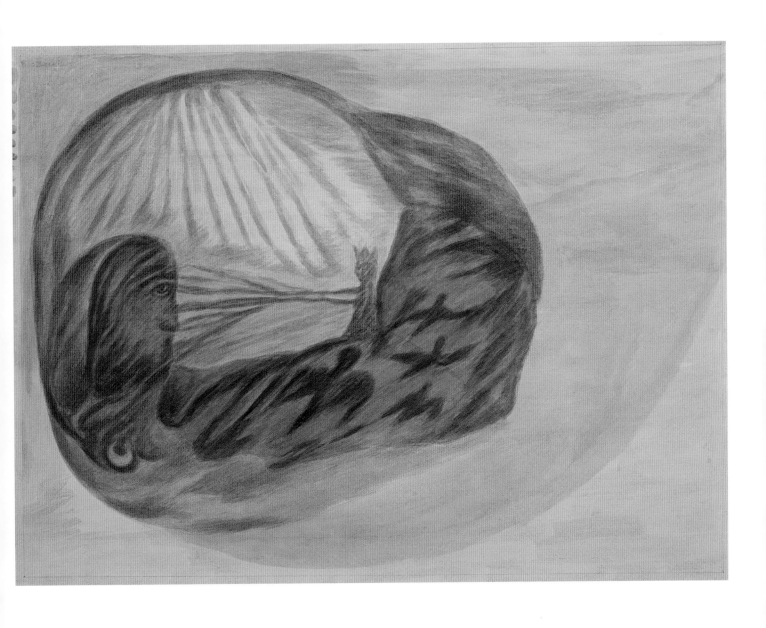

The Ancient Persian. May 15, 1989. Plant colors. 49 x 67 cm. (ca. 19 x 26 ins.)

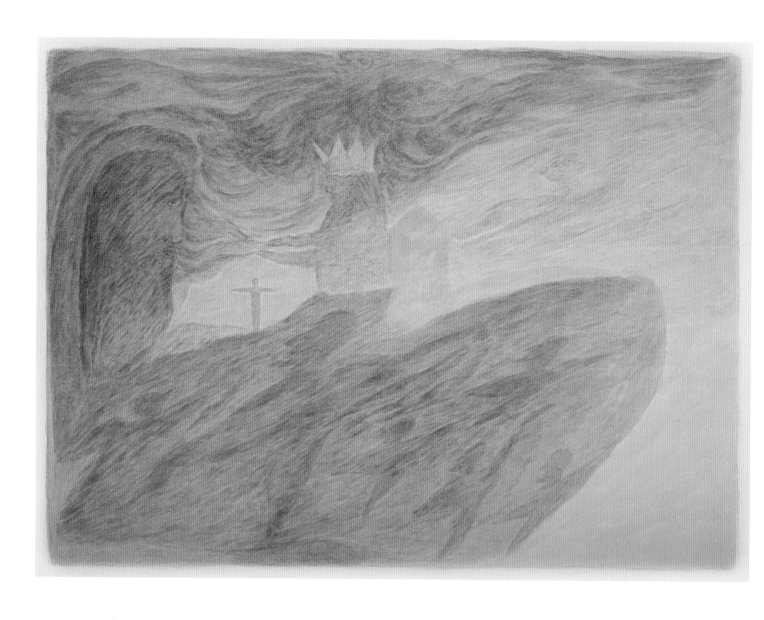

The Ancient Persian. May 1974. Plant colors. 49 x 67 cm. (ca. 19 x 26 ins.)

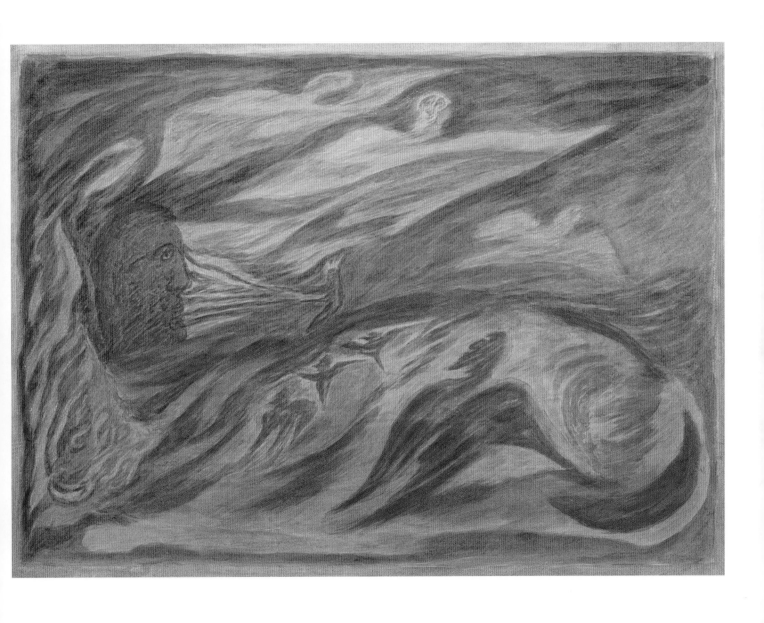

The Ancient Persian. September 11, 1982. Plant colors. 49 x 67 cm. (ca. 19 x 26 ins.)

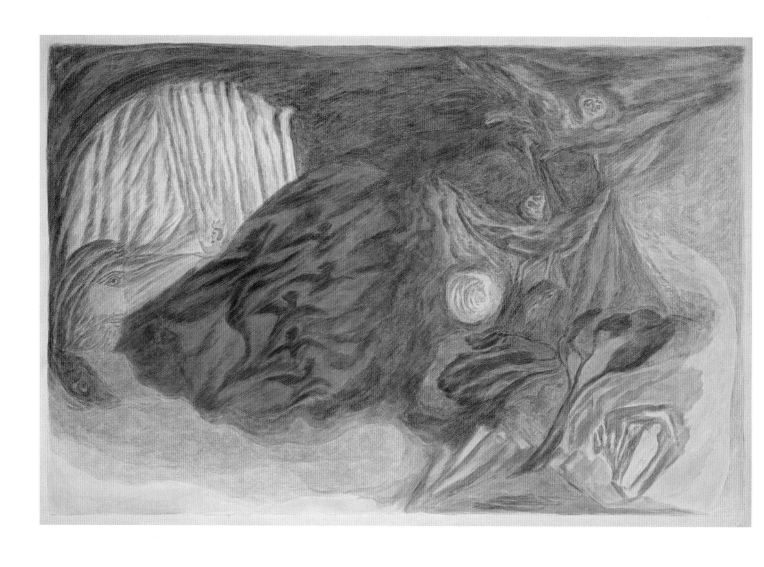

The Ancient Persian / Atlantis. October 1976. Plant colors. 67 x 99 cm. (ca. 26 x 39 ins.)

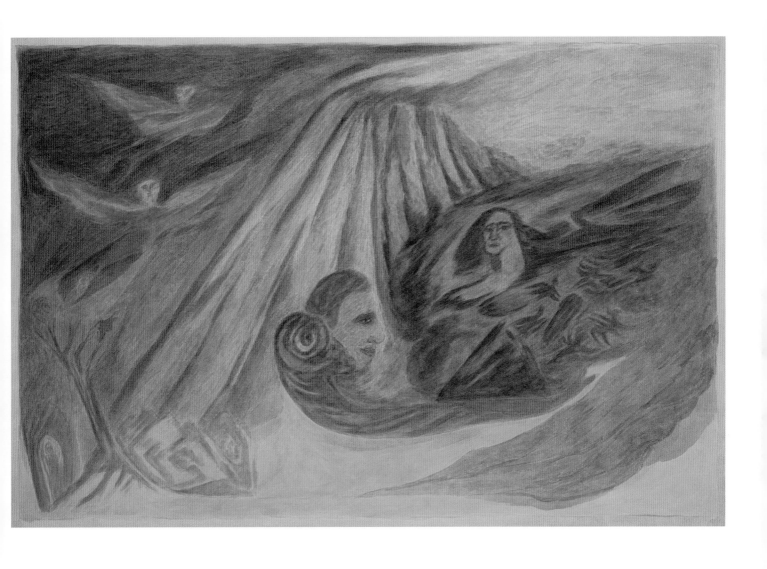

Atlantis / The Ancient Egyptian. Oct/Nov 1976. Plant colors. 67 x 99 cm. (ca. 26 x 39 ins.)

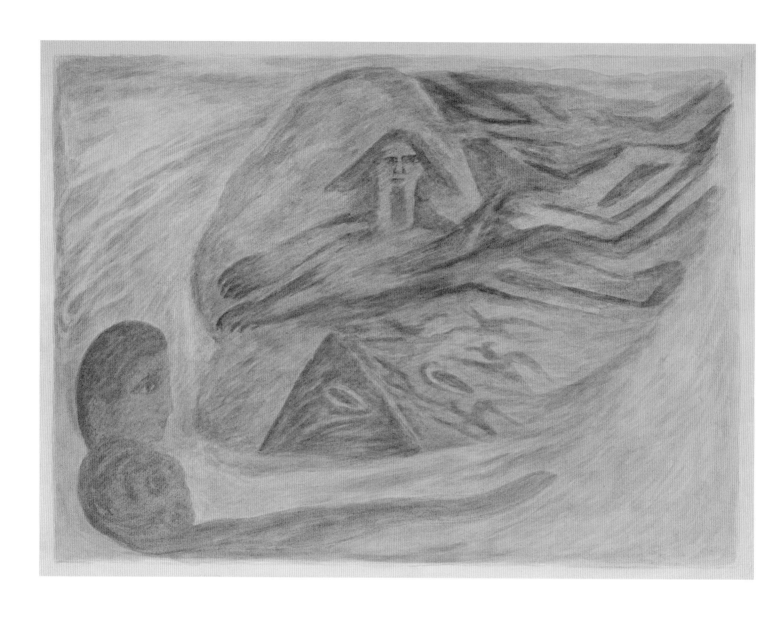

The Ancient Egyptian. March 1974. Plant colors. 49 x 67 cm. (ca. 19 x 26 ins.)

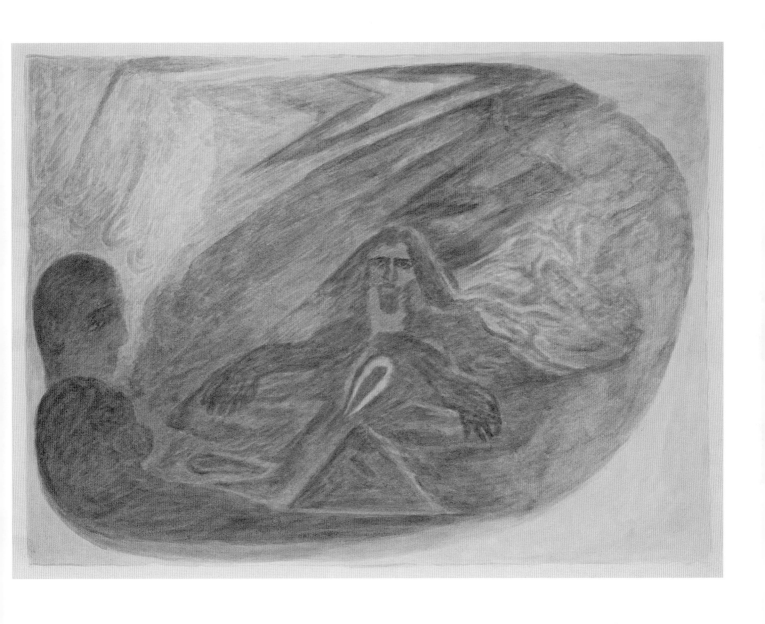

The Ancient Egyptian. March 1974. Plant colors. 49 x 67 cm. (ca. 19 x 26 ins.)

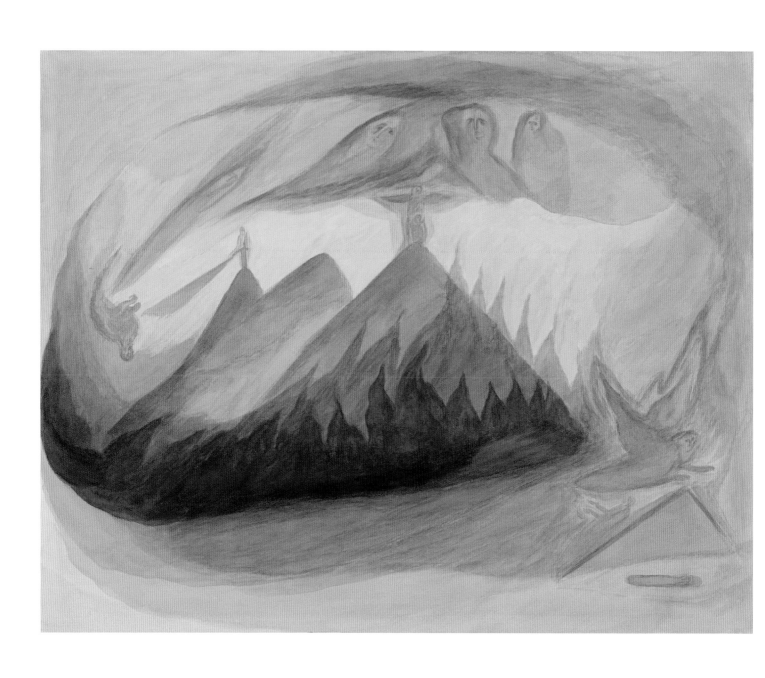

Greece and the Oedipus motif. May 1951. Mineral colors. 49 x 67 cm. (ca. 19 x 26 ins.)

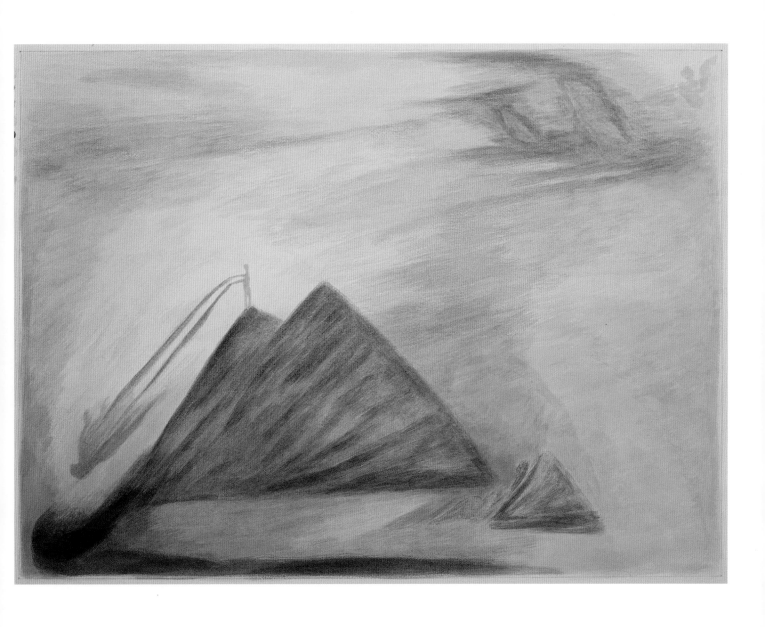

Greece and the Oedipus motif. May 19, 1989. Plant colors. 49 x 67 cm. (ca. 19 x 26 ins.)

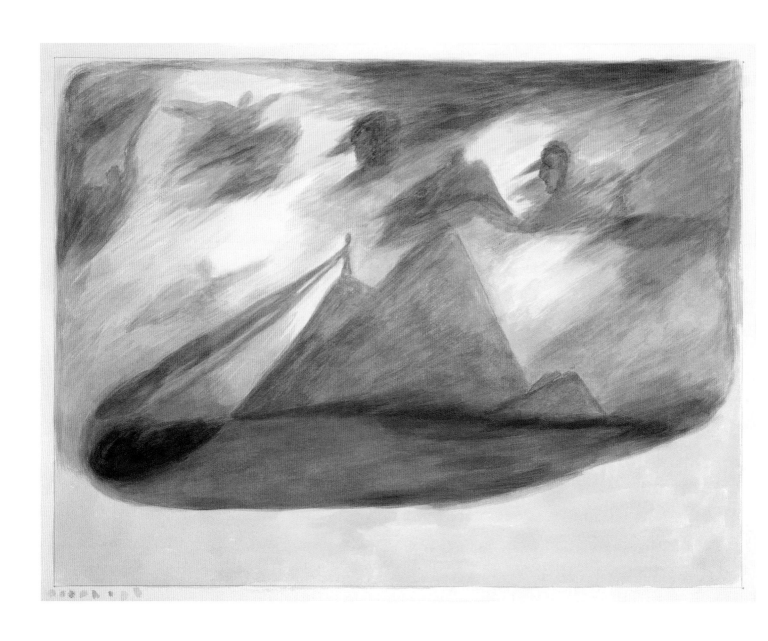

Greece and the Oedipus motif. November 12, 1994. Plant colors. 49 x 67 cm. (ca. 19 x 26 ins.)

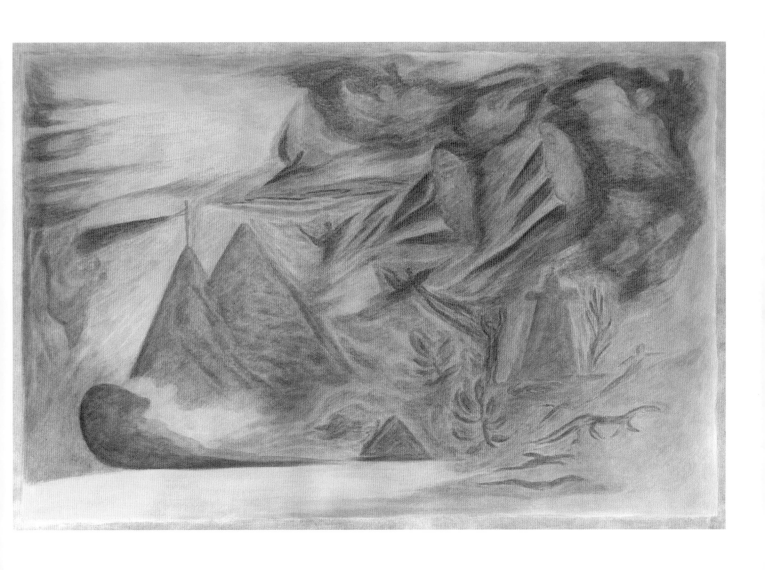

Greece and the Oedipus motif / Lemuria. August 1976. Plant colors. 67 x 99 cm. (ca. 26 x 39 ins.)

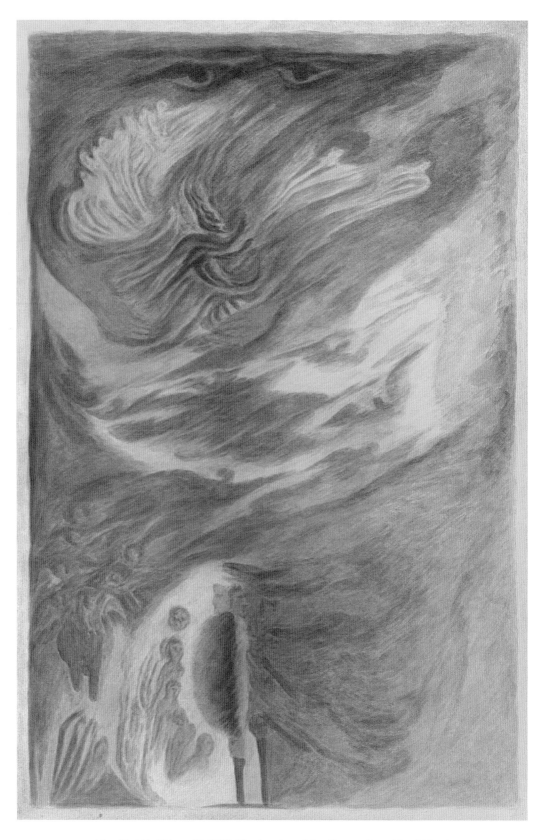

The 'I'–'A'–'O' motif. 1976. Plant colors. 99 x 67 cm. (ca. 39 x 26 ins.)

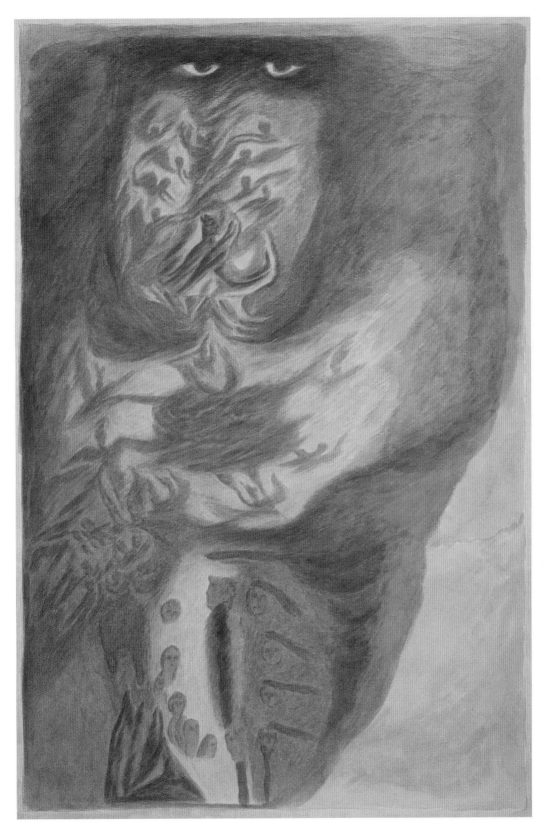

The 'I'–'A'–'O' motif. 1976. Plant colors. 99 x 67 cm. (ca. 39 x 26 ins.)

93

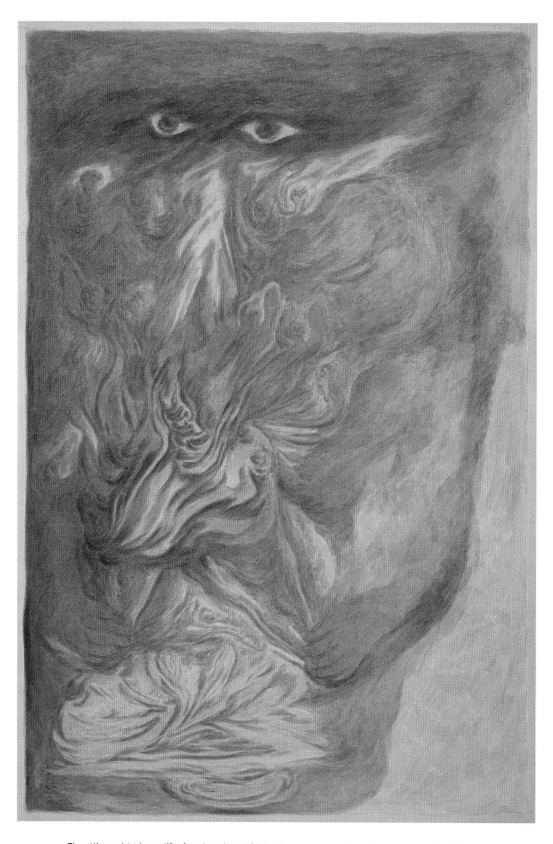

The 'I' and 'A' motifs. September 1976. Plant colors. 99 x 67 cm. (ca. 39 x 26 ins.)

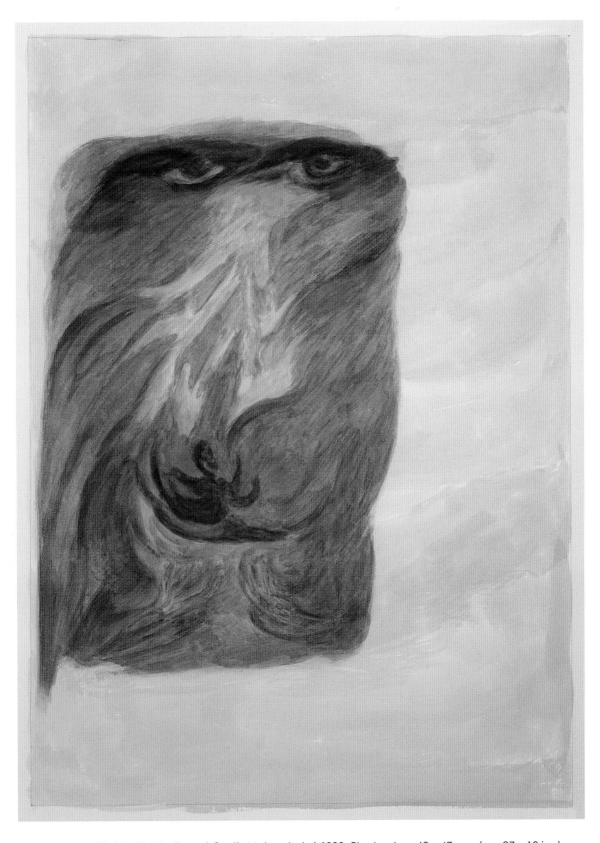

The 'I' motif. (God's Wrath and God's Melancholy.) 1993. Plant colors. 69 x 47 cm. (ca. 27 x 19 ins.)

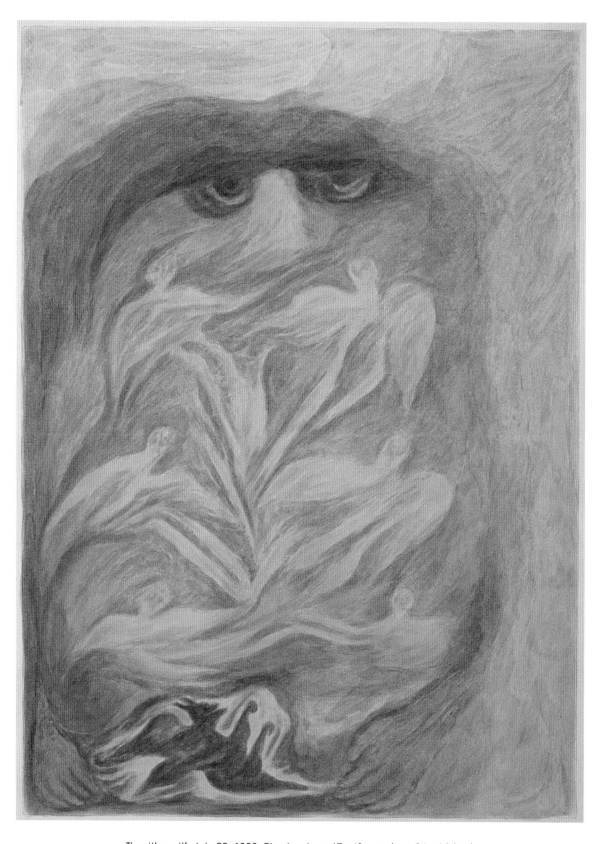

The 'I' motif. July 28, 1989. Plant colors. 67x 49 cm. (ca. 26 x 19 ins.)

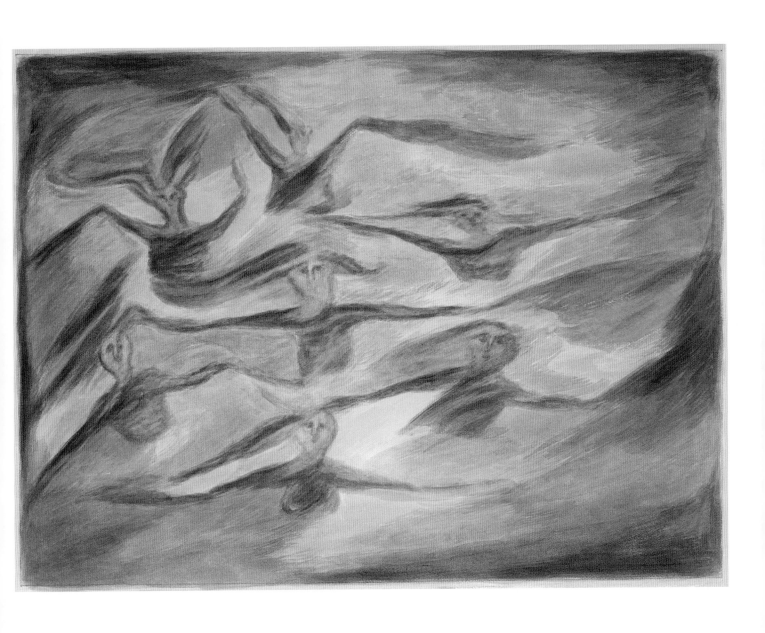

The 'A' motif. (The Round Dance of the Seven.) November 1993. Plant colors. 49 x 67 cm. (ca. 19 x 26 ins.)

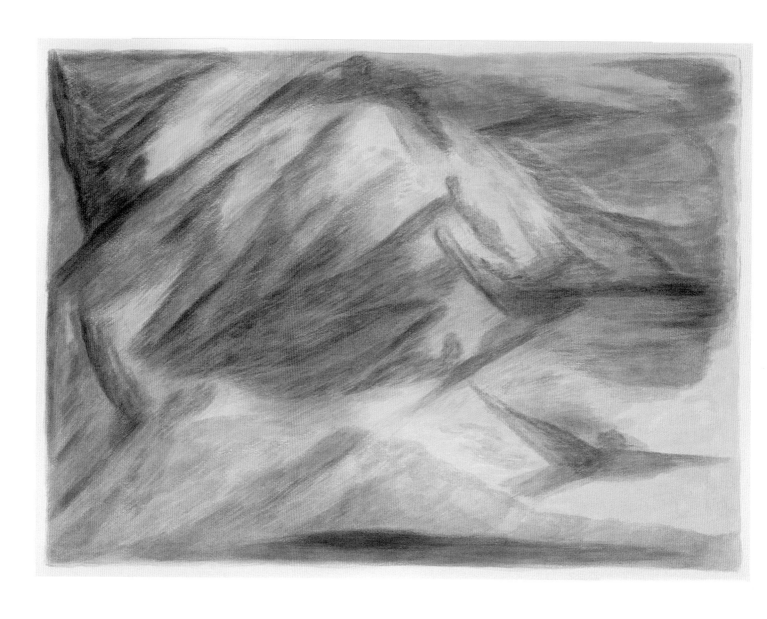

The 'A' motif. (The Round Dance of the Seven.) December 1975. Plant colors. 49 x 67 cm. (ca. 19 x 26 ins.)

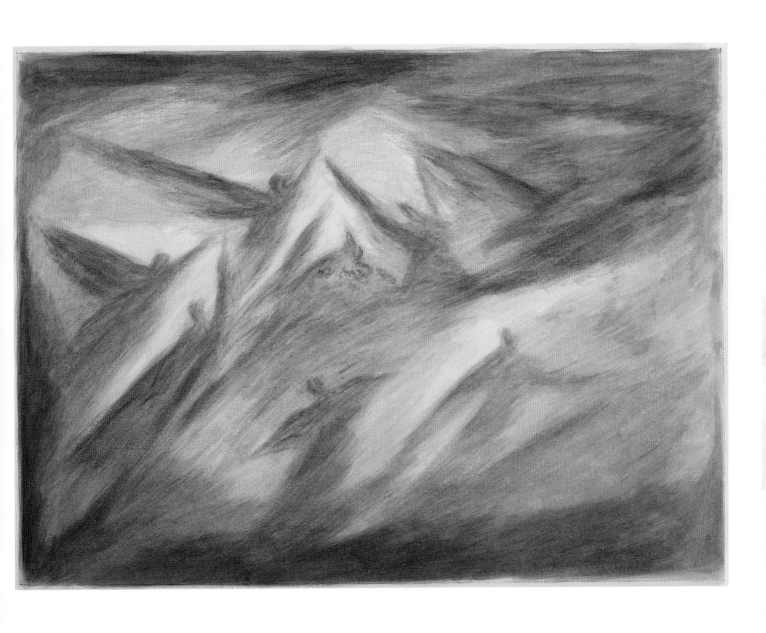

The 'A' motif. (The Round Dance of the Seven.) January 1994. Plant colors. 49 x 67 cm. (ca. 19 x 26 ins.)

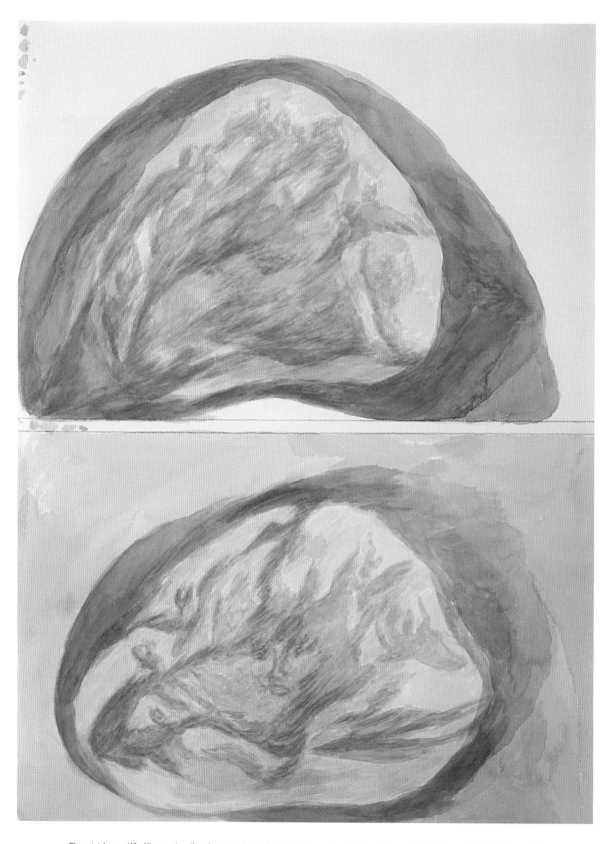

The 'A' motif. (Two studies.) May 1998(?). Plant colors. 37 x 53 cm (x 2). (ca. 15 x 21ins. x 2.)

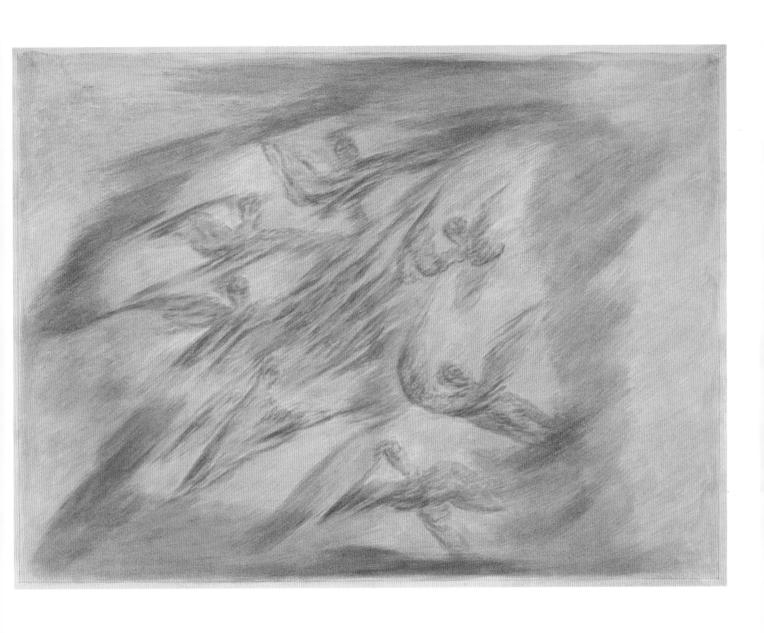

The 'A' motif. (The Round Dance of the Seven.) July 8, 1989. Plant colors. 49 x 67 cm. (ca. 19 x 26 ins.)

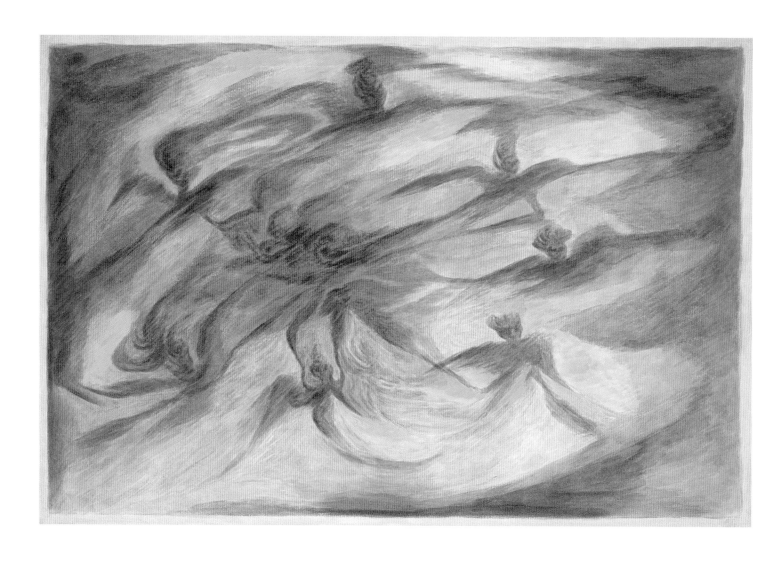

The 'A' motif. (The Round Dance of the Seven.) Winter 1976. Plant colors. 67 x 99 cm. (ca. 26 x 39 ins.)

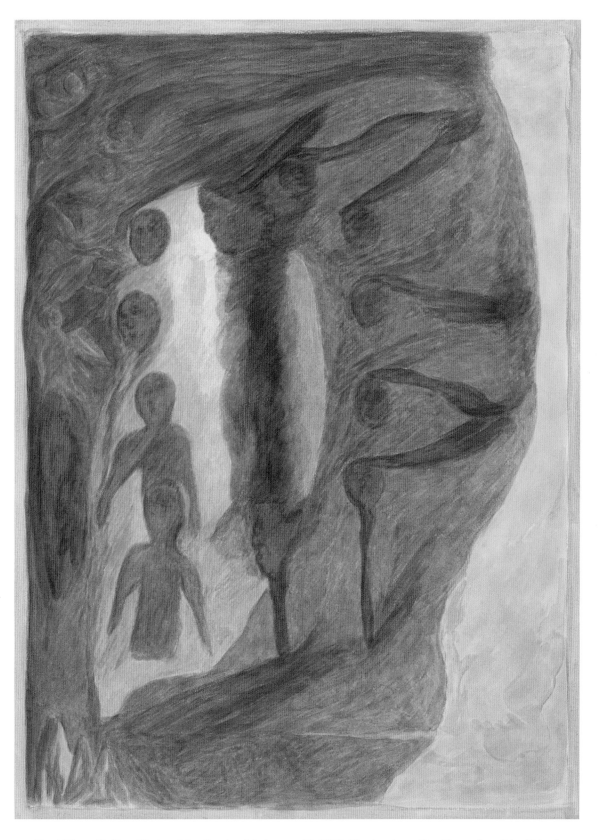

The 'O' motif. (The Circle of the Twelve.) February 12, 1983. Plant colors. 67 x 19 cm. (ca. 26 x 19 ins.)

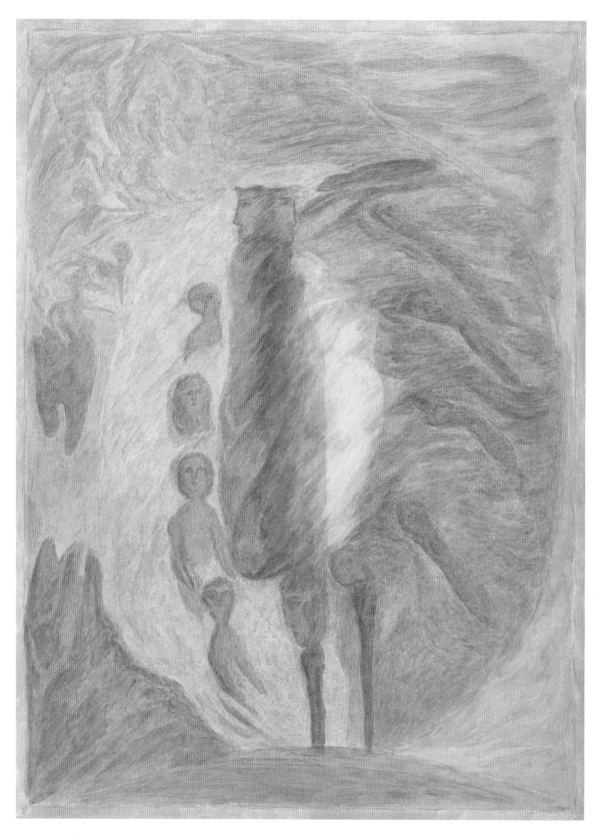

The 'O' motif. (The Circle of the Twelve.) 1974. Plant colors. 67 x 49 cm. (ca. 26 x 19 ins.)

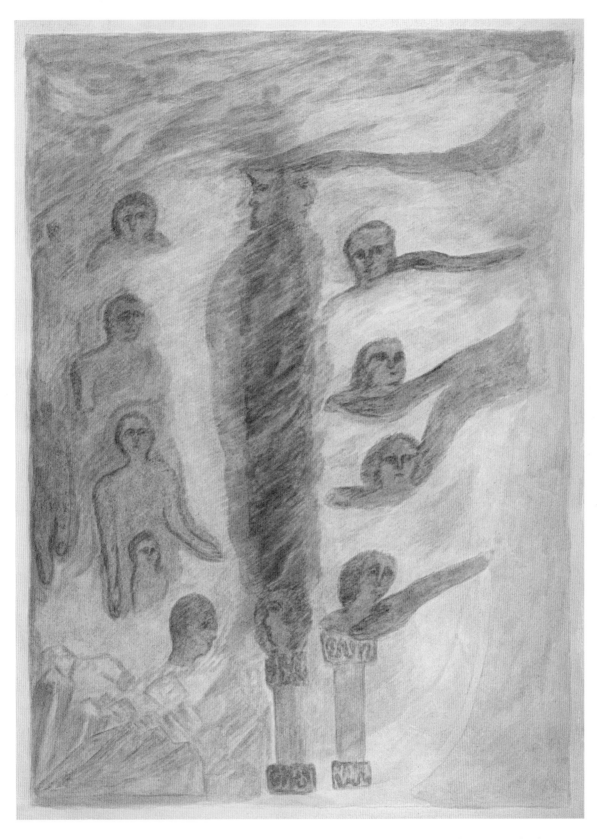

The 'O' motif. (The Circle of the Twelve.) July 1974. Plant colors. 67 x 49 cm. (ca. 26 x 19 ins.)

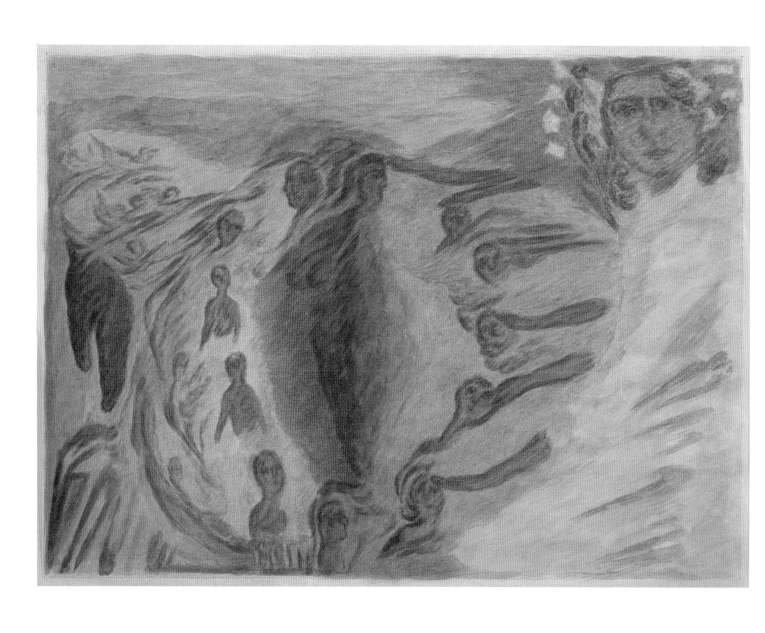

The 'O' motif / The Ancient Indian. June 18, 1989. Plant colors. 49 x 67 cm. (ca. 19 x 26 ins.)

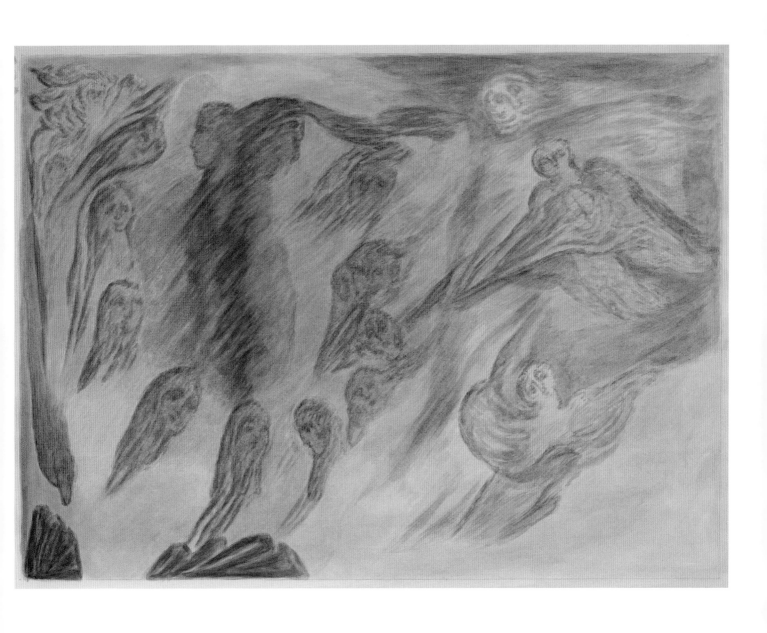

The 'O' motif. (The Circle of the Twelve.) June 22, 1989. Plant colors. 49 x 67cm. (ca. 19 x 26 ins.)

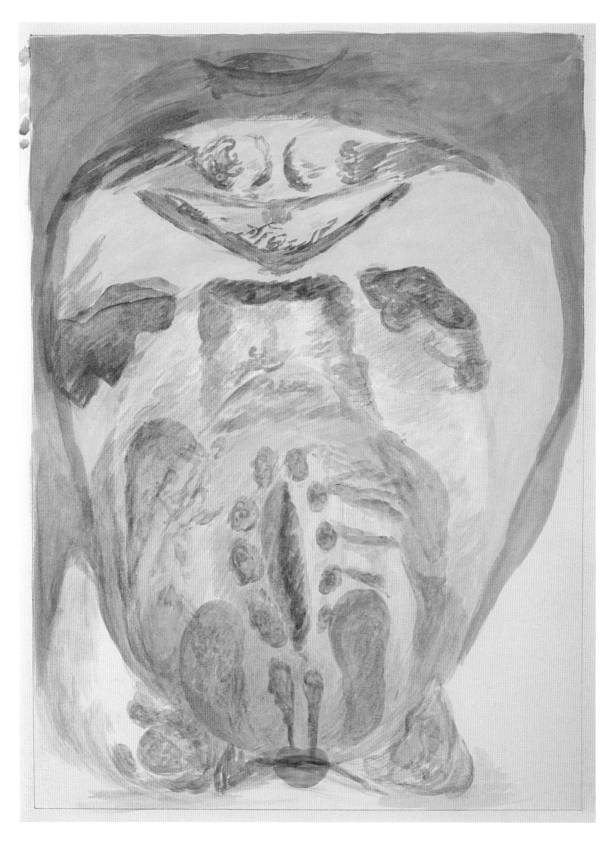

Goetheanum ceiling study. Large Hall. No date. Plant colors. 74 x 53 cm. (ca. 29 x 21 ins.)

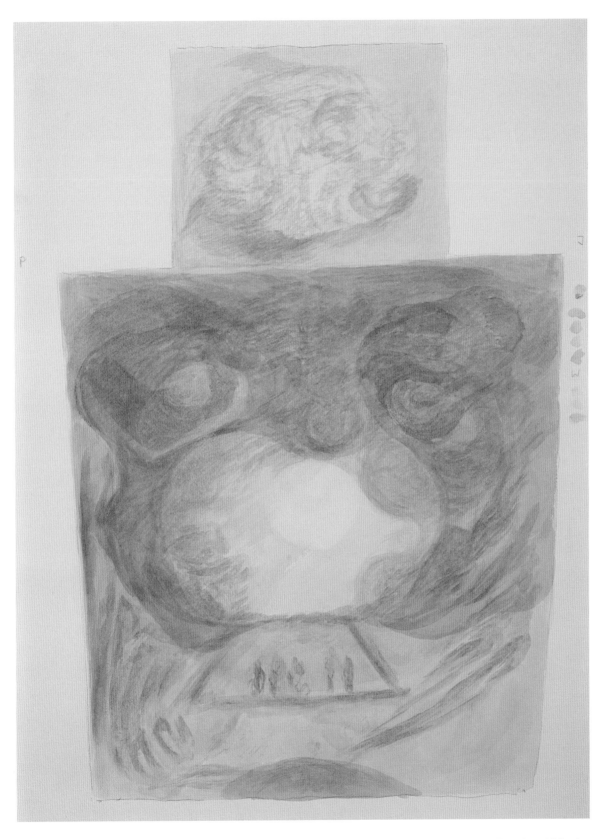

2nd Goetheanum ceiling study. Large Hall/stage area. No date. Plant colors. 69 x 47 cm. (ca. 27 x 19 ins.)

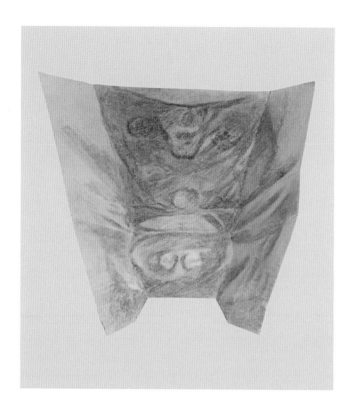
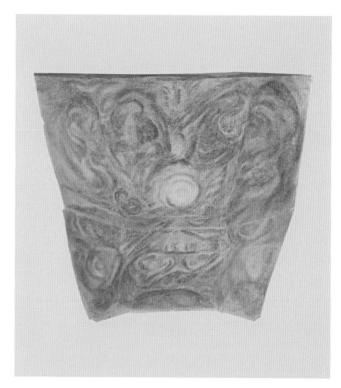
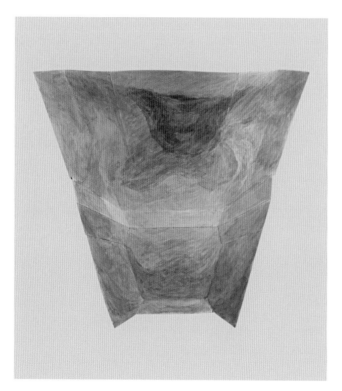
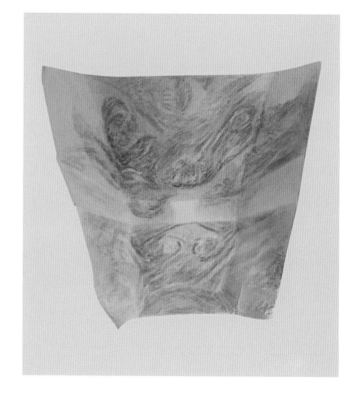

Models of the ceiling in the Large Hall of the second Goetheanum. Painted by Gerard Wagner, ca. 1995.
The trapezoid of the auditorium widens toward the rectangular stage area in the east (not shown here).
Photos: Caroline Chanter.

A Further Development of the
Large Cupola Motifs

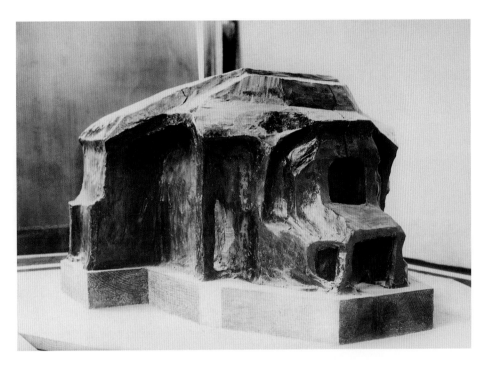

Rudolf Steiner: 2nd Goetheanum Model. Scale 1:100. March 1924

Rudolf Steiner completed the model of the second Goetheanum in mid-March, 1924. Construction of the building was in progress at the time of his death on March 30, 1925. Little is known of his intentions for the interior, including the ceiling of the large hall. However, Hilde Boos-Hamburger reports Rudolf Steiner as saying, in May 1924, 'In the new building we shall have many walls; a lot of painting will need to be done inside.'[1]

The distinctly different forms of the second Goetheanum would seem to call for a corresponding new solution – a different artistic approach to the ceiling paintings – even if the

same motifs come in question. The models painted by Gerard Wagner already indicate such a new approach to the auditorium ceiling, treating it as one harmonious organic whole.

The building material itself differs essentially in the two Goetheanums; the first being constructed of wood, the sculptural forms carved of various hardwoods, while the second is shaped of the denser, more brittle material of reinforced concrete. With the second Goetheanum, the artistic conception of the building underwent a decisive metamorphosis. This has been made evident step by step in a series of models of the west façade by the pioneer architect Albert von Baravalle. He likewise developed an interior model of the large hall which is altogether exceptional in its authenticity, relative to the exterior.

Having previously made numerous studies of the cupola motifs, over a period of decades, Gerard Wagner painted a metamorphic series in 1982 prompted by the question: What would happen if a color sequence found to lead to the motifs of the large cupola were painted on *slightly subdued background colors*, i.e., 'broken' with black?... The mineral hardness of the building material of the second Goetheanum could be said to have its parallel in such a 'breaking' of the background colors of the cupola with black.

The outcome of this artistic experiment was altogether surprising, giving rise to quite new motifs out of the color. However, only the first painting of the series (shown opposite) can be seen as even distantly resembling a cupola motif of the first Goetheanum, the *Elohim* motif. The resulting transformation departs altogether from the original cupola motifs. Though there are twelve large cupola motifs, the metamorphic series consists of eight pictures.

With the remodeling and renovation of the large hall fifteen years later (in 1997), the ceiling project was undertaken by painters appointed by the Visual Arts Section at the Goetheanum. The intention was then to recreate the cupola motifs on the basis of Rudolf Steiner's sketches – on *pure* background colors. By then advanced in years, Gerard Wagner had no direct part in this, though he participated in the early stages in which a larger group of painters practiced painting the sketch-motifs on both a smaller scale and full size. In addition, as already mentioned, he painted a number of scale models of the auditorium ceiling, of which four are shown here.

The artistic experiment of Gerard Wagner indicated above did not then come into consideration. Nor would he necessarily have regarded these pictures as appropriate for the ceiling of the second Goetheanum. They nonetheless stand as an example of extraordinary creative resourcefulness.

– Peter Stebbing

[1] From Hilde Boos-Hamburger: 'The Struggle for a New Spiritualized Painting Impulse' in *Conversations about Painting with Rudolf Steiner*. (p. 79.) SteinerBooks 2008.

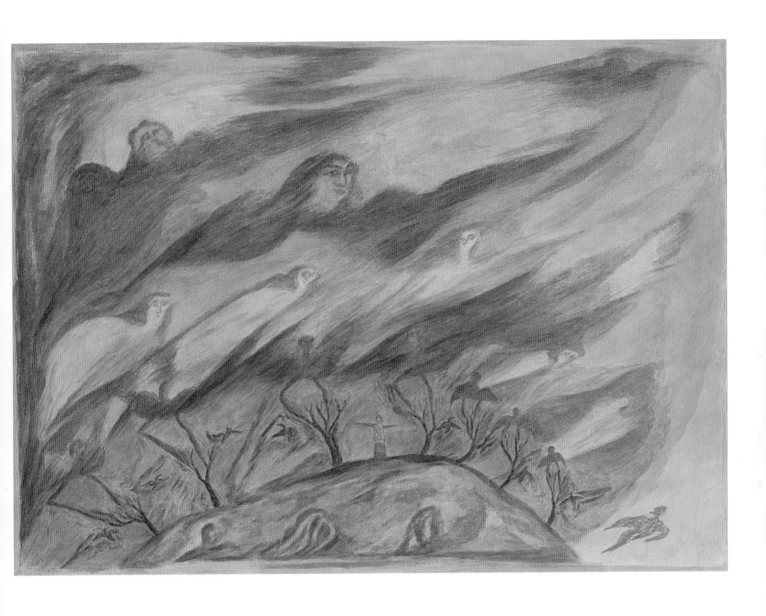

Gerard Wagner: The first picture in a metamorphic series painted on 'broken' background colors.
November 1982. Plant colors. 49 x 67 cm. (ca. 19 x 26 ins.)

II.

THE MOTIFS OF THE SMALL CUPOLA

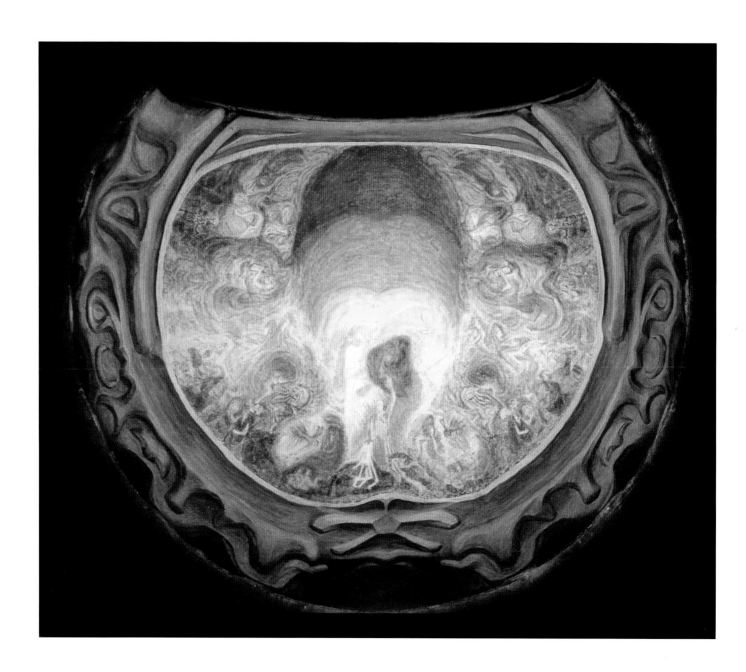

View looking up into a scale model (1:10) of the Small Cupola. Built by Carl Liedvogel and painted by Hilde Boos-Hamburger. Exhibited as part of the Goetheanum Art Collection, Dornach, Switzerland. Copyright holder: M. Boos-Egli, Basel.

The Paintings of the Small Cupola

The Goetheanum as a True Emblem of Anthroposophy
(A lecture held in Dornach, January 25, 1920)

Rudolf Steiner

In moving on today to the paintings of the small cupola – the photographs of the paintings of the large cupola were not such that they could be made into slides – I am nonetheless in a peculiar position. And everyone will find themselves in this position who would call forth an idea of what is intended with the painting of this cupola from reproductions [in black-and-white], before a broader public that does not actually see the matter at hand. For here it is a question of the standpoint in painting mentioned in my Mystery Drama *The Portal of Initiation*: of deriving painting, of deriving the form, completely out of the color. It is a matter of this point of view actually having been affirmed in the paintings of the small cupola, as far as this was possible – there too of course everything has remained at a beginning stage.

Having the form appear as a creation of the color was the intention to be carried out here. In tracing the history of painting, it will be found that this principle, of fetching everything in painting out of the color, can fundamentally only now stand at the beginning of its development. After all, the art of painting was sought, in 'golden' epochs of painting as well, in the mode of expression, the representation, the naturalistic representation of some motif or other, since it particularly tempts in that direction. Even though it has to be admitted – and who would not admit this in regard to the creations of Raphael, of Leonardo, Michelangelo and so on – that a pinnacle in painting is attainable in this way – in striving to represent. Even if it has to be admitted that the entire modern worldview, which is unspiritual, has hardly been able to do anything other than strive for imitation, a quite different basic principle, another artistic ethos has to establish itself in painting, since the need is to come to a spiritualization of our worldview. However, only those will acknowledge this artistic ethos who have a presentiment that each constituent of the world presents something of a creative whole. If one is truly capable of a sensitive feeling for the world of color, one really finds

in color something world-creative. Anyone able to immerse themselves in the world of color will be able to rise to the feeling that out of this mysterious world of color, a world of 'being' sprouts forth. By means of our inner forces, color wants of itself to evolve into a world of being. Just as one can see the grown-up person in the small child as a predisposition, so can one see a world of being as a predisposition, if one has a true sense for color.

But, it is then a matter not merely of having a feeling for the *single* color. As a rule the single color gives evidence only of a relationship between the human being and color. Seeing *blue* means feeling the urge, the longing to be drawn into the space in which the color appears, to follow the color. Looking at *red* calls forth the feeling of being attacked, of having to defend oneself against something. So it is with other colors. Colors also have a certain kinship with what can be formed out of them, when form is to be fetched out of the color. Blue, for example, will always help where the wish is to express movement; red will always help when it is a matter of bringing physiognomy to expression. But in what I am referring to here, it is much less a matter of the single color than of what the colors have to say to each other, what the red says to blue, what the green says to the blue, the green to the red, the orange to lilac and so on. In this dialog and interchange of forces among colors a whole world comes to expression. And one only fully senses this dialog and interplay of forces of the colors, if able to perceive the colors as waves of the sea that rise and fall, and playing over these color-waves, – and at the same time born out of the color-waves – the elemental beings evolving of themselves as though out of these color-waves.

Thus it is a matter of discovering in painting the secret of creating after nature, out of the colors. For a great part of the reality we survey is in fact positively born out of the creative world of color. As vegetation sprouted out of the sea, so everything living grows out of the color world.

In our time, it is deplorable to witness how those with a measure of artistic feeling really experience the old forms in art as having arrived at bankruptcy and as incapable of being continued, while despite this, the world does not want to go along with what can only be given by means of the anthroposophical comprehension of the world. This anthroposophical comprehension of the world has however to go beyond mere abstract concepts. It has to encompass one's whole outlook. One must be able to think in colors and forms just as one can think in concepts and ideas. One must be able to live in colors and forms.

If our building is to become what it is intended to be, then what is of the nature of spirit, what is of the nature of soul and what is physical must each come to expression in it, as in an organic whole. The spiritual essentially comes to expression in the forms of the columns, the architrave, the capitals and so on. In these the spirit is presented that creates forms out of itself. What is of the nature of soul is manifested, for example, in the glass windows. One can sense the soul's participation in the interplay of the external light with what is engraved into the glass. And with an eye for what is painted in the cupolas, one will have a presentiment of the formation of the physical. The cupola paintings bring, so to speak, the physical-corporeal

1. 'Flying Child'

to expression. It is appropiate to the building, that there is this reverse order as compared with the customary arrangement of the three members. This results of itself, as against what is usually imagined, with the spiritual thought of as above, the physical below. There had to be this reverse relation as far as the building was concerned. It is inherent in the whole artistic conception of the building.

But precisely the matter of creating form out of the colors is something I cannot of course show you in black-and-white slides. With these slides we obtain only what is not the essential thing intended, as far as the cupola paintings are concerned. We receive in fact no more than the inartistic basis of what is meant. But of course there is no other way[1] and it is to be hoped that those who see these slides, will recognize that as pictures they *cry out* for something else, that they do not at all bring to expression what is supposed to be there. With the proper feeling in regard to these slides, in relation to the paintings themselves, one will have to tell oneself: Yes, what is there in these slides would speak to us in point of fact in quite another language. And then one will be directed to turn one's attention to the actual building itself. For anyone with artistic feeling, this will be a self-evident matter. On that account I believe it is not altogether unnecessary to show them.

We begin at the point in the small cupola where there is first of all a kind of 'flying child,' adjoining the boundary of the large and small cupolas (*Illus. 1*). This flying child belongs compositionally to what is there to the left. Fetched of course entirely out of the color, the

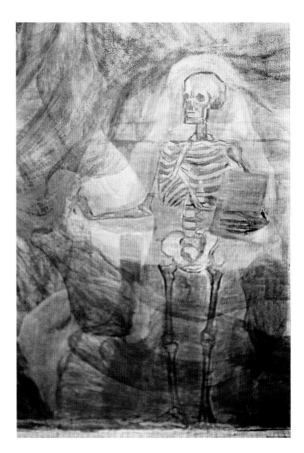

2. 'Faust' figure 3. 'Death'

composition constitutes a motif in its own right within the small cupola as a whole. And you will comprehend the figure of this child, in casting a glance at the two adjoining figures.

We shall now insert the next picture (*Illus.2*): You see here a kind of *Faust* figure. We are placed into the Middle Ages, into the time when our fifth post-Atlantean age begins. It is a matter of the only word to be found here, written out in the letters: *ICH* ['I']. In the entire building you will not otherwise find anything written out in this way. The abstract presentation of this fundamental word 'I,' has its justification here in so far as, with the arising of the fifth post-Atlantean cultural period in which we now find ourselves, in the 15th century, which develops further into the time of Faust in the 16th century, a certain 'detachment' makes its appearance. It expresses itself by means of the mere 'sign,' by means of what disconnects itself altogether from reality. In point of fact, what underlies the actual 'I'-nature of the human being is not yet understood at present. In the course of humanity's development we have still not come to *picture* the 'I.' For in uttering the word 'I,' the human being really only has an abstract point in mind. And for that reason, it has its justification here to introduce the quite unreal designation of the 'I' by means of letters. That can be said to have its justification in the immediate proximity of the Faust figure.

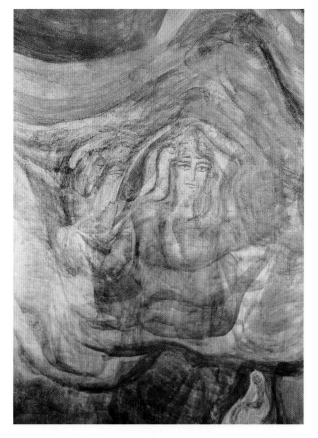 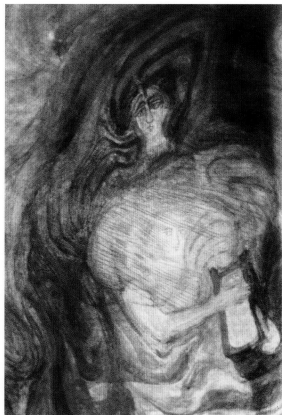

4. 'Athene' figure 5. 'Apollo' and Inspirer

Please do not attach special importance to my saying 'Faust figure.' It is a matter of the composition which includes this figure expressing what the Time Spirit brings to light in just this epoch in a 'seeking' human being. You see this above all in the eye, the demeanor, the gesture of the hands. You see it expressed in the whole attitude of this figure. That it reminds one of Faust is quite incidental. It is a question of the human being of the fifth post-Atlantean time period, who really seeks as is sought in our age. As yet, very few people have become aware of the fundamental feeling that arises with this seeking. Since the 15th century we have increasingly evolved a 'worldview of death,' a worldview which is not capable of penetrating the living. This is connected with the educational phase the human race has to undergo at the beginning of this fifth post-Atlantean time period. Humanity is to reach the point of developing inner freedom, consciousness of self. It can only do so in tearing itself away from Nature. However, tearing oneself away from Nature means forging a union with forces that solely comprehend what is dead. Our concepts, all the leading ideas of civilization, tend toward what is dead. And anyone not becoming dead in themselves, as our modern scholars in fact are inwardly, will feel, in seeking in this way, an inclination towards what makes the human being free, yet at the same time the abyss of what is dead. One has forever the feeling:

Blackboard sketch. Chalk on paper.

You are making yourself free, but in doing so you come into the proximity of death. – Therefore, the figure of Death had to be brought close to this Faust figure in the composition.

Next picture (*Illus. 3*): This is below. You see here the seeking human being, who stands nowadays under the impression, under the feeling-impression of death. This always accompanies precisely the most important ideals in the search for knowledge. For a sensitive soul, that would be unbearable: above a kind of Faust figure, Death below, with no compositional counter-image. Hence, before one comes to this composition of Faust and Death, there is this flying child that presents as it were the antithesis to the perception of death. Thus a triad is to be taken account of: Death, the seeking human being, and the young, fully alive child. With this, we have, painted into this small cupola, what can be portrayed as the initiation of the fifth post-Atlantean age. The initiation wisdom of the fifth post-Atlantean age is, you see, not attainable, without having continually beside one, as it were, the full awareness of the significance of death, not only in human life, but in the life of the whole world. We possess the power of thinking by virtue of bearing death forces continuously within our heads. Were the forces active in the head for the purpose of thinking to permeate our organism as a whole, we would be unable to live. We would constantly die. We live only because the dying tendency of our head is continually balanced out by the living tendency of the rest of our organism. That, briefly and simply stated, is the law of our time, in abstract terms. In telling you this, I can well understand that it does not penetrate especially deeply into your hearts, into your souls. To have lived through it as a matter of experience, however, signifies something tremendous, my dear friends. It means to have experienced the impulse that, with

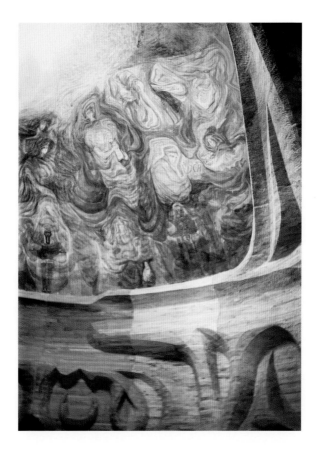

6. The south side of the Small Cupola.

every effort to attain knowledge, says: What you are able to acquire for yourself for the present in the way of knowledge, you owe to death, that enters more and more into earthly life. Only when this initiation principle, now at the beginning of its development, will have spread far and wide, will the active yearning of the new humanity of the future for the compensating spirit come about. – This will be a yearning for a youth that is already a 'Jupiter'-youth – no longer an 'Earth'-youth – which is already a youth of the next planetary embodiment of the Earth. This is what should actually come about in the earthly life of humanity.

The next picture (*Illus. 4*): We then go back to what can be expressed in painting as the fourth post-Atlantean cultural period. Among the paintings of the small cupola a figure emerges here of a kind which in its whole configuration – you will get a sense of this especially in looking at the actual colors of this figure in the small cupola – indicates by its very nature the raying-in of the spiritual world into the human being during the fourth post-Atlantean period, as this occurred in that age. Above this figure you will find the inspirers (*Illus. 5*). In each case, over the main figures you have the corresponding inspiring geniuses. It is just that with the fifth post-Atlantean cultural period, Death itself is the actual inspirer, approaching the human being from below.

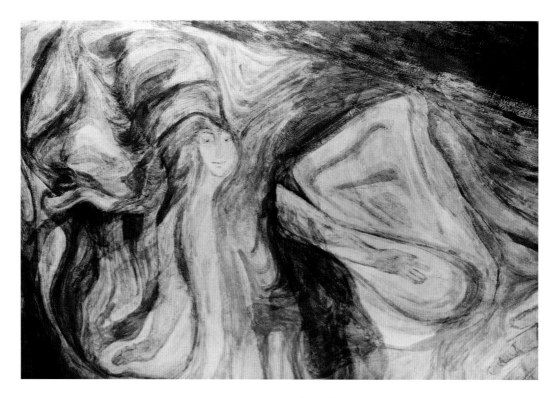

7. Genius ('Faust' motif).

Here you have a kind of god above, an Apollo figure as inspirer. What could enter a human being of the fourth post-Atlantean cultural period by means of inspiration comes to expression in this figure. And thus, painted in this small cupola, you see in fact the history of humanity in its inner, soul development. Of course, you must dispense with all inartistic considerations. In wanting to bring such a figure onto the surface in painting, one has nothing present in one that could lead to the question: What does this or that mean? – Regarding this figure, an inartistic person will say: What do the two or three heads there signify, to the left of the main figure? – That is in actual fact simply an inartistic question, a question the one painting will least of all want to answer, for the reason that in coming to such faces in painting, it is a matter of their simply making their appearance spatially as figures. One does not feel anything capable of encountering the question: What does that mean? Rather does one sense the necessity, out of creative cosmic forces, to add to the surroundings of a figure inspired as this one is, what has to be expressed once again by means of human figures.

I spoke of the creative forces within the color world itself. Nowadays, in looking at painting, one always in fact has the image of something in mind. That is precisely what will have to be overcome. Much more elemental feelings will have to take hold of the soul of the artist. I should like to express myself still more clearly about this: Let us assume I were to paint here a simple patch of color, a yellow patch of color, and add blue here to this patch of yellow. Anyone really experiencing color as something living cannot feel something like that,

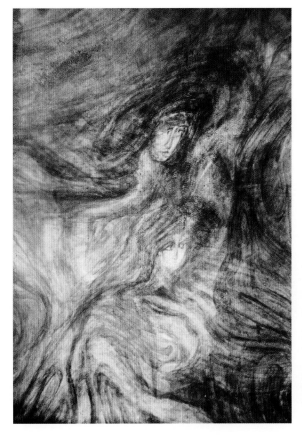

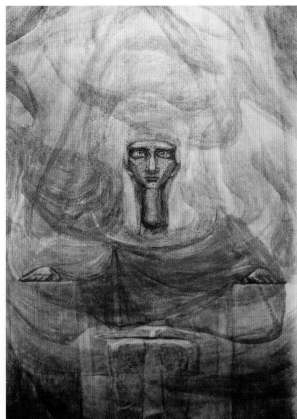

8. Two Inspirers (Egyptian motif). 9. The Egyptian Initiate

a yellow surface of color with a blue surrounding it, and not see a head in profile. (*See blackboard sketch.*)

That follows of itself for anyone who bears the life of color within them. For anyone with an inner feeling for the creative life of color, merely two surfaces of color suffice to lead to an experience of what is of the nature of 'being.' It is not that one arrives at painting a face, for instance in saying: I have seen a face – or even: I have a model and now paint the face in accordance with this model, so that it will be a likeness. Painters will not proceed in that way in the future. Instead, color will be experienced, and quite apart from every kind of naturalism – all reproducing of what is given – they will fetch out of color itself what already lies within it, what *must* be fetched out of it of necessity if one has a living experience of color.

We shall now go to the next picture (*Illus. 6*): Here you have a combination of motifs you saw previously singly: above, the flying child, then the figure of the 16th century, with Death below, the rest being less distinct. In the above you can just make out the inspirer over the main figure you saw previously, only here it is very indistinct (*Illus. 7*). It is difficult of course to convey things that are actually only lightly 'breathed' onto the wall in color, in this crude

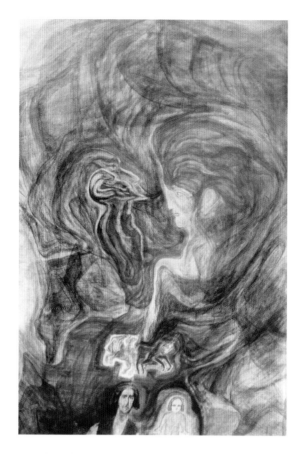

10. Ahriman and Lucifer and the two centaurs over the Germanic Initiate.

manner, employing black-and-white. A good many things can therefore only be taken as a description of what is actually intended.

The next picture (*Illus. 8*): Here you see the inspiring figures of the third post-Atlantean cultural period. From the spiritual world, these inspire the figure that now appears in the next picture.

Next picture (*Illus. 9*): Inspired by the preceding figures, we have here the initiate of the third post-Atlantean cultural period.

Thus the real development of humanity is painted in *soul* terms into this small cupola, not temporally, however, as you will see in a moment, but inwardly. For we now go, not merely back to the earlier, second post-Atlantean cultural period, but back to the Persian initiation principle that has developed further – what was the ancient Persian initiation principle, but which is also the German initiation principle. So, in going to the next picture, we have in fact the Germanic initiation principle. This Germanic-Persian initiation principle is founded basically on dualism. And everything depends on recognizing that all initiation that includes the cultural stream that had its beginning in the ancient Persian cultural period – that had its continuation in the cultural age of Goethe – passing geographically from the

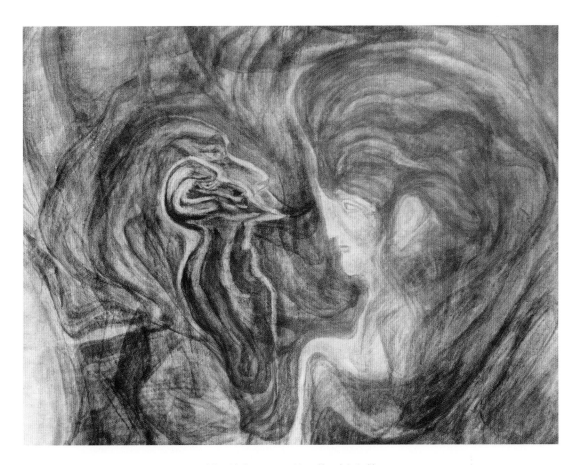

11. Ahriman and Lucifer (detail).

Near East via the Black Sea over to Europe, that this current of initiation has altogether to seek its salvation in a recognition of just how the human being stands within a state of balance to be sought between Lucifer, seen here to the right (*Illus. 10*), and Ahriman, seen here to the left. That is the essential thing to be taken into account. This cultural stream has to gain all possible strength in finding the state of balance between the Ahrimanic and the Luciferic. And in its bearing and physiognomy, it has been attempted in the figure inspired by the Ahrimanic-Luciferic itself (by what asserts itself here to the right as of a sub-human Luciferic nature, here to the left as Ahrimanic), to present that spirituality which derives from a true grasp of dualism; i.e., of the Ahrimanic-Luciferic in regard to which the human being must seek balance. The fact that you see the child here too, as it were carried by the initiate, is not without good reason. For, if one did not continually direct one's gaze at what is rejuvenating and childlike, then what flows into the human being while thus inspired by the dual principle would be unbearable; it would deaden one inwardly. When you see it in the actual cupola, you will notice that a very decisive attempt was made to fetch what is meant here out of the color. The attempt was also to derive the Luciferic and Ahrimanic antithesis out of the color. One must only not quibble, but seek the essential in artistic feeling.

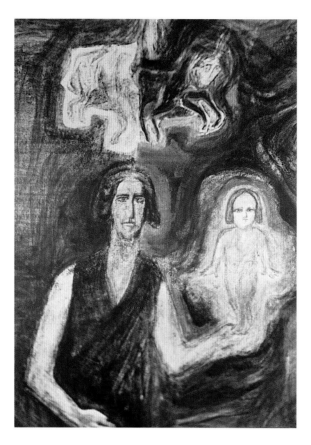

12. The Persian-Germanic Initiate, the Child and the two small centaurs

The next picture (*Illus. 11,* a detail of Illus. 10): Here you see Ahriman more prominently. It is not a matter of two Ahrimans, but of Ahriman and his shadow. Ahriman, you see, does not go about without having his shadow continually beside him. Were Ahriman himself to appear here as an absolutely complete being, he would represent a much too rigidifying, withering principle. There is the need to have his shadow alongside him, which moderates his rigidity somewhat. If you study the colors in the small cupola, you will see that in characteristic, brownish-gray, dark colors, it has been attempted to bring the Ahrimanic- rigidifying principle to expression. It has been attempted to derive everything out of the color.

Here you [also] see the Lucifer motif. You will only completely understand the Ahrimanic and Luciferic, if you view them in correlation with each other. If you look merely at Ahriman or merely at Lucifer, you will actually understand neither properly, but only in having them next to each other, because in the cosmos Ahriman and Lucifer act and work in such a way that what one of them brings about is always taken up and made use of by the other. Thus in their form they can only be rightly understood when conceived in living connection with each other.

What is inspired in this way is shown with the next picture (*Illus. 12):* I hoped to express

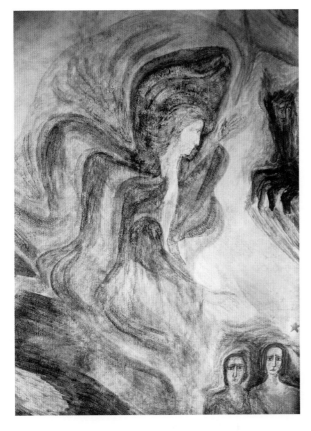

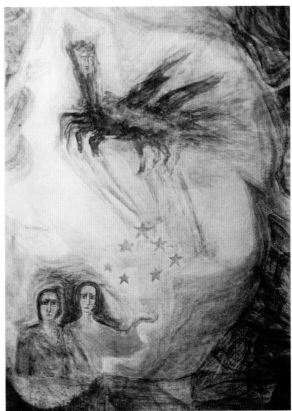

13. Blue Angel (Slavic motif).

14. Slavic Human Being, Double and Centaur

in this countenance, with the corresponding color, what can be expressed more or less in a figure that stands under the influence of this dual principle. Inner stability and at the same time composure in temperament and character are necessary, and joyful inclination towards the young child, in order to be able to bear all that is experienced under the actual inspiring influence of the dualistic principle.

The next picture. [*A detail, not shown here*]: Here you have the same again in another version.

The next picture (*Illus. 13*): Here you see what will one day take over from our cultural period. It lies further toward the central group, towards the Representative of Humanity with Ahriman and Lucifer. This could only be called forth in seeking to bring to expression by means of color and form what surrounds an initiate, i.e., a human being in whom spiritual revelations of the future sixth post-Atlantean cultural period enter in, now in a 'prolog.' It was necessary to visualize, not exactly a Russian of today – but what is to be seen in a certain way in every Russian of today. All Russians basically have their own shadow perpetually as a companion. There is always a second one accompanying them, and that fact is brought to expression here.

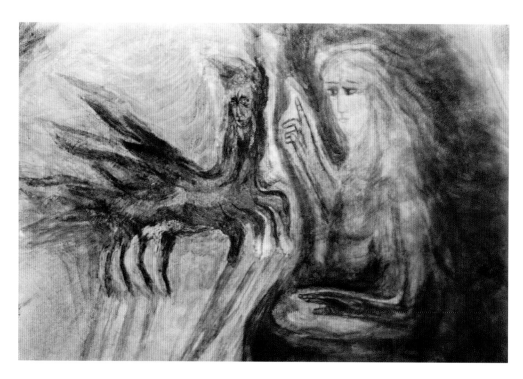

15. Orange Angel and Centaur (Slavic motif). North side.

You now have to imagine the inspirer as more spiritual, compared to the earlier inspiring beings. Hence this angelic figure, which emerges there in its entire form from the blue. You will see this centaur figure more distinctly in the next picture. It is essentially necessary to the inspiring being. You see, this inspiration leads at the same time out into starry realms. The human being is once again recognized in his connection with what is super-earthly in the universe. But what then brings inspiration is no longer to be conceived as having a similarity to the human being. Seeking to arrive at the form, one comes to figures that are no longer similar to the human being, which recall the human being in character and peculiarities of temperament, but which are no longer directly human in appearance.

Here is this inspiring figure, which is a being of the cosmos; it stands in connection with the angelic being that does incline after all towards the human, born completely out of the cloud-like color. You see this here as the actual inspirer.

The next picture (*Illus. 14* and *15*): The same being, only more is to be seen here; the initiate is visible in this picture. Naturally, the entire effect lies once again in the actual color composition, which is of course completely lacking.

The next picture (*Illus. 16*): Here, you now see the middle figure, which shows the Representative of Humanity, with Lucifer above him. It is a matter of the central motif, carried out in painting, below which stands the Group Statue – the main group – now taken up in terms of painting. Here it was more natural to present Lucifer and Ahriman in only one figure each,

130

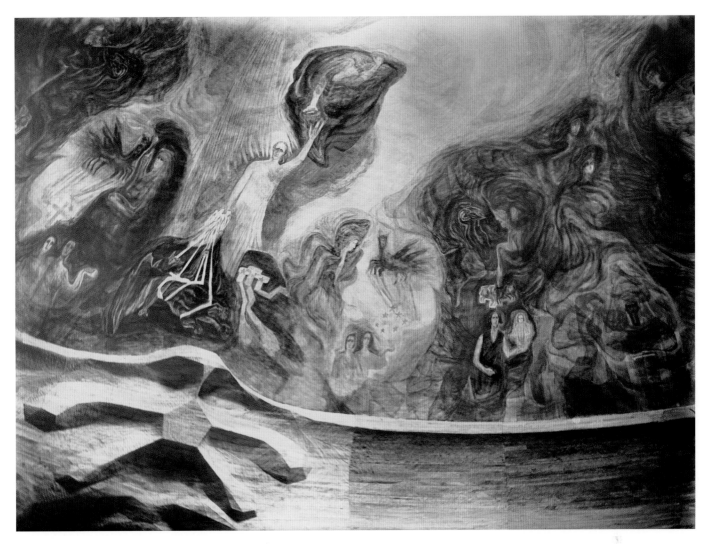

16. Partial view of the paintings of the small cupola. To the southeast.

whereas sculpturally, on account of the weight, on account of its distribution in three-dimensions, they are represented twice. This upper figure is to be understood only out of the colors themselves, from the red of which it is mainly composed, along with a few other color nuances. And here especially it is a matter of showing how it is the human being's task to search for a state of balance between the Luciferic and the Ahrimanic. With the human being, this seeking for a state of equilibrium is to be found quite as much physically, physiologically, as in terms of soul and spirit.

Taken physiologically, physically, the human being is not, for instance, the simple growing entity often depicted in trivial science. The human being always tends, on the one hand, to ossification, on the other hand, to turning soft, to what leads to mucous catarrh. What inclines the human being to mucous catarrh, and comes about if the *blood* gains the

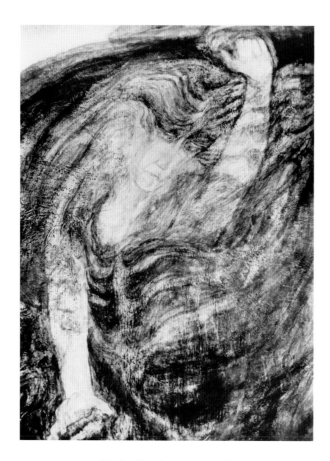

17. Lucifer (central motif).

upper hand, comes from Lucifer. The moment the Luciferic tendency gets the upper hand in the human being physiologically, and fever symptoms appear, the Luciferic predominates. Then, however, the human form begins in a sense to approach this figure more and more (*Illus. 17*). The human being did in fact have this configuration during the ancient moon period. One can say: Human beings would take on such a form if the principle that is chiefly the principle of growth in heart and lung, were to govern the human being by itself. Only because the other pole, the Ahrimanic, stands in the way of this Luciferic tendency is the condition of balance established between what the blood brings about and what is caused by the ossifying tendency. That expresses the matter physiologically, – in terms of the body.

As regards the soul, one can say: The human being is continuously in search of equilibrium between effusiveness, groundless mysticism, which is Luciferic, and the sober, materialistic, abstract tendency which is Ahrimanic. Stated in terms of spirit: The human being is constantly looking to find a balance between those states of consciousness chiefly imbued with light, where consciousness is awakened by means of what relates to light, through illumination of the soul, through what is Luciferic – and the other pole, which is the one where consciousness is brought about by weight, by gravitation, by what is electrical, by magnetism,

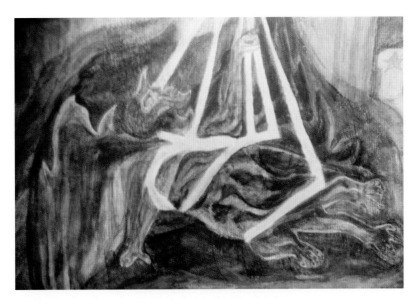

18. Ahriman (central motif).

in short by what draws downward, causing one to take hold of oneself: That is the Ahrimanic. The human being is perpetually a seeker for balance between these two conditions, and it will be noticed that whatever human beings become aware of as being capable of diverting them from the middle path, inclines to the one side, either to the Luciferic or to the Ahrimanic. It would be especially important in studying the human physical organism, to disregard the quite abstract single 'growth principle,' supposedly the only one, and to consider the fact that, telescoped into each other, meshed with each other, polar opposite impulses of growth are present in the human being. The other impulse of growth is the Ahrimanic.

The next picture (*Illus. 18*): This is the exact opposing principle. In every form, in every line you will see the reverse of Lucifer in this Ahriman, who as though grows out of the mass of rock, i.e., out of the earth's weight, wanting to reach up to the human being, so that, were he to seize hold of the human being completely with his heaviness, the human being would be as though deadened through ossification, stifled in disillusionment, in materialism. That has to come to expression in this Ahriman being, who is as though paralyzed by light. Hence the rays of light, which bind him like cords, fettering him. In between, we have the human being, the true human being.

Next picture (*Illus. 16, 19 and 20*): The true human being, representing the state of equilibrium, with Ahriman below him, Lucifer above.

I should particularly like to mention that, here too, it is once again not the essential thing to proceed from the abstract Christ idea. Rather, is it important to experience what lies in this figure as such. One will then be led from the artistic element in this figure, to the Christ. That

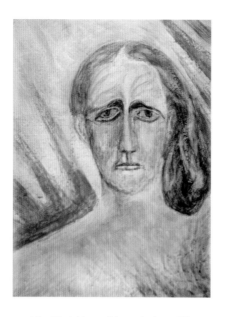

19. Christ head (central motif).

means one will be able to discover, out of feeling, what is inherent in this figure as the Being that constitutes the central point of all earth existence. Christ can be discovered purely spiritually today. But one has to both rightly understand and rightly perceive the human being.

Stated the other way round, it can be said: Those who today understand and feel all there is, in consequence of which the human being can suffer, everything the human being can take joy in, who fully sense how human beings can err to the one side or to the other, can elevate themselves; in striving for real self-knowledge they will discover the Christ, provided they only go far enough on the path of feeling, knowing and volition. They will be able to find the Christ – to be rediscovered in the Gospels and in all historical traditions. One cannot acquire real knowledge of the human being today without at the same time making progress toward knowledge of Christ.

Physiologically, biologically as well, if one rightly understands the physical form of the human being, one will arrive at understanding of Christ. It will be the special task of the fifth post-Atlantean age to come to this understanding of Christ more and more. It was therefore not a matter of placing an abstract Christ figure at the mid-point of our building, the meaning of which would be inquired after, but the Representative of Humanity, out of which the Christ shines forth in His essential being. That is what I would ask you always to consider: Not to proceed from what is prosaic, not from what symbolizes, not from what is abstract, but from what the ensouled eye actually sees – starting out from what is there on the wall, and not from what is merely thought out. What should fill one's thoughts has to come from what is there on the wall itself.

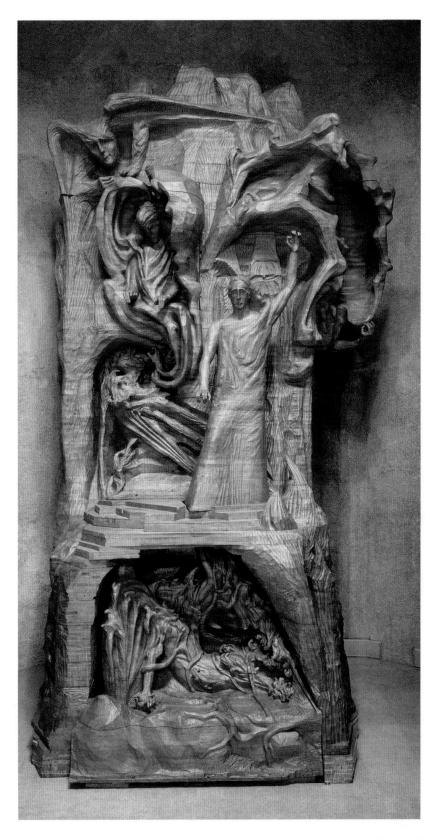

20. The Group Statue. Carved laminated elm. (ca. 9.5 meters or 31 ft. 2 ins.)

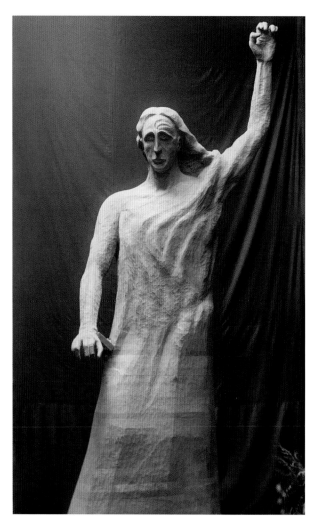

21. The Representative of Humanity (Group Statue).

Of course, what is on the wall is only imperfectly achieved. But every beginning has nec-
essarily to be limited. The Gothic style too was imperfect when it first arose. The complete
and perfect will result from what has been striven for here. That is not to say, the striving
here was not to actually find the true Representative of Humanity, in fact by every means
available to occult investigation. The Christ figure which is the traditional one, actually only
arose in the 6th century A.D. For my part – I put this forward merely as a fact, without
requiring anyone to accept it on faith – but for myself, I am entirely clear about it: for me it is
a fact that the Christ Jesus who wandered in Palestine had *this* countenance, and quite espe-
cially the countenance you can see in the wood sculpture (*Illus. 21 / 22*). It is just that the at-
tempt was made to reproduce in the gesture what *more* is seen, if the ether body is taken into
account, and not only the physical body. Hence the strong asymmetry that has been ven-
tured here. This asymmetry is there in every human countenance, though self-evidently not
to this degree. But the human countenance is in many respects an untrue mask, particularly

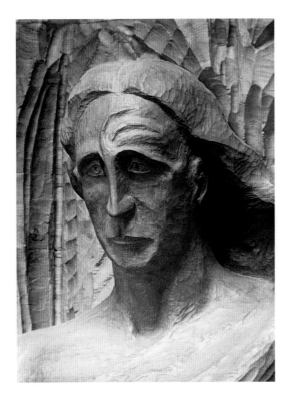

22. Christ Head (Group Statue). Christ Head. Model. Easter 1915.

as the human being bears it today. When humanity will have risen to a certain spiritualization in the sixth and especially in the seventh post-Atlantean age – where the physical human being will no longer dwell on the earth at all – there human beings will bear their true countenance. They will express in their countenance what their true inner worth is.

But all that, I have to say, weighed heavily in wielding the brush and the spatula in portraying the Representative of Humanity. However imperfect the results are, whoever studies them will find that the secrets, the mysteries concerning the development of humanity are after all actually painted into this small cupola. It will be found that what it was intended to express is indeed experienced out of the color. You will see that these black-and-white slides could only indicate what you can gain a feeling for from what is painted in the cupola – based on what I have told you today – without expecting anything of a symbolizing nature, nor anything concerning which one might ask as to the 'meaning' of it.

The next picture (*Illus. 23*): At this point I should like to show you another view of this boiler house. Yesterday I showed you the facade. You can see that this boiler house is thought of as a totality, its profile being in full harmony with the whole, as I explained it yesterday by means of the comparison with a nutshell.

I have now, my dear friends, given you what we have at the moment in the way of pictures. I should like to remark that with this building, it really has been attempted to make the building-idea a unified one as far as this was possible. Thus, for example, you will see the

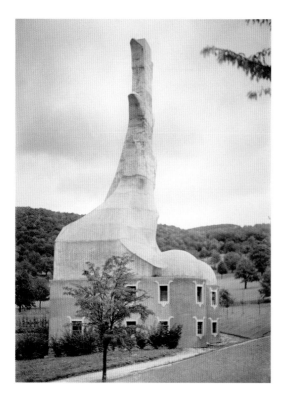

23. Boiler House. Side view.

Boiler House. Façade.

building covered with Norwegian slate. When I once traveled on a lecture tour from Christi-ania to Bergen, I saw the wonderful Vossian slate in the slate-clefts [at Geilo]; and the thought occurred to me that our building must be covered with this slate. If it happens to be a sunny day, taking a look at it, you will find that the characteristic blue-gray shimmer of the slate covering the cupolas does in fact make an impression entirely appropriate to the dig-nity of the building as a whole.

That, for the time being, is what I have to say about the building on the basis of these slides. I wanted to provide some points of reference for friends wishing to take on the task of making this building comprehensible to those for whom the 'Goetheanum' in Dornach is perhaps no more than a name they have heard of, the place itself being only a geographic concept; for friends wishing to make comprehensible to others what is to go out from this 'Goetheanum' for the future development of humanity. It will indeed be very much a matter of bringing this visible, true emblem[2] of anthroposophically oriented spiritual science appro-priately to the world's attention – making it the focus of contemplation in regard to the an-throposophical worldview.

Anyone with a real sense for the turning-point the development of humanity has reached at the present time, will certainly find the needed impulse to make what is to proceed from Dornach more generally known. Admittedly, not many people today see how strong are the

historical forces from the past, effective as destructive forces in the present. Though the devastation in Europe over the last four to five years has been patiently endured, very few people want to think about or understand what has actually occurred. Those who do will see that nothing is to be gained for the further development of humanity deriving from earlier periods – that the new revelation that would enter our earthly world since the last third of the 19th century has indeed to be taken up.

It is not possible to think socially today without taking up the impulses referred to. It is altogether painful to hear of people today who say: Oh, this anthroposophically oriented spiritual science was alright with us, as long as it remained spiritual science, as long as it did not concern itself with external matters, such as the content of *Die Kernpunkte der sozialen Frage*[3]. There were those among the earlier followers of anthroposophical spiritual science who said: Spiritual science suited us well enough by itself. We just can't go along with the change-over to *social* considerations, nor do we want to. Striving merely for a kind of spiritual sensuality, such a way of thinking harbors a sectarian tendency that our movement never wanted in the first place. I should like to know how one can be so heartless, so completely heartless in regard to an impulse that lies in the development of humanity, as to say: Yes, I would like something that warms my soul, that secures immortality, but I want nothing to do with any practical-social consequences of this spiritual striving. My dear friends, is it not after all heartless in times such as these to want no practical consequences from what one strives for spiritually? Is it not a dubious form of mysticism, to fold one's hands and say: Yes, I want spiritual science for my soul, but this spiritual science is not to draw any social conclusions. It *is* heartlessness. For, what a dreadful matter to think this spiritual science is to be the most important thing in one's life – yet it should not know what needs to be done in the present disastrous state of humanity! What would this spiritual science be, if it were not to offer solutions to what humanity urgently needs! Should it remain quite unfruitful for life? Should it be there only in order to pour a kind of soul-sensuality into human beings? – No, it can prove its worth only by showing itself capable of true practical application. And in fact, it means not understanding true spiritual science if one does not want to advance to practical consequences. Spiritual science does not signify knowledge of a mere 'ruminating' kind – spiritual science wants to be integral to real life. For that reason, it is always such a painful matter, that not so very many human souls are able to rouse themselves, out of the impulses of spiritual science, to consider the great concerns of present-day humanity.

What concerns the individual today is in actual fact frightfully insignificant compared to what roars and seethes through humanity. And as soon as one occupies oneself with something or other of a personal nature, one's thoughts ought in reality to be immediately diverted toward the great concerns of humanity. But with how many people does that come in question? Then one has to weigh the fact that it would already be necessary today to impart certain esoteric truths to humanity, yet it cannot be done, because no association exists within which the impersonal, objective principles can gain importance that stand in need of serious consideration. The necessity is imminent, to communicate certain truths of initiation

to humanity. But, it cannot be done when one is dealing with people who are continually preoccupied the livelong day with their personal interests, as though these were of paramount importance. That is what is so infinitely necessary: to turn one's gaze to the great concerns of humanity. Whoever does so will become aware of various things having to do with the present time.

I have had to draw attention again and again to the impending storm of opposition that, with all manner of calumnies and lies, will raise itself against the intentions of anthroposophically oriented spiritual science. People do not want to believe that. But the truth is: spiritual science will not be opposed especially because of its mistakes. It would be forgiven these. Spiritual science will be opposed just when it succeeds in doing something of positive worth. And the severest, most contemptible battle will be directed against the good that spiritual science is able to accomplish. My dear friends! Everyone has to examine themselves stringently, taking a look, over and over again – with the necessary fortitude – at what should be acknowledged as contemptible opposition to spiritual science. It should be asked whether one has perhaps too much in oneself that is similar to what opposes, not the errors, but the positive attributes of spiritual science. Much in this regard stands in need of closer examination. These things have to be pointed out again and again. The time must finally arrive when it will be possible no longer to have to knock at closed doors in communicating certain esoteric truths – simply because people are exclusively pre-occupied with their own personal interests. It should become possible to convey matters of the greatest importance to people's hearts. As it is, one can utter things of the greatest significance today – people take it only as abstract knowledge. Hence these things do not reach their hearts, no matter how shattering. At the same time, everyday, subordinate matters, as well as some larger issues perhaps, do easily reach people's hearts.

We have above all to ensure that what is derived from the spirit actually reaches to our hearts, reaches our souls – that it does not remain merely in our intellect. Much of great importance that has been said today, already found in the contents of anthroposophically oriented spiritual science, does not bear fruit, only because people allow it to reach no farther than their intellect. And then they may even say: Yes, it is something that should be grasped only by the intellect. But it is their own fault in letting it remain only in the intellect, that they take it up only as head-wisdom. That is something I wanted to add as a reflection to this presentation of the building.

From Rudolf Steiner: *Architektur, Plastik und Malerei des Ersten Goetheanum.* (Architecture, Sculpture and Painting of the First Goetheanum.) CW 289. Dornach, Switzerland: Rudolf Steiner Verlag 1972. Lecture held in Dornach, January 25, 1920. Translated by Peter Stebbing.

[1] At the time, color photography was only in its beginnings. 'Uvachrome,' an early, experimental color film, had barely been introduced. The color photos of the small cupola paintings of Rudolf Steiner reproduced in this volume were taken, using this film, by Emil Berger in 1922.

[2] The German word *Wahrzeichen* used here, meaning a 'true symbol' or 'emblem,' is best understood in the sense of: 'the Eiffel Tower is the symbol of Paris.' – Thus, in this case, the reference is to the Goetheanum as the true symbol or emblem of anthroposophy.

[3] *Towards Social Renewal*. CW 23. Rudolf Steiner Press.

*

The Two Centaurs in the Small Cupola Motif of the Germanic Initiate

 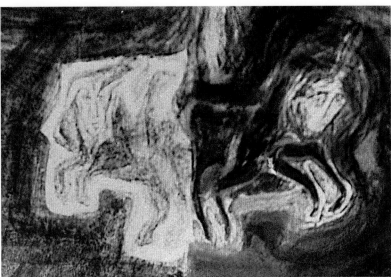

'Here, this kind of dualism once again, in smaller figures formed into centaur-like creatures. This was painted by me during the War. One sometimes has one's private notions in this way. Out of an abstract re-ordering of dualism, there emerged the disastrous fabric of the Fourteen Points of Woodrow Wilson [...] Hence, I indulged in the private amusement of immortalizing Mr and Mrs Wilson here in these figures. That, however, as already mentioned, is of subordinate importance.'

Rudolf Steiner: From a lecture of June 29, 1921 in Bern. CW 289.

Thomas Woodrow Wilson (1856–1924) was the 28th president of the United States, from 1913 to 1921. His first wife, Ellen Axson Wilson, died in 1914, and Wilson married his second wife, Edith Bolling Galt Wilson in December of the following year. Although she consistently took the standpoint that she concerned herself only with her sick husband, she exercised such influence on her husband's politics and that of her country, that she was referred to as the first female president of the United States.

Steiner spoke several times about Wilson after he took office, and quite especially from May 1917 on, up until the karma lectures of 1924.

The Original Small Cupola Paintings of Rudolf Steiner

– The extant color photos –

Rudolf Steiner: The 'Faust' motif with 'Flying Child'. Oil crayon sketch.

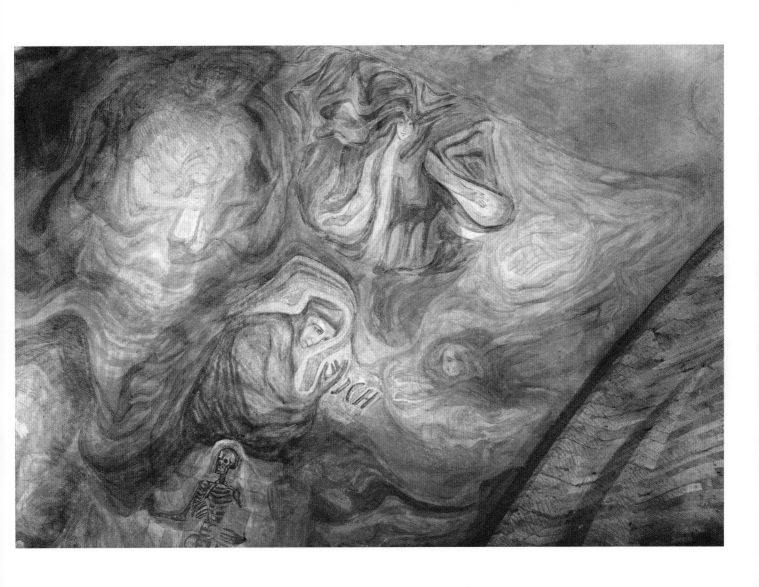

The 'Faust' motif with 'Flying Child'. Ceiling painting in plant colors.
Uvachrome photo: Emil Berger 1922.

Rudolf Steiner: The 'Egyptian Initiate'. Oil crayon sketch.

Rudolf Steiner: 'Athene-Apollo'. Oil crayon sketch

144

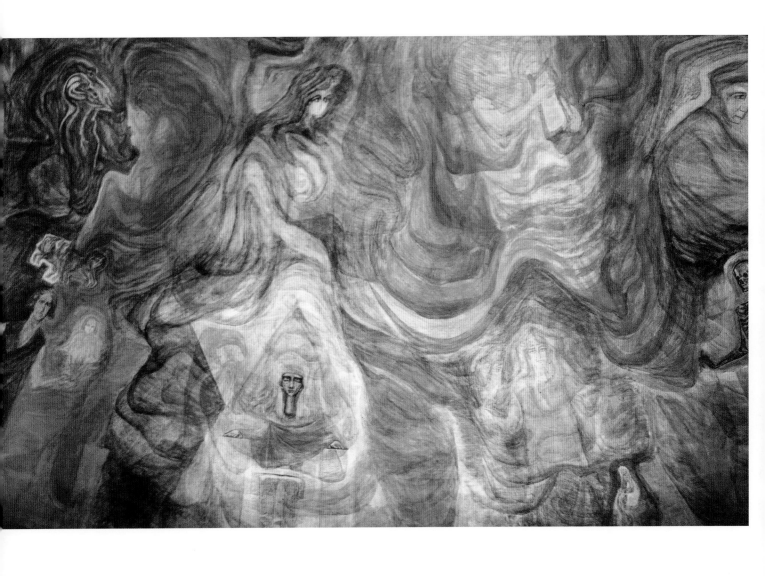

The 'Egyptian Initiate' / 'The Athene-Apollo' motif. Ceiling painting in plant colors.
Uvachrome photo: Emil Berger 1922

Rudolf Steiner: The 'Slavic Human Being' / 'The Germanic Initiate'. Oil crayon sketch

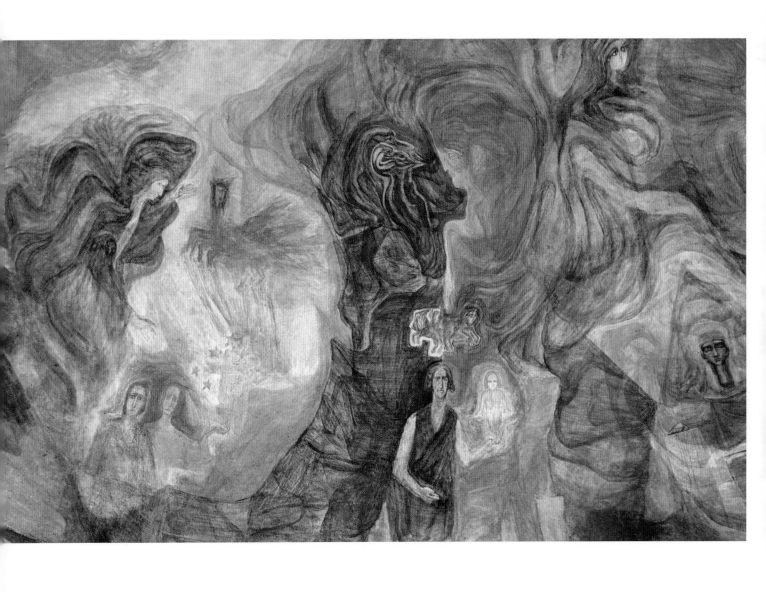

The 'Slavic Human Being' / 'The Germanic Initiate'. Ceiling painting in plant colors.
Uvachrome photo: Emil Berger 1922

Rudolf Steiner: The 'Representative of Humanity between Ahriman and Lucifer'.
The Middle Motif. Pastel sketch.

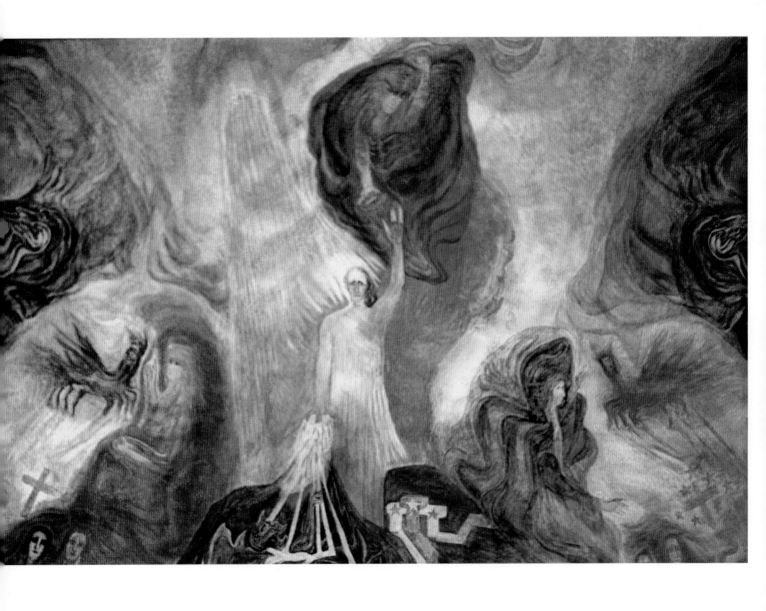

The 'Representative of Humanity between Ahriman and Lucifer' / The 'Slavic' motif.
Ceiling painting in plant colors.

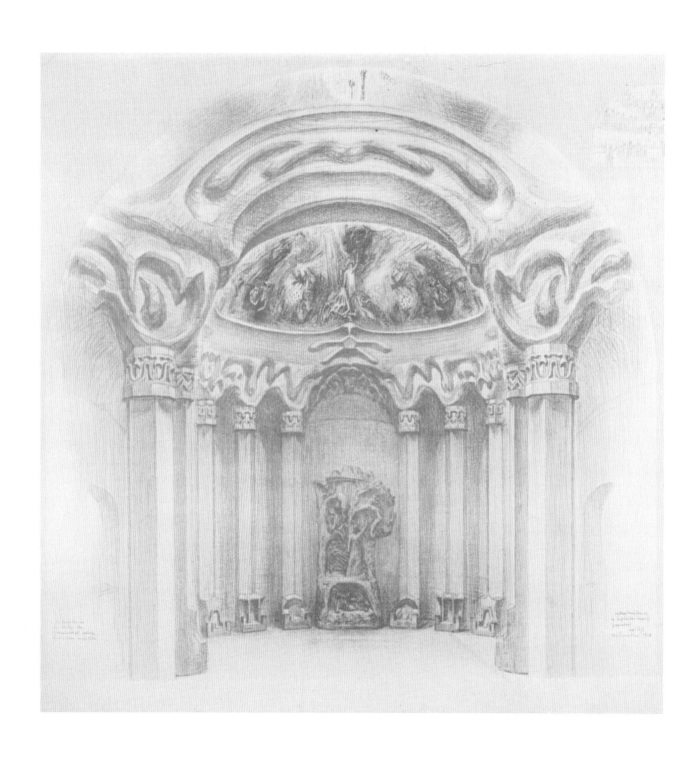

William Scott Pyle: View into the Small Cupola.

Small Cupola Studies of Gerard Wagner

A Note on the Small Cupola Motifs Painted by Gerard Wagner

Gerard Wagner came to occupy himself intensively with the small cupola motifs as a series in the latter part of the 1970s. While these dynamic pictures were shown to students and others, they were not exhibited more generally during his lifetime. They have a different character from his large cupola studies – corresponding to the inherent difference between the two cupolas themselves.

In content, Rudolf Steiner's large cupola sketch-motifs might be compared to the biblical Creation story of the Sistine Chapel ceiling of Michelangelo. The small cupola motifs present a very different perspective. Though evolution comes to expression in both cupolas, the small cupola is concerned with the inner development of the human being in different cultural epochs, past, present and future. It becomes immediately apparent that the individual motifs join together to an extent not found in the large cupola.

As can easily be imagined, the arching of the cupola dome would have been more pronounced for immediate experience in the small cupola than in the large cupola space – becoming of prime importance for the relation of the north and south sides. Any serious attempt to arrive at an artistic solution to painting the small cupola as a whole (in the 'counter-colors') would necessarily require taking this relationship into account. Limited to working on a flat surface, Gerard Wagner did not see a possibility of fully resolving the question of the north side. Ideally, his aim would have been to paint *one* comprehensive, panoramic picture within a domed space.

Gerard Wagner's approach to painting these challenging motifs out of the color was nothing if not disciplined. He consistently painted each one seven times, one after the other in different variations before proceeding to the next. To students at the time, his achievement was both humbling and awesome. – Could anyone ever hope to attain a comparable level of commitment and creative output? What more was left for others to do? The 'master's' response to such diffidence or self-doubt (a *cri de coeur*) seemed mildly indignant: So much more remained to be carried out beyond the 'little' he had accomplished himself. The field still stood wide open for further exploration…

– P. St.

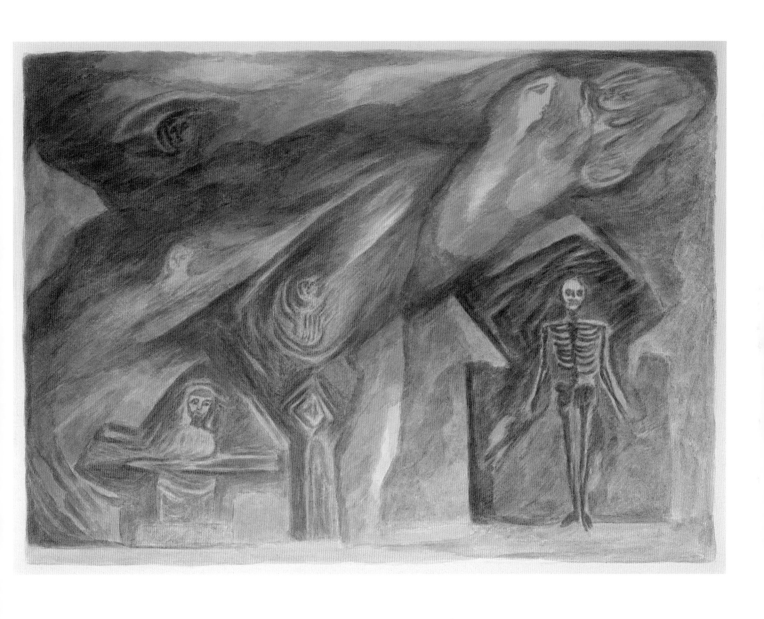

The 'Faust' motif with the 'Athene-Apollo' motif and the 'Egyptian Initiate'.
March 1977. Plant colors. 49 x 67 cm. (ca. 19 x 26 ins.)

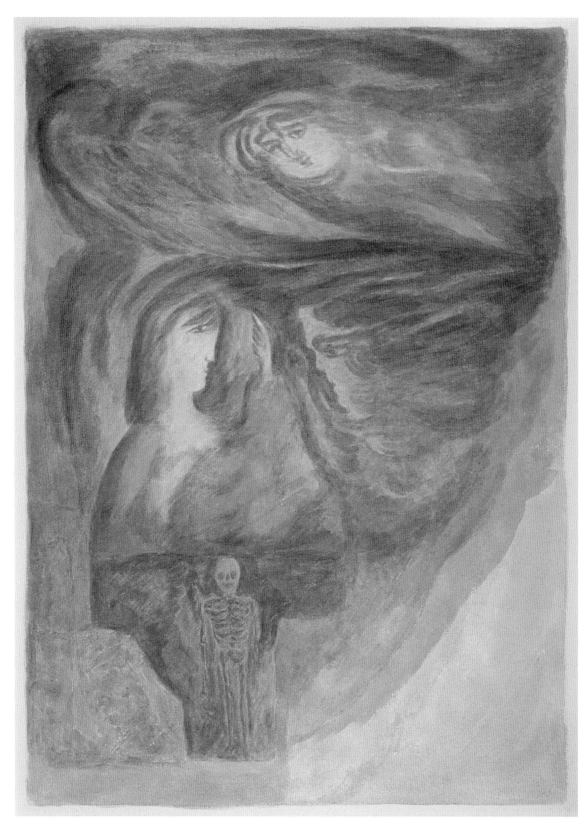

The 'Faust' motif. March 1977. Plant colors. 67 x 49 cm. (ca. 26 x 19 ins.)

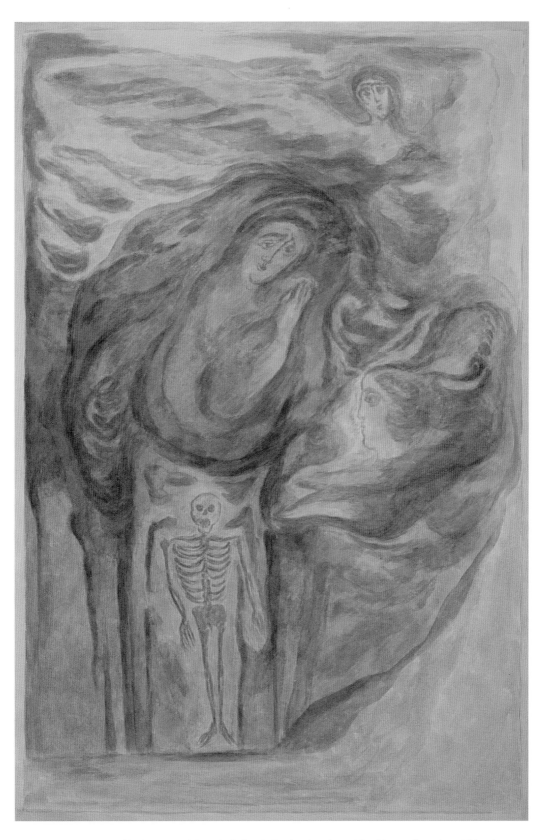

The 'Faust' motif with the 'Flying Child'. 1977. Plant colors. 67 x 49 cm. (ca. 26 x 19 ins.)

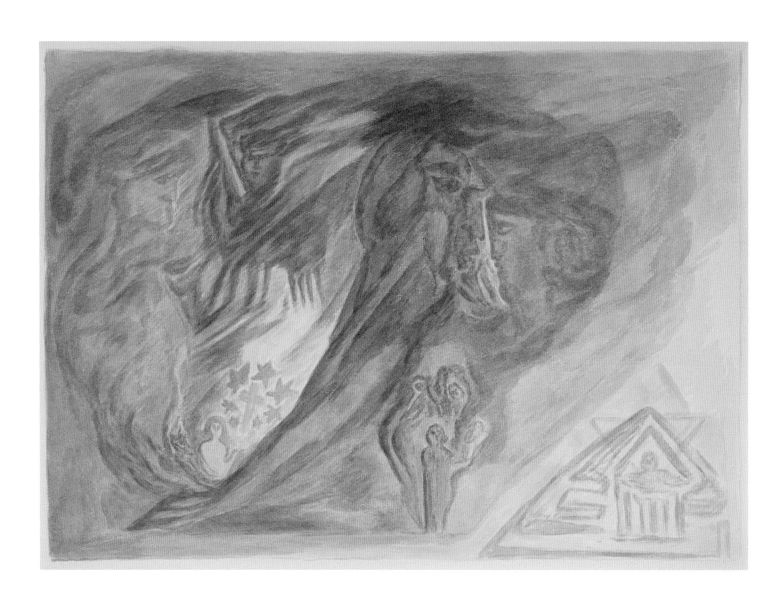

The 'Slavic Human Being' / the 'Germanic Initiate' / the 'Egyptian Initiate'.
March 1977. Plant colors. 49 x 67 cm. (ca. 19 x 26 ins.)

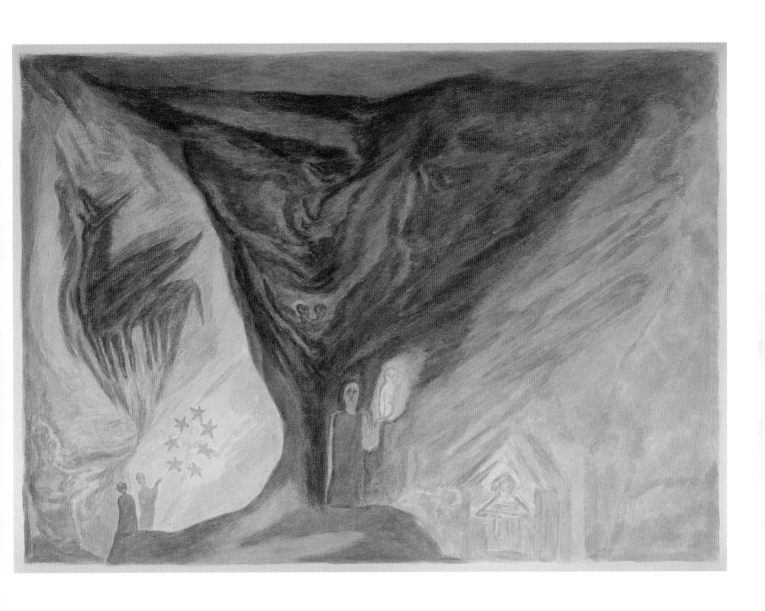

The 'Slavic Human Being' / the 'Germanic Initiate' / the 'Egyptian Initiate'.
February 1977. Plant colors. 49 x 67 cm. (ca. 19 x 26 ins.)

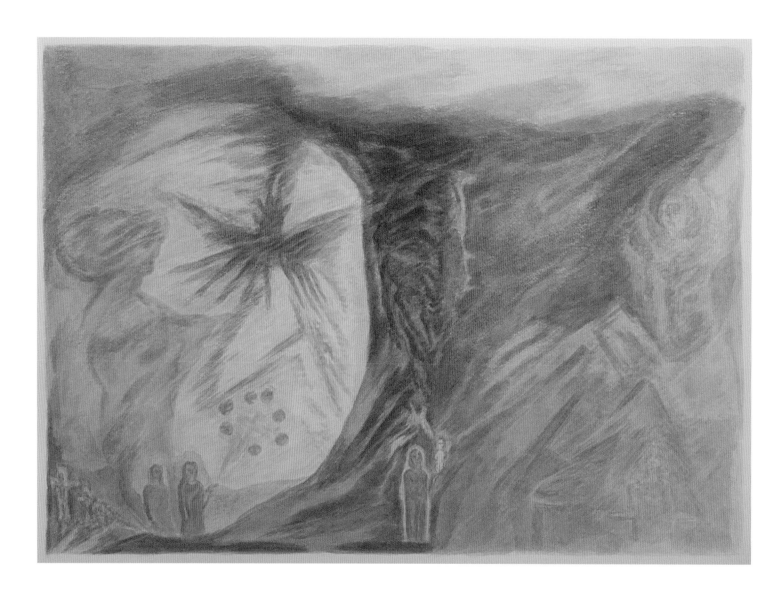

The 'Slavic Human Being' / the 'Germanic Initiate' / the 'Egyptian Initiate'.
February 1977. Plant colors. 49 x 67 cm. (ca. 19 x 26 ins.)

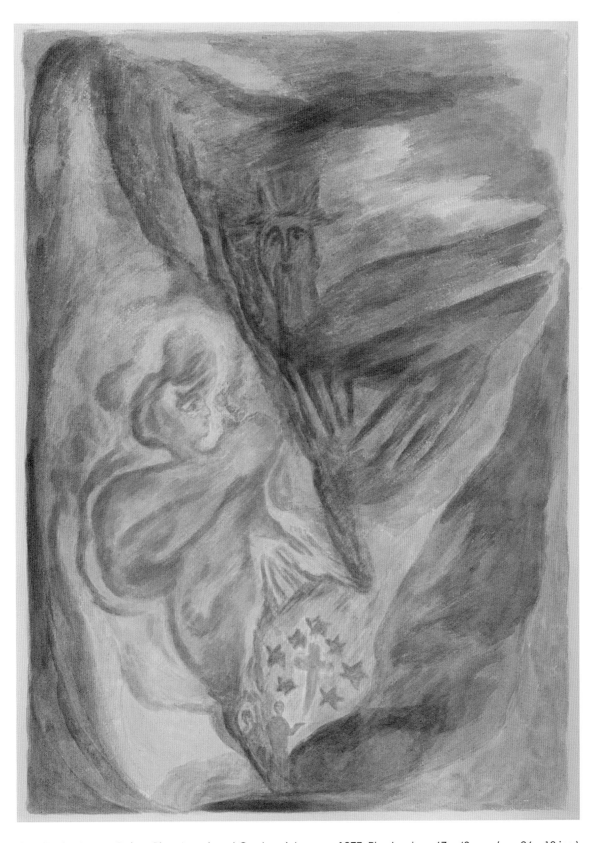

The 'Slavic Human Being, Blue Angel and Centaur.' January 1977. Plant colors. 67 x 49 cm. (ca. 26 x 19 ins.)

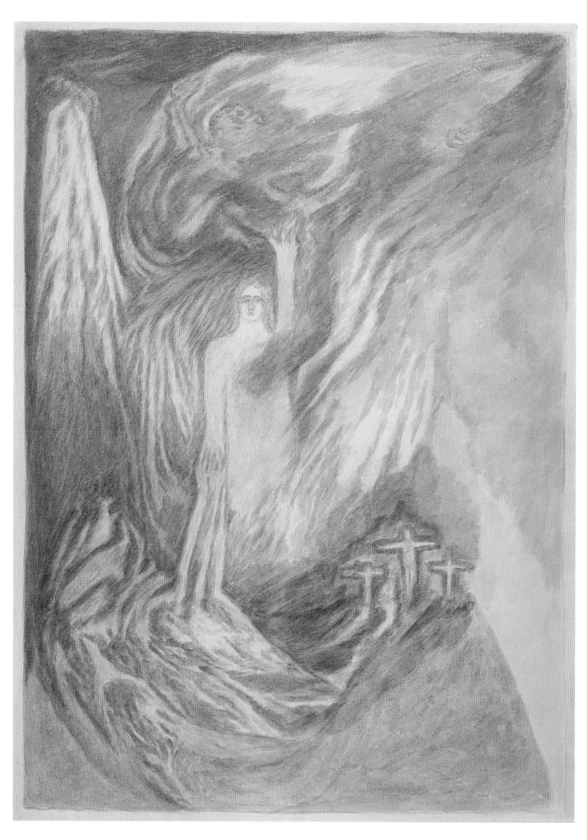

The Middle Motif. Nov./Dec. 1976. Plant colors. 67 x 49 cm. (ca. 26 x 19 ins.)

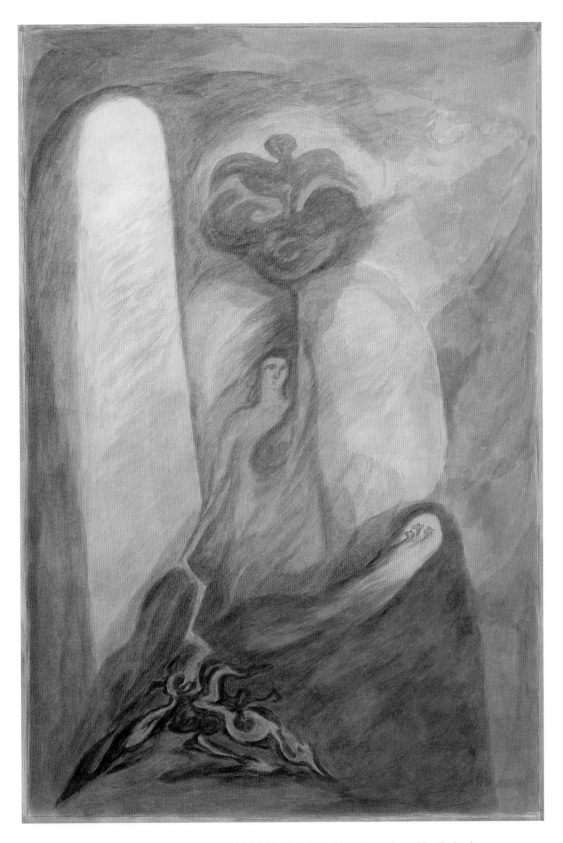

The Middle Motif. March1992(?) Plant colors. 99 x 67cm. (ca. 39 x 26 ins.)

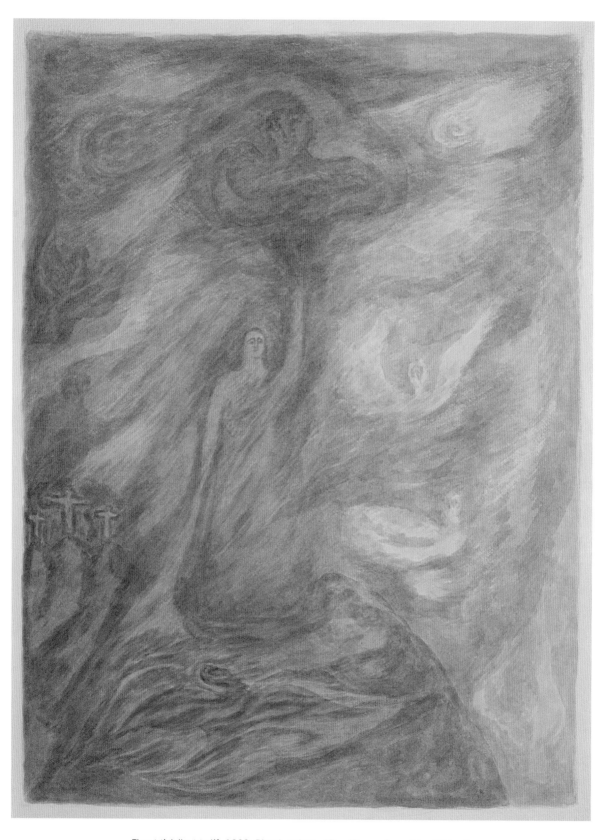

The Middle Motif. 1980. Plant colors. 67 x 49 cm. (ca. 26 x 19 ins.)

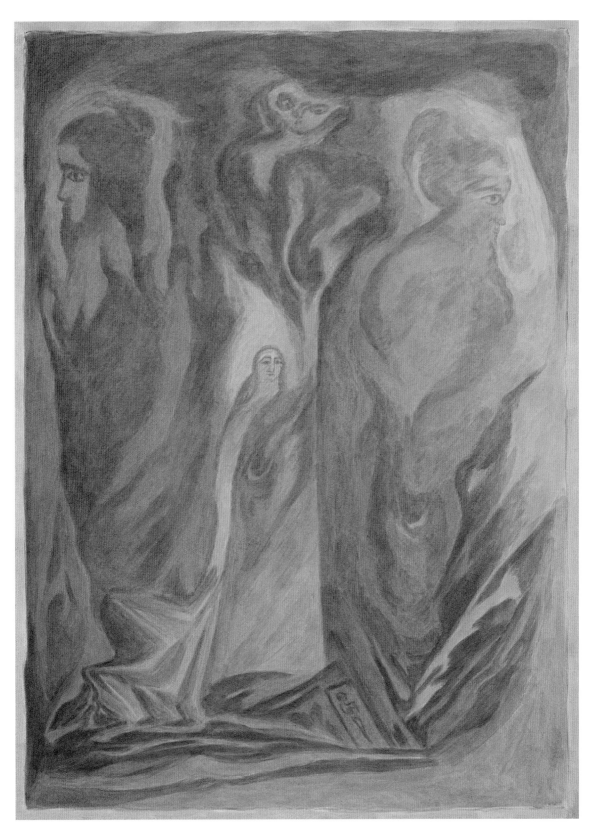

The Middle Motif. December 1980. Plant colors. 67 x 49 cm. (ca. 26 x 19 ins.)

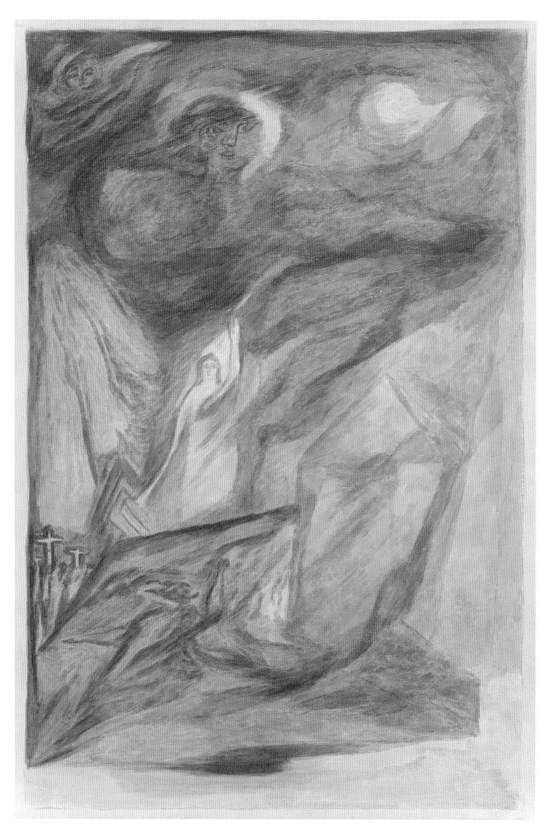

The Middle Motif. May 1977. Plant colors. 99 x 67cm. (ca. 39 x 26 ins.)

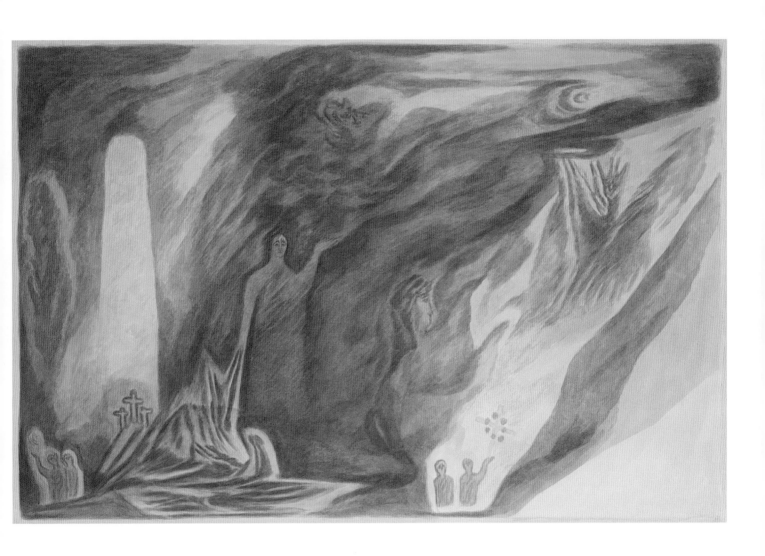

The Middle Motif / the 'Slavic Human Being'. April 1977. Plant colors. 67x 99 cm. (ca. 26x 39 ins.)

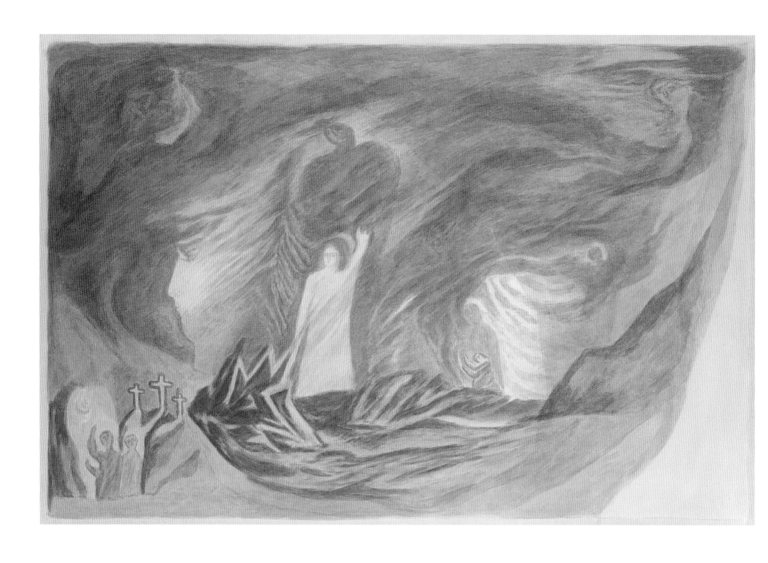

The Middle Motif / the 'Slavic Human Being'. April 1977. Plant colors. 67x 99 cm. (ca. 26x 39 ins.)

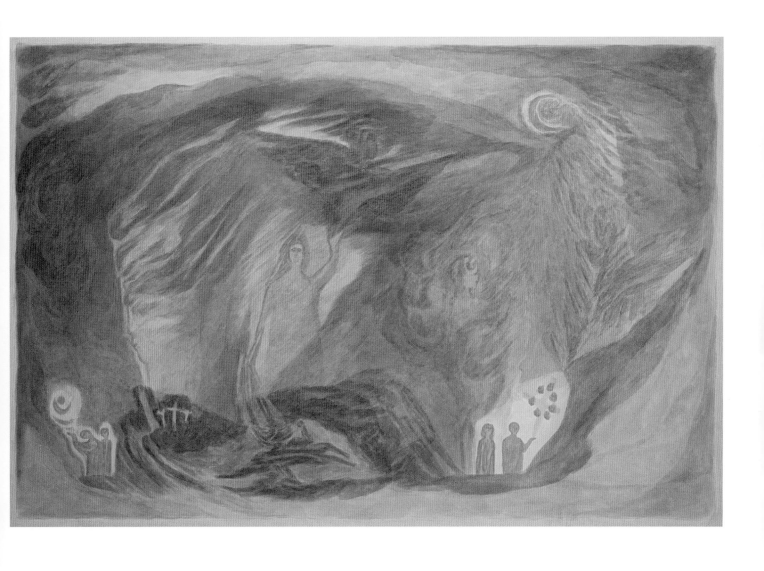

The Middle Motif / the 'Slavic Human Being'. 1977. Plant colors. 67x 99 cm. (ca. 26x 39 ins.)

The Question of the North Side:
'Counter-Colors' or 'Complementary Colors'?

The Original Task

Jeanne-Marie Bruinier declared that Rudolf Steiner had specifically told her, the north side of the small cupola was to be carried out in the 'counter-colors' *(Gegenfarben)* of the south side.[1] This has otherwise been thought to mean, in the complementary colors.

In Daniel van Bemmelen's words:

'She related how Dr Steiner gave her the task to paint the motifs on the other side in counter-colors. Not understanding the term "counter-colors," she asked whether he meant complementary colors, giving the example of red as opposed to green – to which Rudolf Steiner replied:

"No. You can see, I have not painted green in the small cupola. Green only occurs in the large cupola. There the basic colors are taken from the day-spectrum. In the small cupola the colors of the night-spectrum are to form the basis. There peach-blossom is in the middle, and around this the counter-colors group themselves – red/yellow on one side and blue/violet on the other side. You can already see how I began this when, on the left side of the Christ figure – in the counter-color of the blue angel – I painted the red angel on His right side. [The orange angel is meant, since elsewhere Rudolf Steiner refers to this angel as yellow/orange, and the active colors are covered by the expression *red*.] You can also study how I have given the red angel a different gesture. That was simply demanded by the color. In the same way, in painting the figures in the counter-colors on the other side, you should also give them a different gesture corresponding to the inherent nature of the colors."

Jeanne-Marie Bruinier was so startled by the exacting nature of this task that she said:

"I cannot do that, *Herr Doktor*." Sad at first, Rudolf Steiner then said graciously:

"Well, then paint it the way you can." That is the reason the other side was copied exactly.'

Feeling themselves similarly out of their depth, the other painters felt they would also be unable to do this. Thus Rudolf Steiner asked them to paint the north side simply as a mirror image of the southern half, in the same colors.

168

In painting the angel of the 'Slavic' motif in mirror image on the north side – in yellow and orange tones – Rudolf Steiner had, as stated above, already provided an example of what he intended. No longer painted in tones of blue, but in these quite different colors, this angel figure took on a quite different gesture. Here it is important to take into account that in previously painting the blue angel of the south side, Rudolf Steiner had allowed himself an exception color-wise: he had made use of cobalt blue, a mineral color, as well as plant color blue. This much warmer blue had no equivalent among the plant colors used in painting the cupolas.

It becomes necessary to give closer consideration to what actually distinguishes counter-colors from complementary colors.

Goethe's Color Circle

Starting out from Goethe's basic color circle we have, in Goethe's words:

'... an entirely sufficient diagram with yellow, blue and red set over against each other to form a triad; likewise the intermediaries, mixed or derived colors. This arrangement has the advantage that all diameters of the circle indicate without fail the physiologically demanded colors.'

As compared to these widely known physiological opposites, also referred to as afterimage colors, counter-colors can be recognized as being *lateral* rather than diametric opposites. Therefore cool yellow and cool blue, for example, relate to each other as counter-colors. They present us with a fundamental polarity in the sense of Goethe's color theory. Thus orange-

red and violet are counter-colors in the same way. They arise as the enhancement of yellow and blue, culminating in *Purpur* above (a near equivalent of carmine.) Green is to be understood as the 'watery' mixture of yellow and blue, while its complement (carmine), signifying the highest enhancement or intensification (*Steigerung*), is more properly related to a 'fire' process in the alchemical sense. With no lateral counterpart in the color circle, these two complementary colors have, in principle, no corresponding counter-colors. Nonetheless, as lateral opposites, blue-green and yellow-green, for instance, are still to be regarded as counterparts – as counter-colors in the full sense of the term. Here we see an instance of just how far counter-colors diverge from complementary colors.

It follows that such colors involve a single axis of symmetry corresponding to the symmetry of the human form.[2]

The colors of the usual prismatic or rainbow spectrum (with green in the middle) and of Goethe's counter-spectrum (with peachblossom in the middle), formed the basis for the background colors of the two cupolas. Thus Rudolf Steiner regarded green as belonging to the large cupola and as playing no real part in the small cupola, while peachblossom had its rightful place there.

Rudolf Steiner's Twelve-Color Color Circle

The 'g' for gelb (yellow) has been altered here to a 'y' for yellow

In response to a question put by Dr Willem Zeylmans van Emmichoven, in December 1920, Rudolf Steiner sketched a twelve-color color circle. This combined five peachblossom-related

colors (deep rose, pale rose, peachblossom, pale lilac and deep lilac) with the seven colors of the spectrum (violet, indigo, blue, green, yellow, orange and red) to form a new color circle. In doing so, Rudolf Steiner told him:

'The spectrum with its seven colors is only part of the whole, representing only what becomes visible in the sun-spectrum. To comprehend the spectrum as a totality, one has to draw a circle so as to have here the seven colors of the sun-spectrum, and on the other side the five peachblossom-related colors [*Purpurfarben*].'

Then he continued:

'These seven colors are perceived because there the astral body swims, so to say, within the colors. The peachblossom, however, is so delicate, that it hardly manifests itself in nature; but there the 'I' lives in the etheric. Peachblossom [*Purpur*] is precisely the color of the etheric.'[3]

Among the advantages of this twelve-color color circle – the single colors being indicated here by numbers and by their initial letters – is that it allows us to identify the counter-colors without difficulty. Listing them, we see that:

1.	*Deep rose*	stands	laterally	opposite	5.	*Deep lilac*	
2.	*Pale rose*	"	"	"	4.	*Pale lilac*	
3.	*Peachblossom*	"	"	"		--	(no other color)
4.	*Pale lilac*	"	"	"	2.	*Pale rose*	
5.	*Deep lilac*	"	"	"	1.	*Deep rose*	
6.	*Violet*	"	"	"	12.	*Red*	
7.	*Indigo*	"	"	"	11.	*Orange*	
8.	*Blue*	"	"	"	10.	*Yellow*	
9.	*Green*	"	"	"		--	(no other color)
10.	*Yellow*	"	"	"	8.	*Blue*	
11.	*Orange*	"	"	"	7.	*Indigo*	
12.	*Red*	"	"	"	6.	*Violet*	

This color circle also has its relation to the historical development of the sense for color in different cultural epochs.

Nowadays it is generally thought that the tapestry of the sense world spread out before us has always been the same as it is today. Even conventional science can demonstrate that this is not the case. The Greeks, for example, did not see the blue sky as blue, as we see it today. The Greeks had no concept of this blue of the sky. It appeared shadowy to them.

(Rudolf Steiner: December 30, 1921)

171

If the more youthful ancient Greeks of the fourth post-Atlantean cultural period were concerned mainly with the active colors, red and yellow, the more introverted and reflective human being of the Middle Ages felt drawn to blue. The age of the consciousness soul, our modern age, capable of infusing thinking with willing, will seek in blue the quality of red, thus gradually approaching via indigo the mysterious color violet. It thus becomes comprehensible that a widening of consciousness accompanying spiritual scientific knowledge will increasingly awaken an experience of those color nuances lying between violet and red. Thus the further development of human consciousness is reflected in the extension of Goethe's color circle indicated by Rudolf Steiner above.[4]

*

Hilde Boos-Hamburger gives us what has come to be the prevailing view, in the following account of how the north side of the small cupola was to be carried out:

'Dr Steiner painted [besides the central motif and the entire right side] a large part of the symmetrical Slavic period to the left: the orange angel, the Slavic human being with double and centaur. [It is highly unlikely that Rudolf Steiner painted more than the orange angel on the north side. – Ed.] The remaining left side was copied by our colleagues to correspond with the original of the right side. Dr Steiner said at the time, he wanted to paint the blue angel in orange on the left side, in order to show how, with a real understanding of how to live in color, this figure would necessarily have to become quite different in form and gesture. An altogether impressive example from the point of view of comprehending the formative power of color. Afterwards, a few friends related – I did not learn of it directly – that he had suggested, the entire opposite side of the cupola should be carried out in the complementary colors. Understandably, the painters did not feel capable of this, and it thus came to a symmetrical copying of what Rudolf Steiner had painted. I don't know either, who would be up to such a task today! After all, it could not be merely a straightforward matter of painting what was there in the counter-colors. For, out of the inherent "lawfulness" of the colors themselves, a new configuration of form would have to emerge. Hence, not only the same Lucifer in green, but *refashioned* out of the green! Ahriman in a certain degree of lightness! Apollo in dark violet, and so on; the skeleton, whitish in front of the throne!'[5]

Here, understandably perhaps, no particular distinction is made between complementary colors and counter-colors. Rather are they conceived as interchangeable terms.

However, as shown above, there is an evident difference. We thus need to take the standpoint of asking: Should Lucifer not appear in blue and violet tones (while assuming a correspondingly different form and gesture) – instead of in green? Would Apollo not require being painted in a shining, light blue counter-color (similarly changed in form) – rather than in dark violet?

It becomes apparent that, unlike complementary colors, counter-colors do not involve in the same way a reversal of light and dark. Counter-colors may be felt as harmonious 'equivalents' that enhance each other without involving opposition or mutual contradiction.

A Higher Unity

Almost a century later, an aura of mystery still surrounds Rudolf Steiner's intentions for the paintings of the small cupola. Tragically lost to future generations as a result of the fire, this unique work of art can only be imagined today with the help of existing photographs – supplemented perhaps by descriptions such as the following:[6]

'At the request of the painters, Rudolf Steiner painted in the small cupola himself. What movement, what glowing life swept like a storm through the streams of color, veiled one over the other, weaving through everything and creating un-spatial spaces! Out of this becoming, out of these flooding waves, the countenances of the various entelechies looked out. They were characterized with reddish lines, the features mostly asymmetrical and far removed from the classical beauty of the Greeks, yet beautiful through the earnest appearance of truth. A chiaroscuro arose which did not serve sculptural form, but expressed the conflict between the beings of light and the beings of darkness. Cosmic spaces opened up through color perspective. One believed one heard the converse of the hierarchies, and yet in this thunder there was peace. The small cupola was warm, festive and harmonious in its effect.'

In the small cupola studies of Gerard Wagner included here, giving a hint of the north side along with the motifs of the south side, we are granted a renewed sense of this *Zukunftsmusik*.

The reciprocal relation of the counter-colors of the south and north sides would seem to point to a higher unity.

– Peter Stebbing

[1] See Daniel van Bemmelen: *Rudolf Steiner's New Approach to Color on the Ceiling of the First Goetheanum.* St George Publications 1980.

[2] This is at the same time also the underlying principle in the plan of the first and second Goetheanums. In Rudolf Steiner's words: 'Here for the first time a building with a single axis of symmetry has been attempted.' On this point, Margarita Woloschin writes in *The Green Snake / Life Memories* (p. 301-302): 'It was a matter of two intersecting circles. Seven columns on each side carried the mighty architraves of the larger space, which was to be the auditorium. The smaller architrave of the stage area was supported by twelve columns. The amphitheater-like incline of the auditorium required the seven columns to become increasingly higher toward the proscenium and correspondingly thicker. The sculpture of the capitals, of the bases and of the architraves underwent a development, so that in this building only the right (south side) and the left (north side) mirrored each other, overcoming the static nature of the closed form and bringing about an experience of movement, of ongoing development.'

[3] '*Purpur*' and '*peachblossom*,' though closely related, need in some instances to be distinguished from each other. '*Purpur*' is then an intense middle red, '*peachblossom*' a pale carmine.

[4] See Rudolf Steiner: Lecture of December 29, 1912 held in Cologne. CW 142. – As also Rudolf Steiner: Lecture of November 5, 1916 in Dornach. CW 172.

[5] From Hilde Boos-Hamburger: *Die farbige Gestaltung der Kuppeln des ersten Goetheanum.* R. G. Zbinden Verlag, Basel 1961.

[6] From Margarita Woloschin: *The Green Snake / Life Memories* (p. 310-311). Floris Books, United Kingdom 2010.

III.

THE COLORED GLASS WINDOW MOTIFS

Rudolf Steiner: A preliminary sketch for the middle motif of the Red Window.

Rudolf Steiner: Sketch for the Red Window. Side panels.

Indications of Rudolf Steiner
for Engraving the Window Motifs

Assya Turgenieff

From a training early in my youth with the old Belgian etching master *Auguste Danse*, questions of light-and-dark had remained with me that I hoped to submit to Rudolf Steiner. The opportunity to do so did not present itself until the year 1916. Out of this a collaborative work arose which led to the etching of the window motifs. At Marie Steiner's request I attempted to write down my recollections of this.

The Goetheanum window motifs counted as an area in my study of the art of light-and-dark that I long thought I would have to relinquish for myself. Earlier, in 1913, when I expressed the wish to work in Dornach, Rudolf Steiner had designated me for the forthcoming glass work. Thus I had occasion to see his original sketches from time to time.

Swiftly noted down, these were almost childlike in their awkwardness, and yet the closer one scrutinized them, the more grand and unattainable they became – and the more an awareness grew of one's own inadequacy in regard to these sketches. Carrying out the windows for the second Goetheanum many years later, I experienced still more specifically how, with any particular sketch, one discovers something new every day – over a period of months – thus having to review one's work again and again, while still not necessarily approaching the original.

Only when the completed windows had already been installed for some time in the first Goetheanum did the moment seem opportune in which to make up for my omission regarding the windows. By then, my attempts in drawing under Rudolf Steiner's guidance had begun making headway in seeking new creative possibilities in the art of light-and-dark. I hoped to learn new things in connection with the window motifs, and came to the decision to ask Rudolf Steiner whether I might make an etching of the red window. 'Why do you not want to do them all?' he asked. 'Properly speaking, these motifs are *meant for etching*. It would be a good thing to etch them. However, you may introduce *nothing* of yourself into this work.' These words had special significance for me, in consequence of having already experienced what other artists had done in working on these motifs.

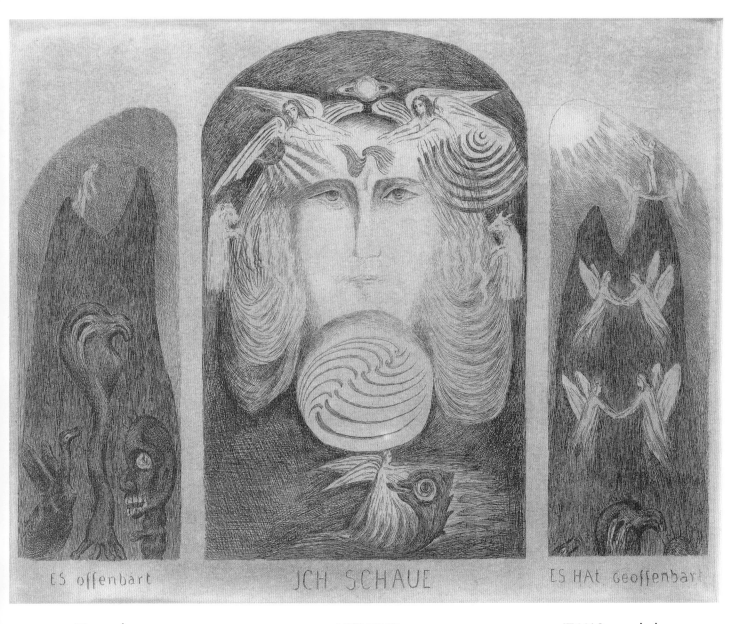

ES offenbärt
JCH SCHAUE
ES HAt Geoffenbart

IT reveals
I BEHOLD
IT HAS revealed

The Red Window in the West

I made a preliminary drawing (of the red window) and Dr Steiner looked at it for a long time, took a pencil and began drawing into it. First he simplified a few details in the lower motif of Michael and the Dragon. – I tried to intercede for them. 'You have done it accurately, I know, but I want to make a change,' he said. With this correction, the lower part harmonized better with the total composition. In addition, he altered the line of the eyebrows, drew a furrow between them and blurred the contour of the crescent form in the neck region. (It seems to me important to mention these changes of Dr Steiner's.)

'*Herr Doktor*, are these three animals human thinking, feeling and willing?' someone inquired who stood by, looking on.

'There's no need to make a fixed scheme out of it,' he replied, 'with that you block access to these things. These "creatures" are realities. They are not abstract thoughts.'

That was a warning. Hence, I asked whether something should not be written underneath the picture. He thought it over – and wrote under the drawing:

IT reveals I BEHOLD IT HAS revealed

The free and bold direction of the strokes in the middle motif of the original sketch seemed to me especially effective. So I copied them in the etching as best I could, and took the first trial print to Dr Steiner.

'The direction of the strokes here is not at all suitable for an etching,' was the first thing I heard him say. 'It would be right for painting. In black-and-white one would have to take a different approach. The direction of the strokes within the surface may never be altered in such a way as to bend it; they have to run uniformly in one direction. For example, from above downwards, or diagonally, or horizontally. You can also cross the strokes, but every surface has to retain its own character. What is of a spiritual nature, these stars for example, or other shapes' – he pointed to my drawing based on the 'Birth' motif – 'have to be quite sharply delineated, as though cut out of the background. Where the soul element is concerned,' – he pointed to the angel – 'one has to weave the forms together with the surroundings in soft transitions, allowing them to merge into each other.'

I went about these new tasks uncomprehendingly. I endeavored to carry them out in the subsequent etchings of 'Birth' and 'Death,' but it did not come off. The various surfaces appeared monotonous, without a proper relation to the whole, and the sharply contoured stars seemed clumsy. Dr Steiner concurred with me in my dissatisfaction and promised to occupy himself once again with the question of how to achieve the art of light-and-dark – he did not yet know the answer.

Having reached deadlock, I could not decide to make a start on the next motifs of the green window. And so time passed, until I heard from a friend that Dr Steiner had spoken with great enthusiasm about a particular modern artist. – Hoping for a clue for my work, I stopped Dr Steiner in order to learn the name of the artist.

'You should never think,' he said smiling, 'that if I find something *beautiful*, that it is also *right* on that account. Those are two different things. One can always have a standpoint from

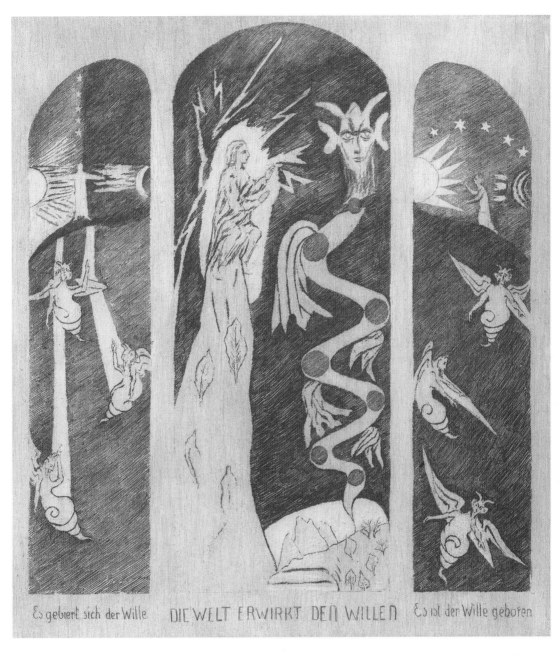

Es gebiert sich der Wille DIE WELT ERWIRKT DEN WILLEN Es ist der Wille geboren

The will gives birth to itself THE WORLD FORGES THE WILL The will is born

The Green Window in the North

The Kabiri, drawing by Rudolf Steiner. (ca. 8¹/₂ x 10¹/₂ ins.)

which to find something beautiful: after all, these things are relative. But there is nothing you need learn from this artist. – On the other hand, I now know,' he continued, 'I now know for certain, how one has to work in light-and-dark. – You must execute the whole picture with the strokes going in *one* direction only. And the direction should be oblique, like this: – (He indicated it with his hand, from above right to below left). That goes for everything carried out in light-and-dark. It is the right procedure. Now I am sure of it,' he repeated.

To avoid being misled as a result of standing opposite to him, I placed myself next to him: 'If I work in this direction,' I said indicating it on my hand, 'it will come out in reverse when printed.'

'For that reason, you will have to work the other way around on the plate, so it comes out right,' was the answer. 'Because, what matters is not you, but the final effect. The observer has to have it that way. Study the drawing I made of the *Kabiri*. It tends in the direction I have in mind, though not carried through fully, as you will notice yourself. There are mistakes in it; but one can already see what is meant.' Thus I obtained a photograph of this drawing from the owner. (*See illustration above.*)

Dr Steiner had shown it to me about a year before, without as yet knowing himself, that here he had discovered an altogether new way of drawing. For, since then he had had me make a number of attempts which stood in contradiction to the new approach. This was a further example of how, with Rudolf Steiner, creating something preceded knowledge in artistic matters.

Apart from the lively character of this sketch of the Kabiri, there is something in it that I should like to call an 'airy sculptural element,' something that projects the figures onto the two-dimensional space as an outcome of light and shadow. They retain their pictorial,

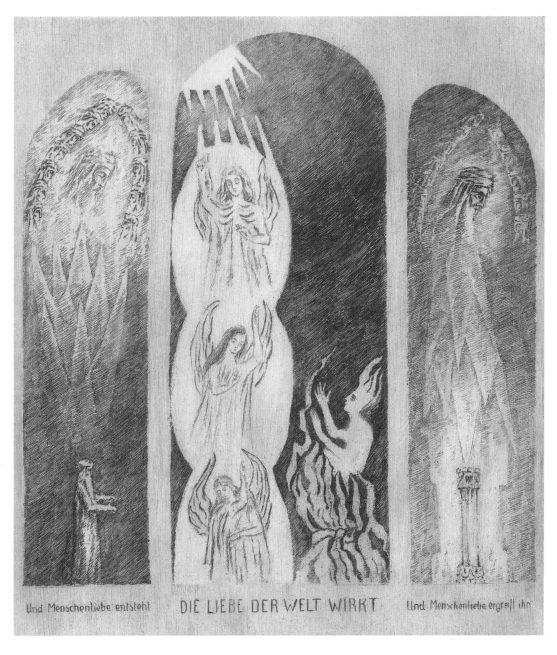

And human love arises THE LOVE OF THE WORLD TAKES EFFECT And human love takes hold of him

The Green Window in the South

Sketch for the Spirit of Gravity (detail). Sketch for the Spirit of Gravity + Moons.

surface character, remaining flat, while the surface itself is as though broken through to a non-dimensional aerial perspective. In this way, this manner of drawing calls forth a new impression of what is three-dimensional, emphasizing precisely the flatness of the picture. And the places where the strokes deviate from the general diagonal direction do indeed appear as errors.

I had still not as yet become fully aware of all this in making a start on the 'Spirit of Gravity' – a motif of the green north window. But the confidence with which Dr Steiner spoke about this new approach reinforced in me the hope that something could be discovered along this path.

At first, this etching came off as dull and insensible in my view: only later did I understand what the errors were. In spite of my objections, Dr Steiner was very satisfied even so, and I was to complete the further etchings in the same manner, to the best of my ability.

I should like to mention some other remarks of Dr Steiner's from earlier on, in connection with the preparatory drawings for the window etchings I brought him to correct at various times. On these occasions he also provided the further inscriptions to go under the etchings.

There was not really much to be said about these drawings. Endeavoring to leave aside any residual ability acquired in earlier days, I had as yet nothing new to replace it with. Dr Steiner looked only to see whether light-and-dark were properly distributed, making a few small alterations. Occasionally, he gave a new sketch.

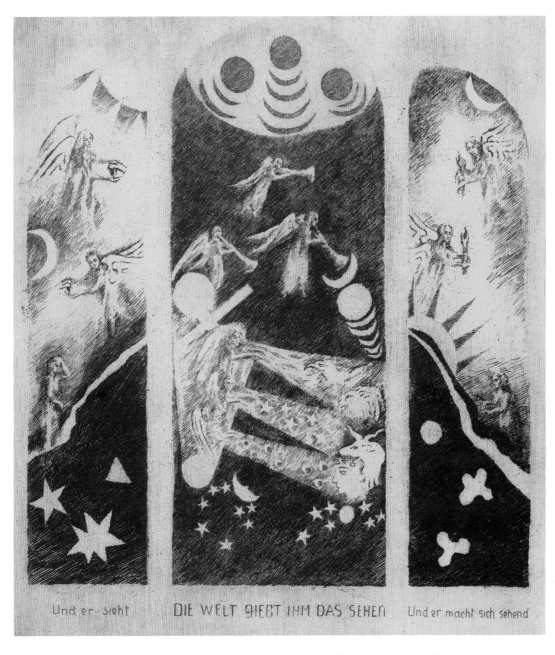

And he sees THE WORLD GIVES HIM SIGHT And he develops seeing

The Blue Window in the North

Thus he provided a sketch for the 'Spirit of Gravity'. (*See illustration in pencil.*) 'In your version, he has not turned out well,' he said, 'the expression is not right; he looks too jolly. This is a great lord; he has to have dignity and solemnity. These forms behind [i.e., seen to the right of] the human being are two aspects of the moon, the one shimmers, with the other there are flames. [*See the two side panels of the green window in the north*]. One strengthens the memory, the other works on the instincts.' – He noted down these forms in pencil more clearly as well.

Much can be learned in comparing these two heads of the 'Spirit of Gravity,' drawn by Dr Steiner about five years apart from each other. The first, indicated with difficulty, almost childlike in its awkwardness, and drawn schematically, yet large and expresssive, like a hieroglyph of the 'Spirit;' the other an image dashed off effortlessly in complete certainty and mastery of form. What can only be guessed at in the first, has come to full expression in the second. In his blackboard sketches carried out during lectures, it can likewise be seen how great Rudolf Steiner's mastery in drawing had become over the years.

'I do not know why trees were made on these rocks instead of leaves,' he said, with regard to this window motif, 'after all I drew leaves – proper leaves.'

I had considerable difficulty rendering the figure of the human being appearing in the main green south window, as though burning in a kind of fire-bush. Nothing about it seemed to conform to the laws of nature – and it looked like a frog. 'Well, if one sits in a fire-bush,' Dr Steiner said, 'it is permissible to look like a frog.'

For the column in the side motif, he indicated that it should have a form of light surrounding it, 'In both cases the light comes from above, in the left as in the right side motif,' he said, 'only here it is displaced more into the below.'

In the blue window in the south, an angel figure emerged only slightly from the light background; the hands stood out as indistinct shadows only, being insufficiently etched. I did not correct it and waited to see what Dr Steiner would say about it. 'That is very beautiful,' he remarked, 'this place has come off especially well.'

In the same window, the forms in the upper part of the middle motif had to be made as light as possible and quite distinct, since there it is a matter of the pure spirit world.

I did not know what to do with one figure – that of Gemini – in the zodiac motif. It seemed not right to me. Dr Steiner thought about it and showed me how the hands were to be drawn extended a little. 'These gestures are not to be thought of in connection with the sounds of speech, he added in reply to my question, 'they are pure will-imbued movements.'

Dr Steiner made a new sketch also in connection with the rose window in the south, of the spirit figure that inclines itself over the sleeping human being: 'It may not be too personal, too lively in its effect,' he said, 'It has rather to be diagrammatic, an image that is completely objective.' [*See pencil drawing.*]

When the question of authorship for the publication of the window etchings was brought up, Dr Steiner told me among other things: 'It is good if people make further use of the impulses given at the Goetheanum: they are there for that purpose. For example, if people

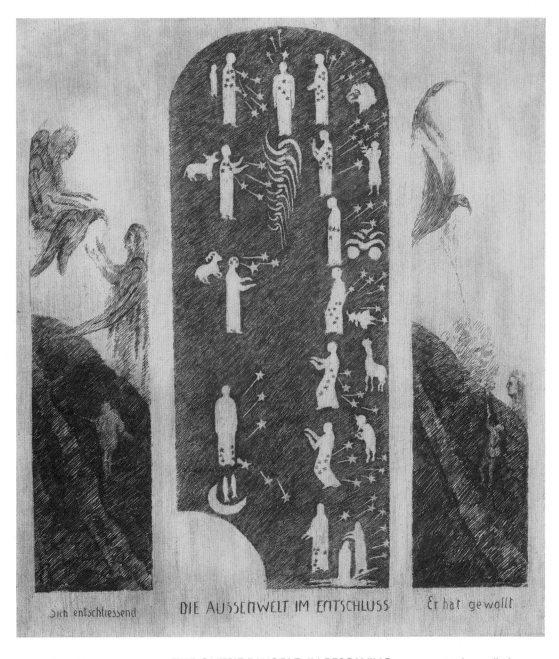

Resolving THE OUTSIDE WORLD IN RESOLVING He has willed

The Blue Window in the South

The Rose Window in the south: Detail study for the middle motif.

allow themselves to be inspired by the 'Group Statue,' the sculptural group in wood. Only, they must declare by some means or other, that they have derived the impulse from the Goetheanum, otherwise it amounts to plagiarism.'

He expressed himself, at the same time in opposition to the 'vain custom' of inserting signatures on the work of art itself. Any given text had rather to be engraved on a little copper plate and put up under the picture to the left. Such a signature or caption could also be added above, either to the left or the right, he suggested, but never underneath to the right, as is the usual practice.

After the window motifs had been completed, I asked Dr Steiner whether he wanted to give me further indications, for a new work. 'You now already have enough, to make progress on your own,' he responded, 'You have all you need in that regard. Later, you will come to understand why I gave you this technique for light-and-dark.

On account of conditions brought on by the War, it took an extended period of time before the completed series of etchings could be published.

In September of 1924, during his final course, the Dramatic course, it was still possible for me to obtain Rudolf Steiner's authorization for the exhibition of this series. His frequently promised lecture on the window-motifs never came about.

From Rudolf Steiner: *Die Goetheanum-Fenster, Sprache des Lichtes*. CW K 12. Textband. Dornach, Switzerland. Rudolf Steiner Verlag 1996.

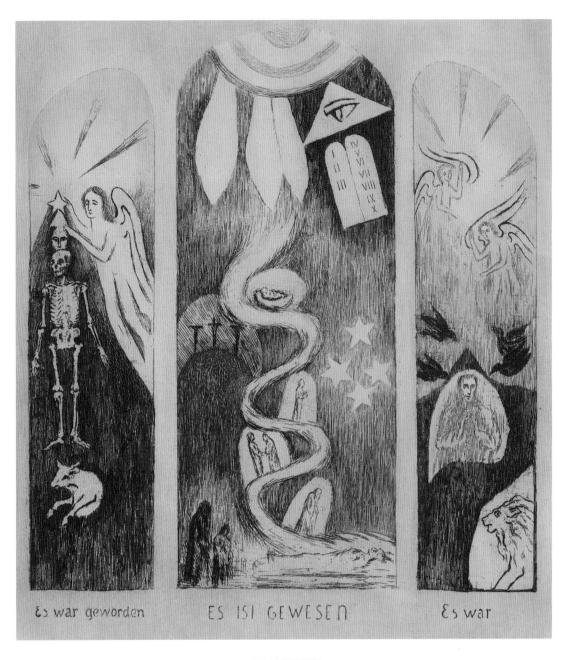

Es war geworden ES IST GEWESEN Es war

It had become IT HAS BEEN It was

The Violet Window in the North

On the Windows of the First Goetheanum

Rudolf Steiner

The Red Window in the West

In contemplating the motifs of this window, you should not think it is a matter merely of symbolic figures. In this large window it can already be recognized that what is created in these windows is nothing other than what results from Imagination. There are mystics who employ superficial aphorisms and peculiar ideas – continually explaining that the external physical sense world is maya, an illusion. People often come up to me and say, so and so is a great mystic, since he is always declaiming that the external world is maya. There *is* something about the physical human countenance that is maya, that is indeed a lie, that is in truth something else.

What comes to light in this window is not something symbolic; a being is envisioned that does not appear for the spiritual observer as it would for sense perception. The larynx is in reality the formative organ for the etheric. As physical larynx, the larynx is certainly maya, and what is given in mere physical sense observation is not reality. What stands behind it spiritually? Spiritual facts are whispered into the ear of the human being on the left and right, and these are cosmic secrets. Thus it can be said: the bull speaks into the left ear, the lion into the right ear. Whether one wants to present such a thing as a motif in a picture, or in words, one can only formulate in words the same as what is already there in the picture itself. However, it has to be borne in mind that such an image can only be understood if one lives within the worldview out of which it proceeds. Without standing in a living way within Christian feeling and perception, a person will also not be able to bring understanding to the pictorial representations brought forth in Christian art.

The artist undergoes much in entering into such a way of seeing; but an experience of this kind is not to be carried over into abstract thoughts, otherwise it will at once begin to fade.

From a guided tour through the Goetheanum for participants of the Summer Art Course, August 25, 1921. In *Der Baugedanke des Goetheanum.* CW 289/290.

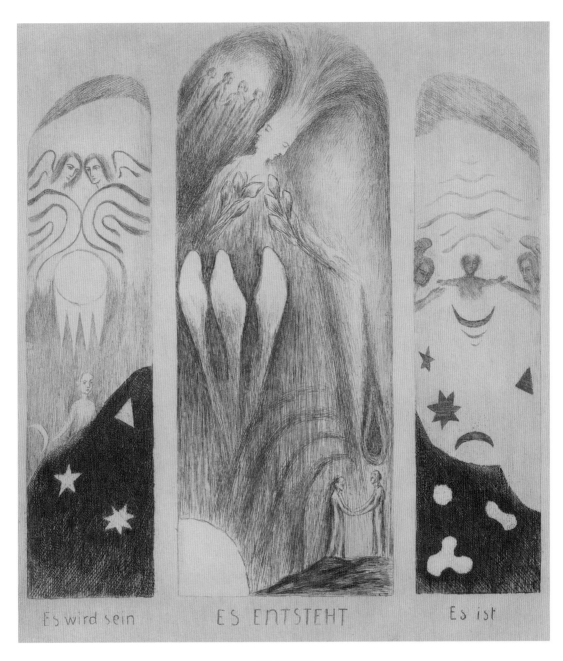

Es wird sein ES ENTSTEHT Es ist

It will be IT ARISES It is

The Violet Window in the South

The Blue Window in the South

Proceeding with artistic feeling in this way, one may venture to elaborate on the motifs in these windows. I cannot of course go into detail, but I refer you to the blue window, where you see the human figure in the two wings, in two situations. In one instance, all those attributes are there that live in the hunter in taking aim at the animal he wants to shoot down. Etched out of the glass, this whole inner aspect is depicted; you find everything poured into what is figural. At a certain stage of inner experience, one can do nothing other than give shape, for instance, to what lives as passion within. And if you imagine the whole picture metamorphosed further, you then have, in the right wing, the human being advancing from the intention to shoot the bird down, to carrying out the deed. He has taken aim and shoots. What has taken place undergoes a transformation and is etched out of the glass in the right-hand window, first yielding the work of art in combination with the sunlight. Each of the windows could be dealt with in a similar way. However, it is not a matter of approaching them with the art of interpretation, but of surrendering oneself in feeling to what is there on the glass. In attempting to interpret, one overlooks the actual artistic intention.

From the lecture of October 16, 1920, in: *Der Baugedanke des Goetheanum.* CW 289/290.

The Violet Window in the North

It is obvious that a person can understand a work of art only in so far as they live in the whole spiritual stream from which the work of art has arisen. Thus, only those will be able to understand our ideal central figure with Ahriman and Lucifer who stand within this stream. But this is something that works of art have had in common throughout history; they are comprehensible only to those within the spiritual stream in question. Solely in belonging to a spiritual stream can a work of art be genuine. Integral to a work of art is its spiritual orientation. Just as a person having an understanding of the *Sistine Madonna*, or let us say, the *Transfiguration* of Christ by Raphael, must know something corresponding to the spiritual stream out of which the picture arose, so anyone viewing our building has naturally to have within them, in heart and mind, what belongs to our spiritual stream. With this present in the soul, the work of art is able to speak of its own accord. There is then no need to write anything underneath by way of explanation, a title for instance.

In looking at one of our glass windows and seeing below a kind of coffin with a dead person in it, and farther up, on a winding path, an old man, for example, a youth, and then

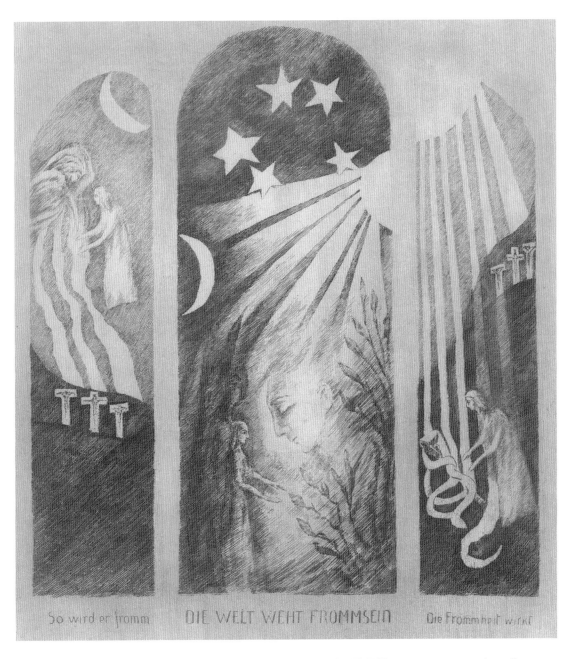

Thus he becomes devout THE WORLD WAFTS DEVOUTNESS Devoutness takes effect

The Rose Window in the North

a virgin and also a child – having taken up our spiritual science, it will be possible to recognize the 'retrospect.' One sees one's earthly life in retrospect immediately after crossing the threshold of death. It is, of course, necessary to know this. Then, however, the picture becomes effective by virtue of what it contains, just as the *Sistine Madonna* is effective for one who is familiar with the Christian story.

<hr />

From the lecture of January 9, 1916, in: *Der Baugedanke des Goetheanum.* CW 289/290.

The Rose Window in the South

Given that the motifs here in the glass windows are partly motifs that arise as images of the soul-life, you can see that the attempt has been to actually metamorphose the human body. – Look for example at the rose-colored window here. In the left wing you will see how something emerges like the west portal of the building; in the right wing there is a kind of head. On the left you see a human being resting on an incline, looking toward the building, and on the right, another figure stands looking toward the human head. With that, nothing speculative or mystical is intended, but rather an immediate inner experience. This building could not arise otherwise than in sensing in a mysterious way within it, the form of the human head. And out of an organic power on the one hand, and the form of the human head on the other, there results, in terms of feeling, the configuration of the building. Hence, the human being sitting on the incline observes inwardly the metamorphosis of the building: in one instance as a human head, in another as the building, manifesting outwardly. With that, if I may say so, a motif is given that embodies an inner experience.

<hr />

From a guided tour through the Goetheanum for participants of the Summer Art Course, August 25, 1921. In: *Der Baugedanke des Goetheanum.* CW 289/290.

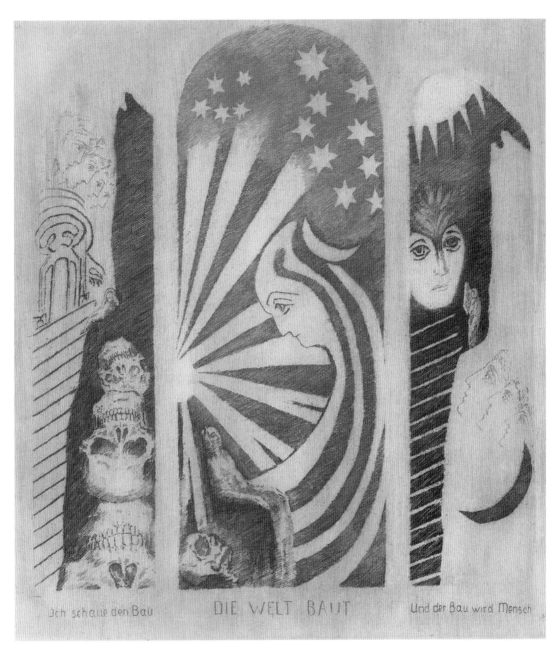

Ich schaue den Bau DIE WELT BAUT Und der Bau wird Mensch

I behold the building THE WORLD BUILDS And the building becomes human

The Rose Window in the South

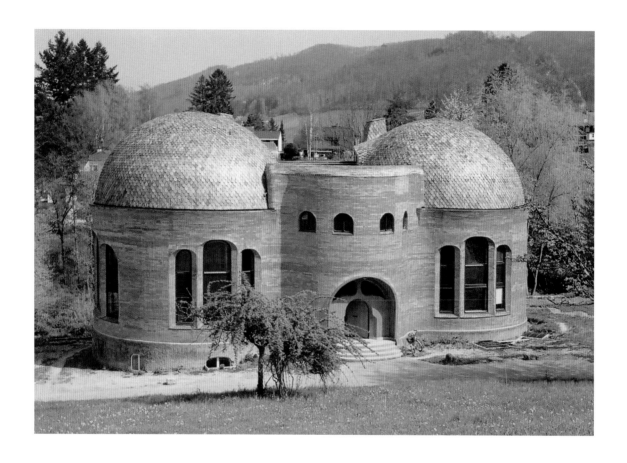

The 'Glass House' in Dornach, built 1914 as a studio for the production of the glass windows of the first Goetheanum. Designed by Rudolf Steiner, it served later also for the engraving of the colored glass windows of the second Goetheanum by Assya Turgenieff. Renovated 2007. Photo P. Stebbing.

Assya Turgenieff in the Glass House Studio, ca. 1940. In the background is her 1:1 preliminary drawing for the Red Window middle motif of the second Goetheanum.

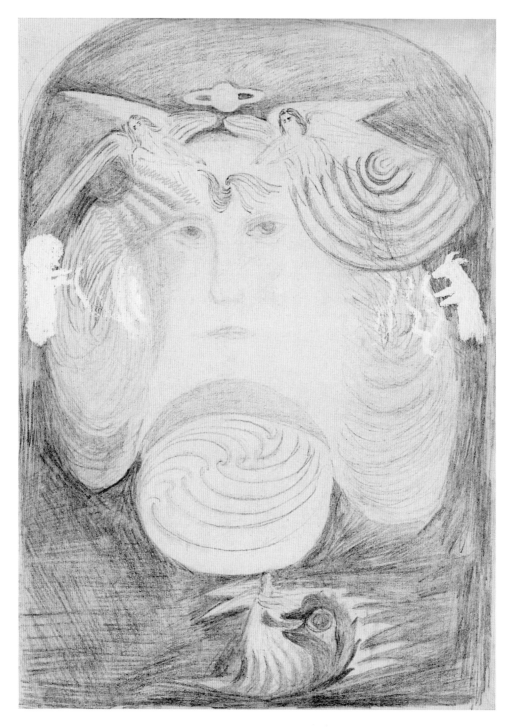

Rudolf Steiner: Drawing for the Red Window. Middle motif.

The Red Window Middle Motif Metamorphosed

– Paintings of Gerard Wagner –

A Note on the Red Window Middle Motif Painted by Gerard Wagner

It can be said that this motif held a special significance for Gerard Wagner – the only glass window motif he took up and transposed from the art of light-and-dark into painting (the art of color). He painted it many times as a single motif, or as part of a metamorphic series. By this means, he showed its essential relation to other archetypal motifs of Rudolf Steiner.

It will appear self-evident that the starting-point for painting such a motif is a red toned page. And this is indeed for the most part how Wagner began the paintings which follow.

The red 'initiation motif' as it has sometimes been called, was given by Rudolf Steiner for the main entrance of the Goetheanum building in the west: A challenge to self-knowledge and to self-transformation.

*

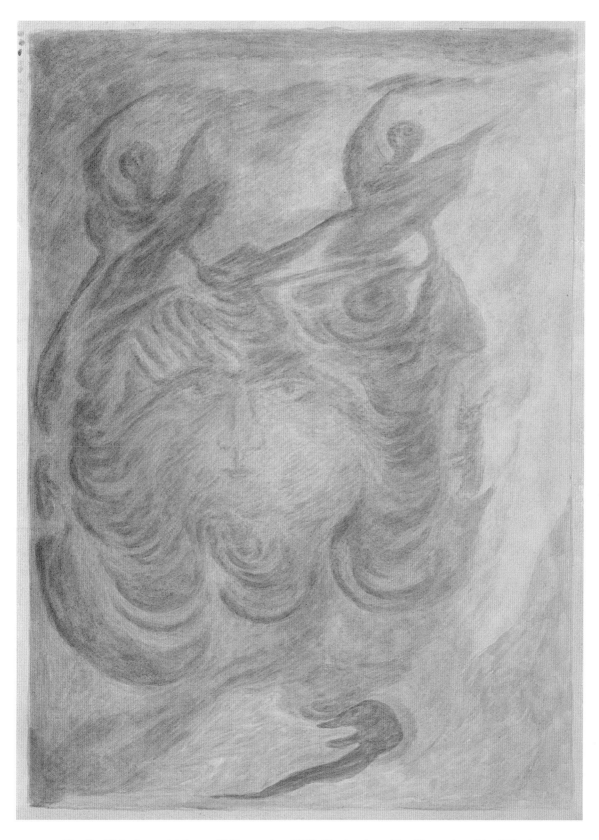

The Red Window middle motif. November 1974. Plant colors. 67 x 49 cm. (ca. 26 x 19 ins.)

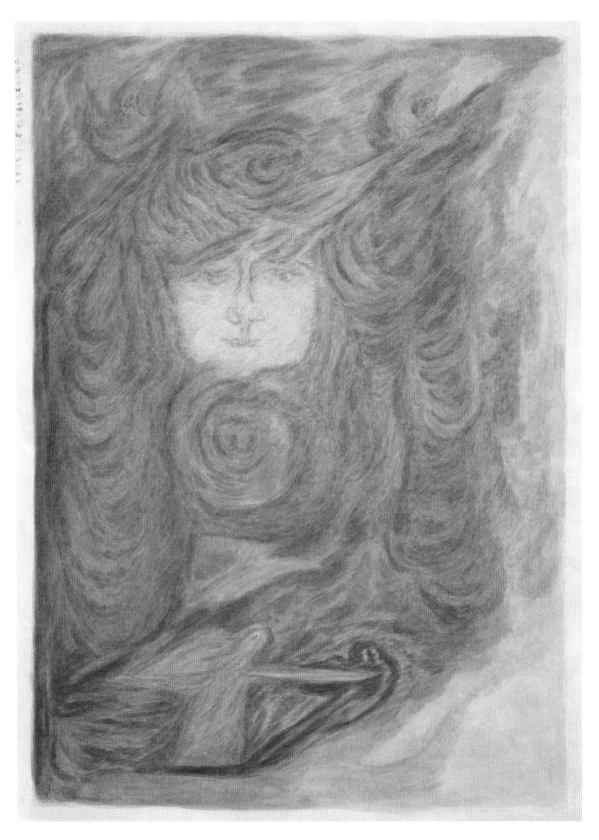

The Red Window middle motif. November 1974. Plant colors. 67 x 49 cm. (ca. 26 x 19 ins.)

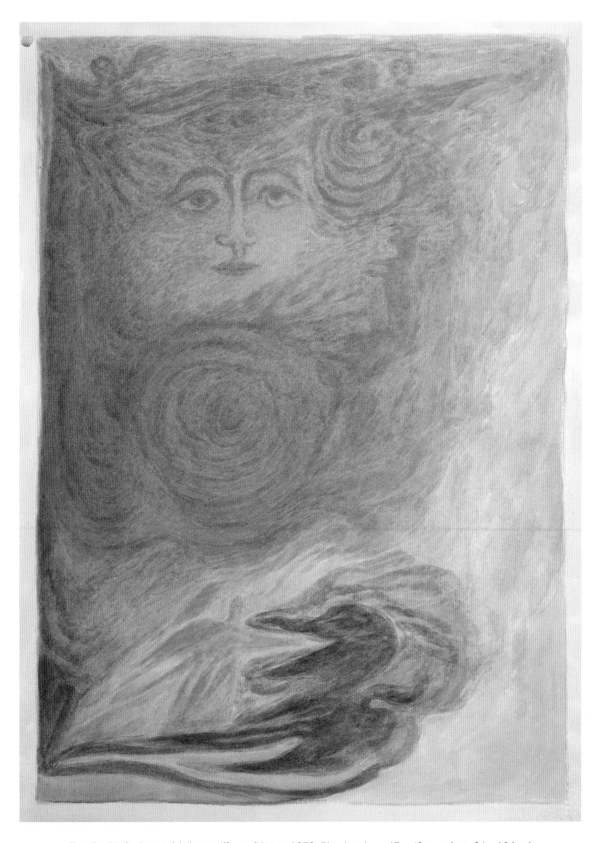

The Red Window middle motif. April/May 1972. Plant colors. 67 x 49 cm. (ca. 26 x 19 ins.)

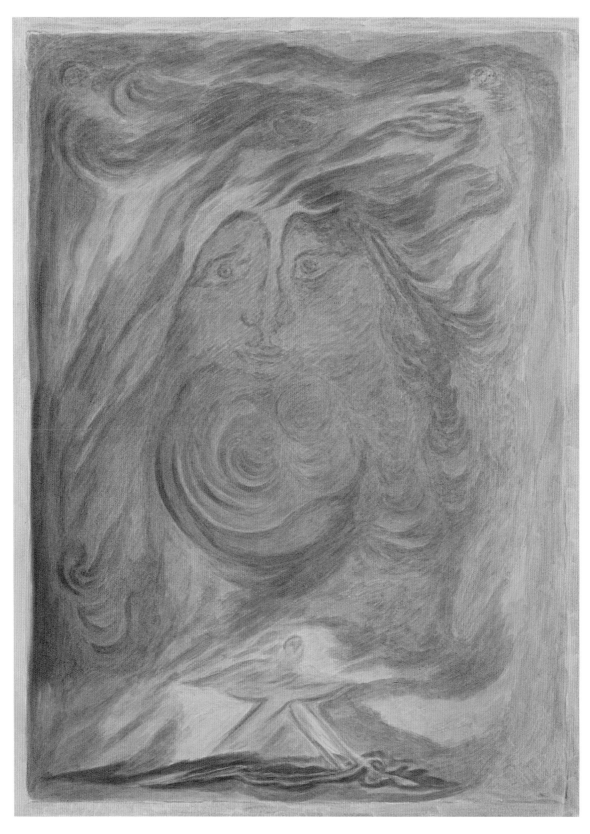

The Red Window middle motif. October 1980. Plant colors. 67 x 49 cm. (ca. 26 x 19 ins.)

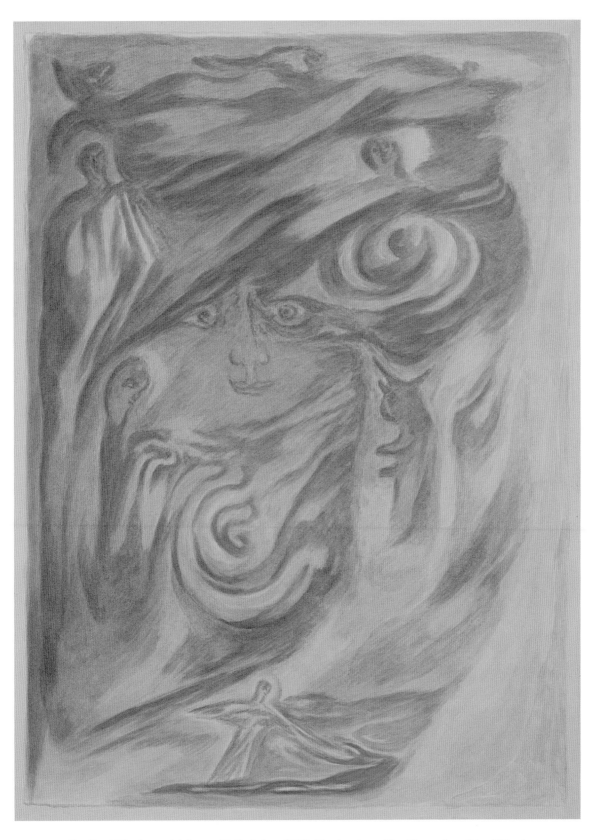

The Red Window middle motif. October 1980. Plant colors. 67 x 49 cm. (ca. 26 x 19 ins.)

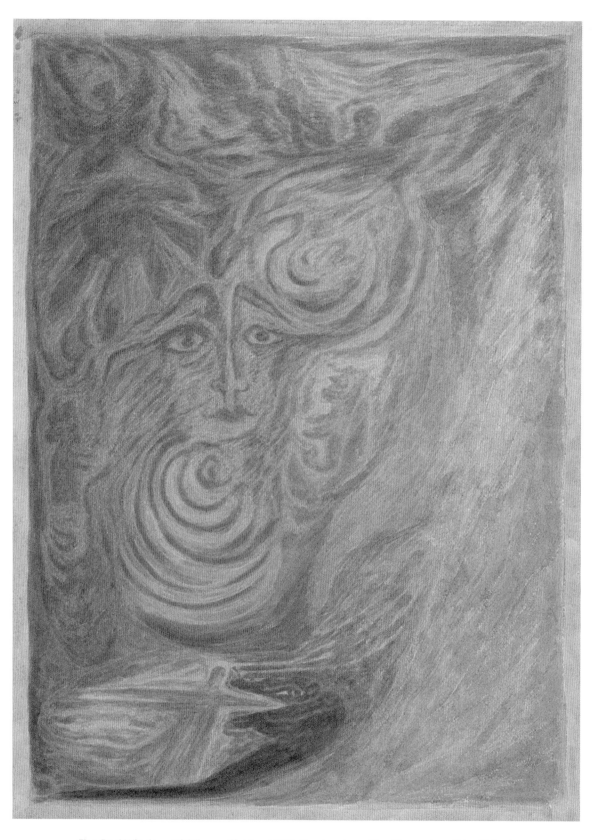

The Red Window middle motif. May 1972. Plant colors. 67 x 49 cm. (ca. 26 x 19 ins.)

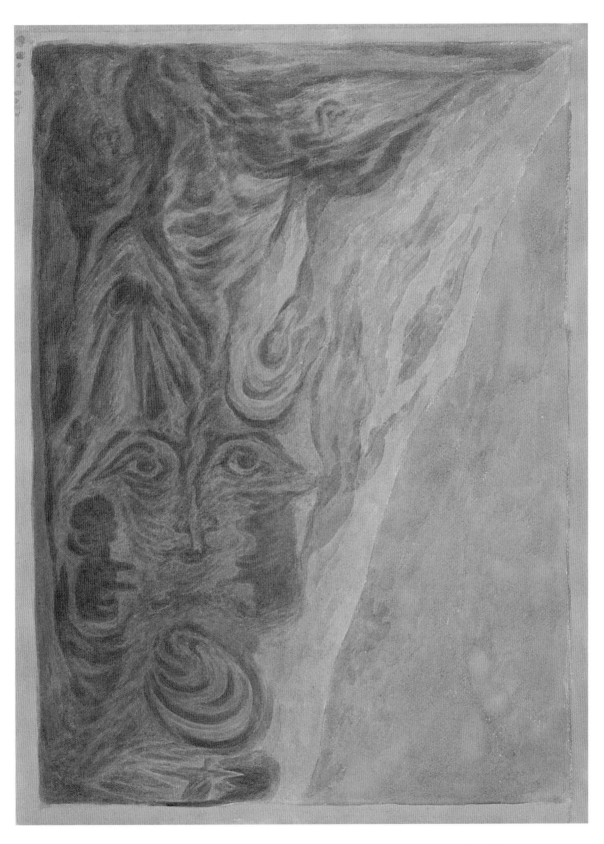

The Red Window middle motif. May 1972. Plant colors. 67 x 49 cm. (ca. 26 x 19 ins.)

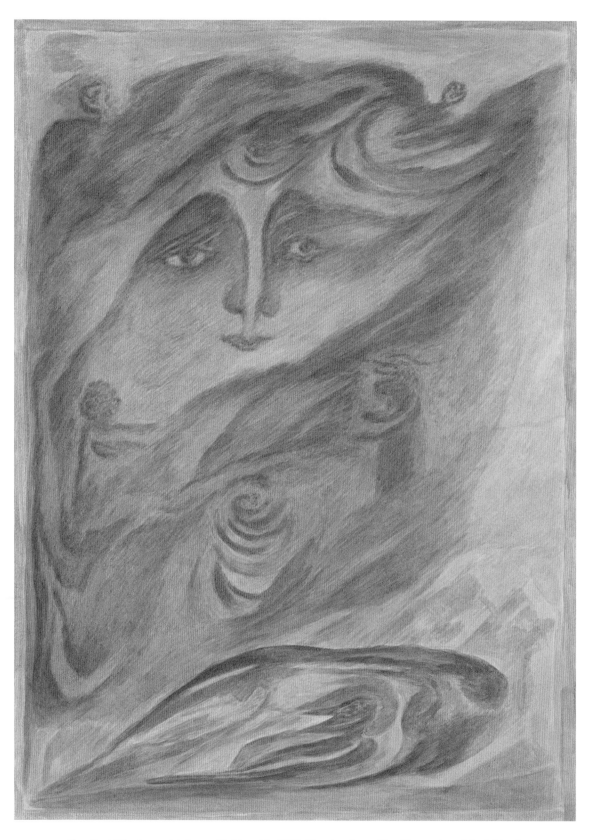

The Red Window middle motif. May 12, 1982. Plant colors. 67 x 49 cm. (ca. 26 x 19 ins.)

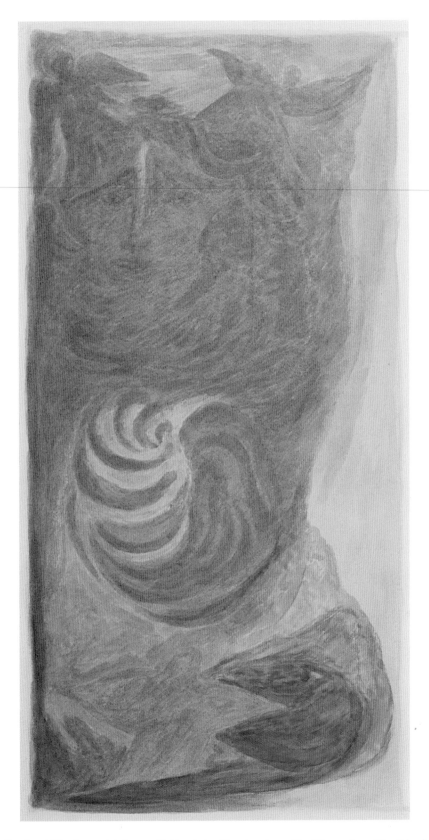

The Red Window middle motif. No date. Plant colors. 48 x 24 cm. (ca. 19 x 9 ins.)

APPENDIX

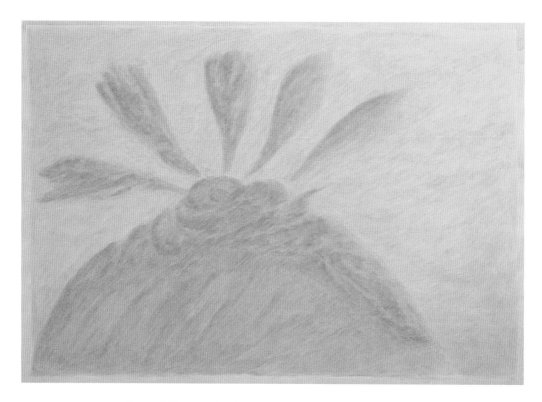

Gerard Wagner: Sunrise I. 1971. Plant colors. 49 x 67 cm.

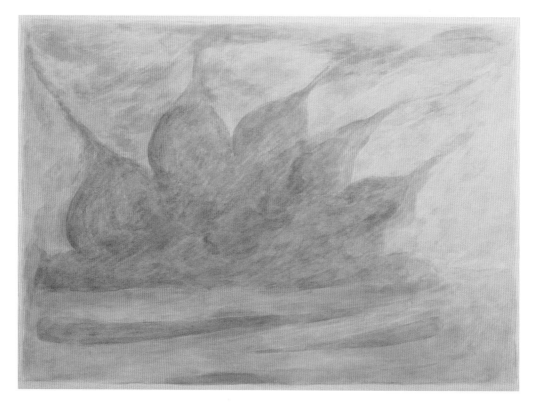

Gerard Wagner: Sunset I. 1971. Plant colors. 49 x 65 cm.

A Path of Practice in Painting

Gerard Wagner

In the year 1928 I was admitted by Henni Geck into her painting school. The classes took place at that time in Rudolf Steiner's lofty studio (*Hochatelier*) in the Carpentry Building, where the great wax and plasticine model of the sculptural group *The Representative of Humanity* stood. On the walls all around hung the originals of the training- and motif-sketches. A new art of sculpture and a new art of painting. Here the whole mood of the teacher still lived, and the earnestness of his manner of working.

Henni Geck had been present when all the sketches were made. Following an indication of Rudolf Steiner, we were directed to transpose the motifs, given in pastel, into watercolor. In doing so we had to pay careful attention to the forms and their mutual relationships of balance, down to the smallest detail. Henni Geck always gave us the color sequence. After nine months – as the result of tragic circumstances – the classes ceased in this form. Later, the sketches came to be hung in the Goetheanum, where they were accessible to students and those interested. But that brief time of instruction became of lasting value for all later years.

I had only painted the first three motifs: the *Sunrise, Sunset,* and *Shining Moon.* By means of careful observation, while attempting to live into the colors, lines and forms of these models, something transpired within one: a tremendous interest arose that could be expressed more or less in the words: 'Why, those are organisms!' One experienced something in connection with these formations of which one had to say to oneself: 'They are "exact," as though without anything accidental or arbitrary in their creation. They do not depict any objects of nature – but the details of their forms and movements are so mutually adapted to each other, carry and determine each other, as otherwise only the members of a living organism do, where every detail is necessarily linked to the whole. They do not depict – they *live.'*

This was something like a permanent feeling, which was only gradually to become more conscious in the course of the following decades.

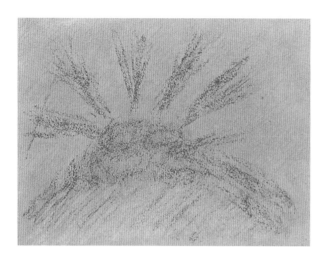

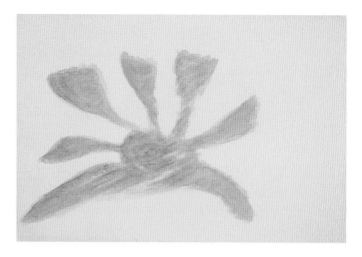

Rudolf Steiner: Sunrise I. Pastel Sketch.

Gerard Wagner: On a warm yellow toned page: warm red.

The painting instruction had left me with a great riddle. Rudolf Steiner speaks continually of form arising out of the color, saying it should be the work of color. One can assume that it happened like that in his pictures.

With Henni Geck we had to lay on the three beginning motifs each time with vermilion red: in one case – following the example of the sketch – in the form of a rising sun, secondly in the form of a setting sun, and thirdly in the form of three moon sickles. And it became a question for me: If we begin three such different motifs with the same color (as the first on a white page), how is that to be reconciled with the above mentioned requirement?

I began searching for answers. I asked myself: if I were to alter *one* color somewhat in building up the sketch motifs, of which the early ones are painted with only three to four colors, how would the form then have to change? In doing so, I followed a suggestion of Rudolf Steiner, to paint on colored backgrounds, or to 'imagine' the white page toned with a color before painting.

Experimental series were begun on single sheets of paper of the same format: one color, or also two colors, one of which changes in the smallest steps from page to page (e.g., from blue-green to yellow-green, from cool red to warm red, and so on) – posing with each color change the question as to the corresponding form transformation. The attempt was to participate in the life of colors, making it into my own experience.

214

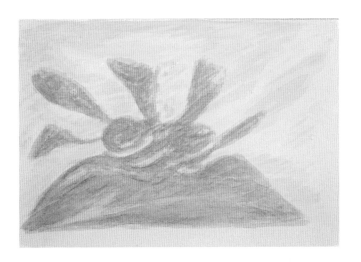

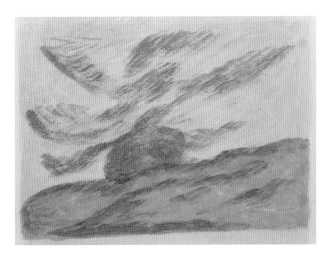

On a warm yellow toned page:
warm red–red-violet–warm yellow.

On a pale red toned page:
violet–yellow–red.

With that the goal was set: How does one find the way into this life of color, how does one come to terms with it – the universal element of life permeating the whole process of painting? The further question had then to be asked: How do the single colors conduct themselves differently in this life element? How does living form arise out of color?

Those are the great ever-present questions, for which the answers are sought over a lifetime. They are never 'known' – one continually tests them as to their rightness. A great part of the work that finally results consists in this.

It was a question of practicing in such a way as to train one's color feeling. The sketches of Rudolf Steiner made one thing clear relatively soon: that the element of life in which his colors were always immersed, and which was formed and made visible by means of them, can only be taken hold of by a feeling-perception that has cast off every kind of merely subjective color response. One sought access to the living, the world of formative forces. This could only come about in proceeding from a higher principle.

Thus one stood initially at the beginning of a long path: Many years passed in practicing, seemingly for no reason. Foreseeing how long it would take to arrive at the point of 'beginning to paint,' of being able to paint a picture in the sense striven for, was naturally impossible. One's presentiment said, twelve to fourteen years.

The question of how form arises out of the color, and the extent to which anyone can

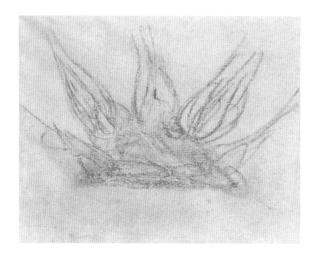

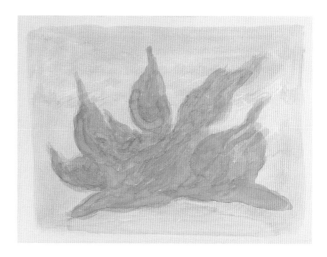

Rudolf Steiner: Sunset I. Pastel Sketch.　　　Gerard Wagner: On a violet toned page: warm red.

answer it, depends on how far they are in a position to have an objective experience of color so strongly in them that it drives out the mental image. Only much later does one know why this is so difficult, and what it means. One is not spared the long periods in which one lays one color after another onto the paper while experiencing nothing. Only in isolated moments does a *real* experience seem – as though in a flash – to penetrate through to one. The attempt is then to catch hold of it, so as to repeat it. This goes on for years, till the moments multiply. Some day, it must be possible for them to become a continuous stream.

But even if one were never to attain the goal of finding the form out of the color – of lifting the 'veil of Isis' – the inner schooling involved proves to be a path to one's true humanity, and noticing this, one can do no other than traverse it. *Learning* becomes the sole occasion for painting.

A particular help in eliminating subjective arbitrariness is an exercise of Rudolf Steiner that points to 'qualitative measuring.'[1] The measuring of color qualities is so important, because it permits the painter to develop alertness and direction in seeking, while at the same time letting color experience 'fall asleep' completely in the activity of creating. The striving while painting is to surrender all experience to doing, holding back nothing in one's own feeling. Actual feeling may neither remain 'consciousness of self,' nor 'feeling of self,' but must become pure, verifiable will activity.

On a violet toned page:
Cool blue–warm-red.

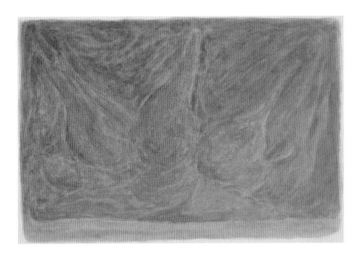

On a violet toned page:
Cool blue–warm red–ultramarine–cool red.

By means of the *sequence* in which the colors are chosen, in qualitatively *measuring* and *weighing* them, forms came about. Their justification was followed up in seeking the preconditions for their coming into being. Numerous experiments were made, leading to plant and animal forms. Access was sought to the human figure as well by means of color.

Rudolf Steiner has given many indications leading into these domains. They begin with apprehending the forces of sun and moon in the life organism of nature and the human being and lead by stages to his large watercolors, which encompass the whole path: *New Life – Easter – Archetypal Plant – Archetypal Human Being* (or *Archetypal Animal*.)

A further archetypal motif, *The Threefold Human Being*, became the starting point for extensive occupation with the formation of the human figure out of color. These pictures of Rudolf Steiner belong to the world of archetypal images. Between their point of origin and where we stand as earthly human beings, lie all the kingdoms of nature. We are invited to discover them anew, from *within*, out of the color.

Whoever attempts to follow this path can come to the certainty: the indications of Rudolf Steiner, if sufficiently entered into, enable one to apprehend the formative forces of color and to create within this life-element, without profaning it. In giving us such pictures of life formed out of color, he has set goals for the far future of painting.

Having the artistic works of Rudolf Steiner always present was the prerequisite for going

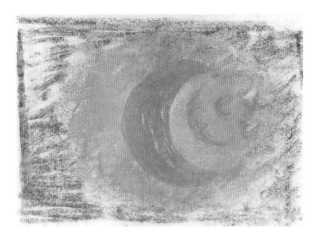

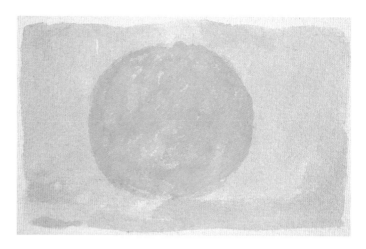

Rudolf Steiner: Shining Moon. Pastel sketch.

Gerard Wagner: On a cool blue toned page: cool yellow.

this path, and, at the same time, the intensive participation in performances of eurythmy and stage art, the work of personalities such as Marie Steiner and Albert Steffen, and of the many others who left their mark on the cultural life of Dornach. It goes without saying; all this had the greatest influence on one's own work, which would have been unthinkable without those stimuli. Rudolf Steiner had disclosed goals of humanity in art and science.

Concerns of a mere personal nature become meaningless in this regard. Gradually the experiments with color, carried out ever more consistently over the years, took on clearer form. They led to metamorphic series that present an attempt, in working methodically with color, to come to real insights in painting.

Fundamentally, all the paintings arising in this way can be considered part of this practicing – since they were painted above all to determine the relation of color to form. The thought of painting pictures that might be exhibited or sold could not have been further from my mind. The process of painting itself was what interested me – the immersion again and again in this mysterious process, the way in which colors mutually support and carry each other in a 'floating equilibrium.' It was not a question of giving a name to, or interpreting a 'motif' as such. This came about only gradually through ever more exact insight into the logical consistency of the 'color build-up,' which is the basis for the formation of the motif.

That is not only an artistic problem in painting, but also in music. Like the sequence of

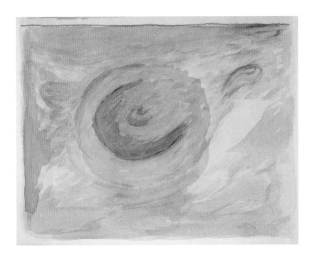

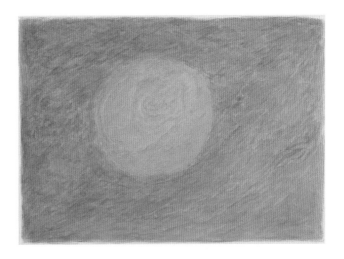

On a cool blue toned page:
Cool yellow–cool & warm blue–warm red.

On a cool blue toned page:
Yellow–warm blue–warm red–warm yellow

tones and intervals in music, so do the colors also take their course through time, becoming visible in space. At the moment of appearing on the surface of the picture, they are actually at the end of their path. They are at home in the astral world and enter the realm of formative forces by means of etheric vibrations – themselves shaping within these forces. Only now, in the process of formation, do we become conscious of the *motif* revealing itself in the rhythm of the color sequence. The motif has only been brought to full realization when, in actual contemplation, our consciousness is satisfied as regards the whole human being.

From Gerard Wagner: *Die Kunst der Farbe.* (The Art of Color.) Stuttgart, Verlag Freies Geistesleben 1980. This excerpt translated by Peter Stebbing.

[1] See Rudolf Steiner: *Colour,* especially the lecture of July 29, 1923, 'Measure, Number and Weight.' CW 291. Rudolf Steiner Press, U.K. 1992.

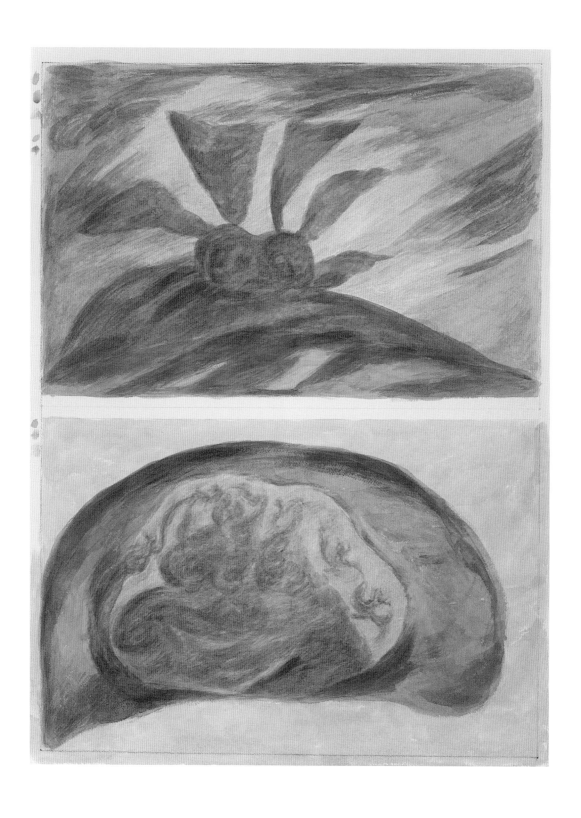

Gerard Wagner: On white: Violet–red–yellow–(2 x). *Sunrise I*. Nature Mood sketch.
On incarnadine: Violet–red–yellow. The 'A' motif of the Large Cupola.
1994. Plant colors. 72 x 54 cm. (ca. 26 x 21 ins.)

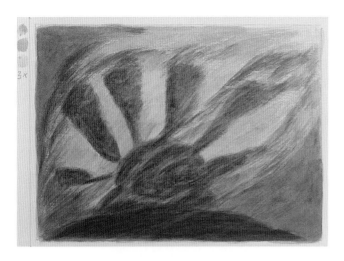

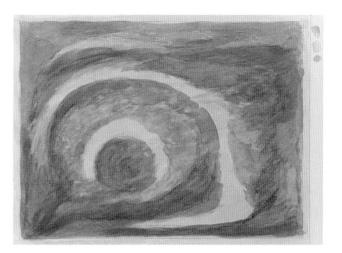

On yellow: Red–violet–yellow–(3 x).
March 1994. Plant colors.

On a warm red toned page: Red–yellow–violet.
March 1994. Plant colors.

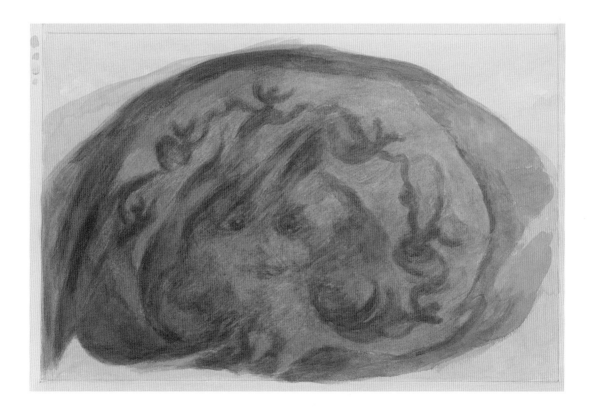

Gerard Wagner: On a peachblossom toned page: Violet–red–yellow–blue.
 The 'A' motif of the Large Cupola. May 1994. Plant colors. 34 x 52 cm. (ca. 13 x 20 ins.)

The five studies of Gerard Wagner shown above clearly bring Rudolf Steiner's 'Nature Mood' sketch-motifs into connection with a motif of the large cupola of the first Goetheanum.

Biographical Sketches

THE LARGE CUPOLA PAINTERS

Hermann Linde (1863–1923)

Hermann Linde was born August 26, 1863 in Lübeck. He grew up with six siblings, becoming an apprentice in his father's photo store at eighteen. He attended the Art Academy in Dresden, deciding at 21 to become a painter. Continuing his studies in Weimar, he afterwards travelled to Italy, Egypt, Ceylon, India, and Kashmir.

A painting entitled *Arab Cobbler* earned him a silver medal at the Crystal Palace in London. A German Impressionist, Linde counted as a leading painter of Oriental subjects, with paintings in principal museums of Germany. In 1899 he married the painter Marie Hagens.

Hermann Linde attended The Munich Congress of 1907, later painting a large part of the scenery for the four Mystery Plays of Rudolf Steiner performed in Munich.

Rudolf Steiner asked him to coordinate the painting of the large cupola. In 1916 he was commissioned by Helene Röchling to paint 12 pictures for the Mannheim Branch, illustrating Goethe's *Fairy Tale*.

Marie Linde-Hagens (1870–1943)

Marie Hagens was born in Bremen June 19, 1870 into a well-to-do family, and studied painting in Paris and Munich.

She travelled with her husband to hear lectures of Rudolf Steiner. In the Mystery Drama performances in Munich she played the part of the Other Maria and of the Guardian of the Threshold.

Following her husband's death, she lived with her daughter Agnes in Italy.

Ottilie Schneider (1875–1943)

Ottilie Schneider was born September 27, 1875 in Prague, becoming a member of the newly founded Anthroposophical Society in 1913. Prior to working in Dornach on the Egyptian and Persian motifs of the large cupola, she was known as a book illustrator. Returning to Prague after completion of the large cupola paintings, she eventually had to leave Czechoslovakia following the Second World War, on account of her German ancestry. She then took up residence in Hessen.

Richard Pollak (1867–1943) – Hilde Pollak-Kotanyi (?–1943)

Richard Pollak, born July 5, 1867 near Prague, grew up in a prosperous Jewish mercantile family. Having first worked as a wholesale trader, he attended the Art Academy and School of Applied Arts in Prague, continuing his studies at the Academy of Visual Arts in Munich.

Pollak became a widely recognized portrait painter, winning prizes in Paris and Munich. After settling in Vienna, he became acquainted with theosophy, and got to know his future wife, Hilde Kotanyi, also a painter. She came from a large Jewish family in Budapest. They joined the Theosophical Society in 1906, and met Rudolf Steiner in 1907.

Hermann Linde. Selfportrait.
1905. Oil on plywood.

Imme von Eckardtstein

In 1914 Rudolf Steiner suggested they move to Dornach to work on the first Goetheanum. In 1915 Hilde Pollak undertook to paint a program poster for the first performance of Faust's Ascension. At Rudolf Steiner's instigation, painted program posters became an integral part of such events from then on.

In 1941 Richard Pollak was arrested by the Gestapo, along with his wife, and taken to Theresienstadt (near Prague), and later to Auschwitz-Birkenau in Poland where he died. She is presumed to have died in Dachau.

Lotus Peralté, also known as *Baroness Paini-Gazotti* (1862–1953)

Born November 28, 1862, she travelled widely and spent time in India. She met Rudolf Steiner around 1909, and applied herself to making his work known in Paris. She and her husband transferred their membership to the German Section of the Theosophical Society and moved to Munich in 1911.

From 1924, she lived near Nice on the Côte d'Azur, and later in the village of Puy l'Evêque in southern France.

Imme von Eckardtstein (1871–1930)

Baroness Imme von Eckardtstein was born November 5, 1871 in Lunéville. She lived for a time in an artists' colony near Bremen. She met Rudolf Steiner in 1904, and took part in preparations for the Munich festival performances, with responsibility for costumes. She acted a part in Edouard Schuré's *Sacred Drama of Eleusis*, and assumed the rôle of Lucifer in the Mystery Dramas from 1911 on.

On Rudolf Steiner's advice to derive colors for painting from plants, a small laboratory was set up in July 1912 (called the *Chemisch-theosophisches Laboratorium*) in Munich, on the initiative of

Arild Rosenkrantz and his wife Tessa.

Baroness Imme von Eckardtstein and Oskar Schmiedel. This undertaking was transferred to Dornach in 1914, where the colors for painting the two cupolas of the first Goetheanum were produced by Oskar and Thekla Schmiedel.

Five studies of the 'O' motif by Imme von Eckardtstein and two of the 'I' motif are preserved in the Goetheanum Art Collection.

In later years, Imme von Eckardtstein worked with Marie Steiner in helping to put on the Mystery Dramas in the second Goetheanum.

(Adequate portrait photos have proved unavailable in the case of other large cupola painters.)

THE SMALL CUPOLA PAINTERS

Baron Arild Rosenkrantz (1870–1964)

Baron Arild Rosenkrantz was born in Frederiksborg near Copenhagen. His father (administrator of a royal castle) died when he was three, leaving four sons to the care of his Scottish mother. In 1886 the family moved to Rome, where Arild initially became a pupil of the fresco painter Modesto Faustini (1839-1893). He continued his studies in Paris, exhibiting at the Salon de la Rose Croix. In 1895 he worked at Tiffany's in New York, and in 1898 married his Scottish cousin, Tessa, later a keen advocate of the rebuilding of the Goetheanum. He met Rudolf Steiner for the first time in London in 1913.

Rosenkrantz was asked in 1924 to paint the seven apocalyptic seals for the English edition of Rudolf Steiner's lectures 'Occult Seals and Columns.' He had a hand in decorating Rudolf Steiner House in London and in founding the first English eurythmy and speech school. In 1939 he returned to Denmark.

Having previously been influenced by the Pre-Raphaelites and by William Blake, Arild Rosenkrantz evolved a fluid, dynamic style of painting, in luminous colors.

Margarita Woloschin

Ella Dziubanjuk

Margarita Woloschin (1882–1973)

Born Margarita Vassilyevna Sabashnikova, January 31, 1882 in Moscow, she studied painting with several well-known painters, including Ilya Repin and Konstantin Korovin. She heard Rudolf Steiner for the first time in 1905 in Zurich, and decided to become his pupil. She married the poet, painter, and journalist Maximilian Voloshin in 1906 in Moscow. In 1913 she co-founded the Anthroposophical Society in Russia. Generally known in later years as Margarita Woloschin, she lived in Stuttgart, active as a eurythmist, and also painting a number of altarpieces for the Christian Community. She wrote an autobiography, *The Green Snake / Life Memories* in German, which has gone through 8 or 9 editions since its first publication in 1954. It has been translated into both Russian and English.

Ella Dziubanjuk (1881–1944)

Ella (Elisabeth) Dziubanjuk was born November 24, 1881 in Ruthenia (south of the Carpathian Mountains, then Hungary, today part of western Ukraine). She had acquired an art training in L'viv, and worked both in the small cupola and as a eurythmist. In an *in memoriam*, Marie Steiner wrote of her, 'Diligent and unpretentious as well as talented, she was – by local standards – a rather exotic being. Uncommonly appealing, she won many hearts. At exhibitions her work was always noticed and singled out for commendation. It was the same in Paris, where she settled when [Tatiana] Kisseleff (1881–1970) took over the direction of the eurythmy school there. The artistic events gained from her collaboration, and onerous domestic work alongside the teaching activity was made easier with her help.'

She passed away in a Paris hospital February 5, 1944.

Jeanne-Marie Bruinier

Jeanne-Marie Bruinier (1875–1951)

Jeanne-Marie Bruinier lived in Dornach from 1914 until 1922. She had become a member of the Theosophical Society in Warsaw, and of the Dutch Anthroposophical Society in The Hague, where she lived following her time in Dornach. Little further information about her is currently available.

The Art Collection at the Goetheanum is in possession of a study by Jeanne-Marie Bruinier of the 'Faust' motif on primed plywood.

Mieta Pyle-Waller (1883–1954)

Originally named Maria Elisabeth Waller, one of three daughters of a Dutch ship owner, she had wanted at first to study singing. Mieta Waller got to know Rudolf Steiner at the Theosophical Congress in Munich in 1907.

Becoming one of the closest co-workers of Rudolf and Marie Steiner, she lived in the same household with them from 1908 until 1924, and was appointed their heir in the event both were to die at the same time. She received her training in eurythmy and speech formation from them directly.

Mieta Waller made a significant financial contribution toward construction of the first Goetheanum building, and supported production of the Mystery Dramas. The first Johannes Thomasius, she also played the part of Faust in the première performance of the Ariel Scene.

After the founding of the publishing venture *Der Kommende Tag* (The Coming Day) in 1920, Mieta Waller transposed many of Rudolf Steiner's graphic forms into finished book covers.

She married the American painter William Scott Pyle in 1924, and made an architectural model for their house in Dornach. In 1930 Mieta Waller modeled a design for the *Speisehaus* restaurant

Mieta Waller & Marie v. Sivers in Schuré's
'Sacred Drama of Eleusis', 1909.

Louise Clason

near the Goetheanum. She subsequently contributed significantly also to the design of the Auditorium of the Threefold Educational Foundation in Spring Valley, NY, besides creating a model for the room in the Goetheanum in which the Group Statue was to stand.

Having resettled in the United States together with her husband and daughter, Joanna, Mieta Pyle-Waller founded a workshop for the production of plant colors. After her husband's death in 1938, she took up residence with her daughter in Greenwich, Connecticut.

Louise Clason (1873–1954)

Born January 27, 1873, Louise Clason was a resident of Berlin from about 1900. She chose painting as her field of study. In Berlin she attended lectures of Rudolf Steiner at the *Architektenhaus*, becoming a member of the German Theosophical Society in 1908. She took an active part in the festival performances of the Mystery Dramas held in Munich, assuming the rôle of Astrid.

Having moved to Dornach, Louise Clason initially carved in the first Goetheanum, receiving the 'Athene-Apollo' sketch-motif from Rudolf Steiner for the small cupola in November 1914. This work in painting continued until the autumn of 1917.

Louise Clason later became a practicing eurythmist, taking responsibility for the eurythmy wardrobe of the Goetheanum ensemble, and becoming a long-term, loyal co-worker at the Goetheanum.

– P. St.

Portraits courtesy of the Goetheanum Photo Archive.

About the Painter Gerard Wagner

Gerard Wagner was born the 5th of April[1] 1906 in Wiesbaden, the youngest of three sons of a steel factory owner and an English mother of German extraction. When he was two years old, his father died. Four years later, having spoken only English, he returned with his mother to the Manchester area, where she had grown up.

A moment in his early childhood is perhaps indicative. Admonished to remain still, he was placed in front of a flower bed to be photographed with his one year older brother, Felix, who was to water the flowers with a watering can. He noticed that the jet of water did not seem to move, but remained still. 'It works,' he told himself. Always keenly interested in what the eye actually sees, he once remarked, for example, that when a bird flies into the distance, at a certain point it suddenly disappears for the sense of sight: it is then as if the air had swallowed it up.

After he had drawn a robin using a matchstick and red fruit juice, his mother gave him his first colored pencils.

> It may have been a quiet summons to the future painter, when the English nanny, while walking with the two smaller boys along a wooded pathway, scooped a clump of frogspawn from the edge of a nearby pond – much to their astonishment. She put this in a large jar in the children's room, tending it till the tadpoles slipped out and gradually evolved into small frogs. – Finally, she painted this whole development in stages on a large sheet of paper in watercolors, hanging it on the wall of the children's room.[2]

Attending the public boarding school to which he was sent along with his next-older brother proved on the whole, with its many demands, an unsatisfying and sometimes distressing educational experience.

His schooling completed, Gerard Wagner went to St. Ives, a small fishing village and artists' colony on the west coast of Cornwall, in order to learn from a well-known landscape painter, *John Park* (1878–1962). His teacher emphasized atmospheric color over drawing. The subjects, painted in oils, included seascapes and portraits of fishermen. A wooden building on the seawall, formerly used to dry herrings, served as Gerard Wagner's studio. Like John Park, he also worked outdoors in the little harbor with its fishing boats, or in the picturesque streets and winding alleyways.

The following year, primarily to strengthen his drawing, he undertook formal artistic training at the Royal College of Art in London. With the adjoining Victoria and Albert Museum accessible to students through an inside doorway, he often went there and sought out the Raphael Cartoons. The museums of London had much to offer in the way of art treasures of previous centuries. He developed a life-long appreciation for the paintings of van Gogh. Much of his own later work could be seen, from a certain point of view, as being a further development of van Gogh.

An aunt drew his attention to the teachings of Rudolf Steiner. In London Gerard Wagner became a member of the General Anthroposophical Society in 1926. Deciding to visit Dornach soon afterwards, he in fact stayed on there, though he had originally intended to settle in Paris.

Three years after the burning of the first Goetheanum and one year since Rudolf Steiner's death, there was intensive building activity on the Dornach hill. The mighty concrete second Goetheanum

Gerard Wagner. June 1939.

stood half finished, still enclosed in scaffolding. Seeing the paintings of *Henni Geck* (1884–1951), he applied to study in her painting school at the Goetheanum, which had been accommodated in Rudolf Steiner's studio in the Carpentry Building.

> These pictures made an enormous impression on the young painter. Their intensity of color, their luminosity, the sureness with which they were executed, were something he had never seen before in watercolor painting. These were motifs not fetched from the world he had known hitherto. For him, they were astounding, perfectly shaped and captivating in their effect, with not a trace of naturalism: a completely new art of painting.[3]

However, at that time his name could only be added to a waiting list. During the two years before it became possible for him to begin the training with Henni Geck in 1928, he partly painted on his own. But he also took speech lessons with *Ilya Duvan*, enabling him to participate in rehearsals under Marie Steiner's direction. He took part in performances of scenes from *Faust*, and the Egyptian Temple scene in Rudolf Steiner's fourth Mystery Drama, *The Souls' Awakening*.

By now the second Goetheanum building was nearing completion as far as the exterior was concerned, so that the final, first 'unveiling' of the west façade could take place in 1928. – The task of solving how this important feature of the building was to be carried out, based on Rudolf Steiner's model, had been entrusted to the young architect *Albert von Baravalle* (1902–1983).

The unique cultural life of Dornach in the following decades included the first staging of many of Albert Steffen's plays.

> The 'building idea' given momentum here by Rudolf Steiner did not extend only to the architecture of a building as such. In every field of artistic and cultural life, work was accomplished on construction of the 'Building'. This work is something that continues, extending over generations. Everyone participating in it for a while contributes what is within their

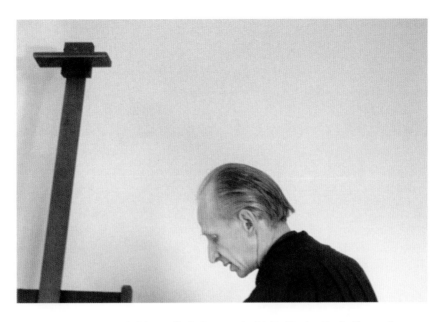

Gerard Wagner in his studio in Dornach. 1969. Photo: Erwin Thomalla.

power to contribute toward the success of the whole … Without as yet fully realizing what was in process of being initiated here, he [Gerard Wagner] nonetheless sensed how everyone active in this place strove for something far higher than what the individual could have attained out of his own forces. Miraculous were the impressions when, in inwardness and true self-forgetfulness, words sounded across from the stage, through which goals of humanity could palpably be experienced for a moment.[4]

The limited, nine-month period of study with Henni Geck that became possible before the school ceased in the form in which it had existed until then, proved decisive for the further development of Wagner's work. The circumstances surrounding the closing of the school in 1929 have to be viewed in the context of ongoing problems in the Society's history at that time, concerning which Gerard Wagner later remarked: 'What time and energy were lost for the tasks we have to fulfill!'

Years of solitary practice in experimenting with color followed. Rather than working out a personal style, or a particular way of painting, the aim was the more farreaching and challenging one of coming to an objective (i.e., generally valid) experience of how form can arise consistently out of the relationship of one color to another – always taking the sketch-motifs of Rudolf Steiner as the essential point of reference.

After twelve years, all preparatory work until then having been intentionally destroyed by the artist, Gerard Wagner held what was the first exhibition of his work in the Carpentry Building at the Goetheanum – with a theme of tree motifs. Though generally little noticed, these pictures brought an appreciative response from the leading pioneer eurythmist *Marie Savitch* (1882–1975), who had herself originally studied painting in St. Petersburg and Christiania.

In 1950, a collaboration arose with Elisabeth Koch, later Frau Wagner, in that she became one of his earliest painting pupils. – The endeavor was then to make the path he had gone both teachable and

learnable for others. A further development was the mutual founding of a painting school in 1964 and, in 1980, the first publication of *The Individuality of Colour,* for which he painted the numerous color examples in the book.

From 1939 on, over a period of sixty years, Gerard Wagner turned again and again to the Goetheanum cupola motifs, painting them in many variations, particularly during the 1970s. He left some 240 cupola studies in all.

In addition to painting pictures – often in metamorphic series – indications of Rudolf Steiner were followed up and developed that had been given for applied art, handwork, and the new art of costuming.[5] Numerous such studies arose, partly as a result of requests made by teachers in German Waldorf Schools. Book covers as well as package designs for the American Weleda came about in a similar way. From time to time Gerard Wagner was approached for Goetheanistic solutions to wall-painting and murals, as in the curative home, Haus Arild, near Lübeck; the Waldorf School at Überlingen; in the Paracelsus Hospital in Unterlengenhardt; and also in both the English Hall and the Foundation Stone Hall in the Goetheanum.

While the dining hall murals at Haus Arild were in progress, the founder and director, *Frida Lefringhausen* (1901–1996), an early patron of Wagner, ventured at one point to ask the artist, how he had come to the remarkable color, an atmospheric yellow-green, surrounding the central motif of the Madonna and Child like an aura? – The poetic and at the same time enigmatic response: 'To restore herself, Nature seeks out the human being.' ('*Die Natur ruht sich aus bei den Menschen.*')

From 1970, the newly developed plant colors of *Günter Meier* of the Plant Color Laboratory at the Goetheanum became available and from then on he painted almost exclusively with these.

Exhibitions of Gerard Wagner's work have been held in a number of different European cities, as well as in Australia, New Zealand and America.

Three major exhibitions should especially be mentioned: in the State Hermitage Museum in St. Petersburg (Menshikov Palace) (1997); a large commemorative centennial exhibition at the Goetheanum in Dornach, Switzerland (2006); and another at the Palace of Art of the Society of Friends of Fine Arts in Cracow, Poland (2006).

In the extraordinary range and extent of his work, its depth, in his hallmark metamorphoses, as well as in the rigorous and at the same time playful method he evolved, one can sense one of the truly great accomplishments of the 20th century. Still barely even noticed by the world at large, it is a life-work that has yet to be duly recognized.

Gerard Wagner left over 4,000 paintings. Their significance can hardly be measured.

– Peter Stebbing

[1] The date of the historical Easter Sunday. –
He died the 13th of October 1999 in Arlesheim, Switzerland.

[2] Gerard Wagner: *Die Kunst der Farbe* (p. 20).

[3] Ibid. (p.22)

[4] Ibid. (p. 21-22)

[5] Such an art of apparel is the counterpart of architecture as an art.
See: Rudolf Steiner: *The Arts and their Mission.* CW 276. Lectures II and VII.

Selected Bibliography

Bemmelen, Daniel J. van. *Rudolf Steiner's New Approach to Colour on the Ceiling of the First Goetheanum.* St. George Publications 1980.

Boos-Hamburger, Hilde. *Die farbige Gestaltung der Kuppeln des ersten Goetheanum.* R.G. Zbinden 1961.

Grossman, Edith. *Why Translation Matters.* New Haven and London: Yale University Press 2010.

Proskauer, Heinrich O. *The Rediscovery of Color.* Translated by Peter Stebbing. Spring Valley NY: Anthroposophic Press 1986.

Raske, Hilde. *The Language of Color in the First Goetheanum.* Dornach, Switzerland: Walter Keller Verlag 1987.

Stebbing, Peter (Ed.) *Conversations about Painting with Rudolf Steiner. Recollections of Five Pioneers of the New Art Impulse.* Great Barrington MA: SteinerBooks 2008.

Steiner, Rudolf. *Die Goetheanum Fenster. Sprache des Lichtes.* Dornach, Switzerland: Rudolf Steiner Verlag 1996.

_____ . *Architektur, Plastik und Malerei des Ersten Goetheanum.* (Contained in CW 289). Dornach, Switzerland: Rudolf Steiner Verlag 1972.

_____ . *Der Dornacher Bau als Wahrzeichen geschichtlichen Werdens und künstlerischer Umwandlungsimpulse.* (CW 287). Dornach, Switzerland: Rudolf Steiner Verlag 1985.

_____ . *Der Goetheanumgedanke inmitten der Kulturkrisis der Gegenwart.* Collected essays 1921–1925 from the weekly *Das Goetheanum.* (CW 36). Verlag Rudolf Steiner Nachlassverwaltung, Dornach, Switzerland 1961.

_____ . *Das Malerische Werk.* (CW K 13-16/52-56). 432 pages. Dornach, Switzerland: Rudolf Steiner Verlag 2007.

_____ . *Colour.* (CW 291*).* Translated by John Salter and Pauline Wehrle. Sussex: Rudolf Steiner Press 1992.

_____ . *The Arts and their Mission.* (CW 276). Spring Valley, NY: Anthroposophic Press 1986.

_____ . *Kunst und Kunsterkenntnis. Grundlagen einer neuen Ästhetik.* (CW 271). Dornach, Switzerland: Rudolf Steiner Verlag 1991.

Turgenieff, Assya. *Erinnerungen an Rudolf Steiner und die Arbeit am ersten Goetheanum.* Stuttgart: Freies Geistesleben 1993.

Wagner Gerard. *Three Grimms' Fairy Tales. Paintings by Gerard Wagner.* Edited by Peter Stebbing. Great Barrington MA: SteinerBooks 2010.

_____ . *Die Kunst der Farbe.* (The Art of Color). Stuttgart: Verlag Freies Geistesleben 1980.

Wagner-Koch, Elisabeth and Wagner, Gerard. *The Individuality of Colour. Contributions to a Methodical Schooling in Colour Experience.* Translated by Peter Stebbing. Sussex: Rudolf Steiner Press 2009.

Woloschin, Margarita. *The Green Snake. Life Memories.* Translated by Peter Stebbing. Edinburgh, UK: Floris Books 2010.

About Peter Stebbing

Born in Copenhagen, Denmark in 1941, Peter Stebbing attended Waldorf Schools in England. Having studied at art schools in Brighton and London, he emigrated to the United States in 1966, continuing his studies at Cornell University and earning the M.F.A. degree in painting in 1968.

While teaching design and color courses over a period of six years in the City University of New York, he began a practical exploration of the scientific color phenomena set forth by Goethe in his color theory. This led eventually to a turning point – to the crucial question of finding a correspondingly lawful approach to color in painting.

The new and wholly different training in color experience begun in 1976 with the painter Gerard Wagner, on the basis of Rudolf Steiner's sketch motifs, resolved fundamental artistic questions with a coherent and systematic approach. Fully in accord with Goethe's discoveries and method, this approach may be termed 'Goetheanistic'.

Peter Stebbing subsequently established a painting school at the Threefold Educational Foundation in Spring Valley, N.Y., teaching there from 1983 till 1990. Since 1992 he has been director of the Arteum Painting School in Dornach, Switzerland (www.arteum-malschule.de.vu).

OTHER PUBLICATIONS TRANSLATED AND EDITED BY PETER STEBBING

_____ *The Rediscovery of Color* by Heinrich O. Proskauer. Anthroposophic Press 1986.

_____ *EOS Art Journal*, Issues No. 1 (2007), No. 2 (2008) and No. 3 (2009).

_____ *Conversations about Painting with Rudolf Steiner*. Steiner Books 2008.

_____ *The Individuality of Colour* by E. Wagner-Koch and G. Wagner. Rudolf Steiner Press 2009.

_____ *The Green Snake / Life Memories* by Margarita Woloschin. Floris Books 2010.

_____ *Three Grimms' Fairy Tales / Paintings of Gerard Wagner*. SteinerBooks 2010.

A Note of Thanks

Special thanks are due to the following individuals and institutions for assistance in making this edition possible:

_____The Gerard and Elisabeth Wagner Association, CH 4144 Arlesheim, Switzerland. www.gerardwagner.de

_____The Gerard Wagner Foundation, Ghent NY 12075, USA.

_____Jörg Bucher and Maria Feck, Hamburg, Germany. (*Photography.*) www.be-lichtung.de

_____Urs Rüd, Basel, Switzerland. (*Typesetting, Layout.*)

_____John Macdonald, Westchester IL 60154, USA.

_____Antonio Papa, Sturm AG, Basel, Switzerland. (*Photography, Color restoration, Proofs.*)

_____The Rudolf Steiner Archive, 4143 Dornach, Switzerland.

*

The following black-and-white photographs by *Gertrud von Heydebrand-Osthoff* are reproduced courtesy of the copyright holder *Staatsarchiv Basel*:

Page	Title/Subject	Archive-number
2	From the north, end of construction period.	BSL 1023 1-1-3
21	From the southwest, with approach road and footpath.	BSL 1023 1-2-5
131	Small Cupola. (Partial view.)	BSL 1023 1-4-20
123	Small Cupola, South side.	BSL 1023 1-4-21
128	Germanic Initiate.	BSL 1023 1-4-22-1
133	Ahriman in the cave.	BSL 1023 1-4-24
126	Ahriman and Lucifer. (Germanic Initiate.)	BSL 1023 1-4-26-1
132	Lucifer. (Middle Motif.)	BSL 1023 1-4-24-2
121	Apollo as Inspirer.	BSL 1023 1-4-27
119	'Flying Child'.	BSL 1023 1-4-28
125	Two Inspirers. (Egyptian motif.)	BSL 1023 1-4-29-1
130	Centaur and Orange Angel. (North side.)	BSL 1023 1-4-29-2
121	Athene.	BSL 1023 1-4-29-3
134	Christ head.	BSL 1023 1-4-29-4
120	Death.	BSL 1023 1-4-29-5
125	Egyptian Initiate.	BSL 1023 1-4-29-6
120	'Faust'.	BSL 1023 1-4-29-7
124	Genius. ('Faust' motif.)	BSL 1023 1-4-29-8
129	Russian human being with Blue Angel.	BSL 1023 1-4-29-10
129	Russian human being with Centaur.	BSL 1023 1-4-29-11
28	View into the Small Cupola.	BSL 1023 1-4-1
18	Large Hall. (View to the southwest.)	BSL 1023 1-4-7
138	Boiler House. (Façade.)	BSL 1023 3-1-2-3
138	Boiler House. (Side view.)	BSL 1023 3-1-2
137	Model of Christ head. (Three-quarter view.)	BSL 1023 4-4-13
136	Representative of Humanity. (In the studio.)	BSL 1023 4-4-24